Playing House

Playing House

A Starter Guide to Being a Grown-Up

Celeste Perron

ILLUSTRATIONS BY KERRIE HESS

HarperResource

An Imprint of HarperCollinsPublishers

PLAYING HOUSE. Copyright © 2005 by Celeste Perron. Illustrations © 2005 by Kerrie Hess/Arts Council, Inc. All rights reserved. Printed in the United States of America. No part of this book may be used or reproduced in any manner whatsoever without written permission except in the case of brief quotations embodied in critical articles and reviews. For information, address HarperCollins Publishers, 10 East 53rd Street, New York, NY 10022.

HarperCollins books may be purchased for educational, business, or sales promotional use. For information please write: Special Markets Department, HarperCollins Publishers, 10 East 53rd Street, New York, NY 10022.

FIRST EDITION

Designed by Renato Stanisic

Library of Congress Cataloging-in-Publication Data

Perron, Celeste.
 Playing house : a starter guide to being a grown-up / by Celeste Perron ; illustrations by Kerrie Hess.
 p. cm.
 Includes index.
 ISBN 0-06-074163-5
 1. Home economics. I. Title.
 TX 145.P45 2005
 640—dc22
 2005040233

05 06 07 08 09 WBC/RRD 10 9 8 7 6 5 4 3 2 1

Contents

Acknowledgments

This book wouldn't exist without the help of many, many people who offered me their wisdom and support along the way. First and foremost, my wonderful, supportive husband, Jason, who has patiently suffered through much of my domestic self-education; my amazing parents, Owen and Maureen, who've lovingly indulged me in recent years by re-teaching me kitchen and housekeeping lessons they'd no doubt tried to teach me a hundred times before; my sister, Stephanie, sister-in-law, Torrey, and great girlfriends, especially Jen, Rosie, Lauren, Melissa, Hedyeh, Catherine, Lindsay, Amy, and Esther, who are the best support system a girl could ask for; my wonderful editor, Kathy Huck at HarperResource, for believing in this book and throwing her talent behind it; my incredibly supportive and wise agent, Katharine Cluverius of ICM; Kate White, editor in chief of *Cosmopolitan*, my former boss and always role model; illustrator Kerrie Hess, who brought these pages alive with her artistry; and Nicole Beland, who contributed much of the inspiration for this book and was behind it from the very beginning.

It goes without saying that I'm immensely indebted to all the experts cited throughout these pages, who so generously shared their time and wisdom with me in order to educate women on the topics they're so passionate about. Thank you, thank you, thank you.

How This Book Began

A few years ago I was living the kind of life I'd always hoped to have in my twenties, a lifestyle that's glamorized in novels and TV shows about single urban girls—I was almost always out. Six nights out of seven I devoted to having fun, or at least going in search of it. When I wasn't at work, I was always at a party at a store or a gallery or a club, or having drinks or dinner with girlfriends or colleagues, or on a date with a boyfriend or potential boyfriend.

Back then I looked at my apartment mostly just as a place to shower, change clothes, and get ready to go out again. I didn't spend much time or energy making it attractive, comfortable, or homey. Trying to have some reasonably clean clothes in the closet and remembering to pay the electric bill every once in a while was the extent of my homemaking agenda.

This lifestyle was really fun for a few years, and even if the frenetic pace of it got stressful at times, it seemed pretty good overall—until the day when I grew tired of always being out running around and realized I didn't have anywhere else I wanted to go. I craved a real home, but my parents lived across the country, and what passed for my "home" in my adopted city was a patched-together mental place based on where my clothes were at any given moment—half a drawer of basics in my boyfriend's dresser, some accessories at the office, the tote bag in which I was schlepping around a change of undies and an extra pair of shoes, and the pile

of laundry back at my apartment. The place where I technically lived didn't feel at all like a home, and I had no idea how to turn it into one. It hit me that I was no longer a young girl—I was a well-educated, reasonably well-paid grown-up woman—but I still had no idea how to really feed myself well, make my living space attractive and welcoming, or confidently entertain others.

I was sort of embarrassed by my total lack of domestic know-how, but could comfort myself that few of the other women I knew had much of a clue about these things either. My friends and acquaintances who didn't party as much as I did worked even harder, and by the time they got home from grueling days at the office and sessions at the gym, they could only muster the energy to pick up a takeout menu and reach for the remote. The single working girl who has either happy hour instead of dinner or Moo Shu Vegetable in front of the TV is a cliché, but it's been reality for lots of us. Our excuse for being so domestically challenged, and it's a legit one, is that when you work hard all day, it's difficult to get motivated to cook and clean and feather your nest in your free time. But another big reason so many young women don't cook for themselves or take great care of their homes is that they don't really know how—sure, we can read a cookbook and can clean well enough to keep things sanitary, but these things are not second nature to us. Women of our generation weren't raised to be homemakers. We were raised to do whatever we wanted.

Now, I know that's a great thing, and I'm grateful to the feminists who secured it for us. I'm aware that while earlier generations of women were expected to have a labor-intensive dinner waiting on the table for their husbands every night, we're lucky that we can choose what we want to eat and when we want to eat it and have someone else make it for us if we so choose, and that our men never expect us to have dinner waiting (and given how clueless I was in the kitchen for most of my twenties, my boyfriends much preferred to order out or just cook for themselves). So this isn't some sort of postfeminist manifesto. I'm quite positive that young women's lives today are better than they ever have been, but I'm also sure there's some satisfaction and comfort and fun to be had in a little old-school homemaking, and it's something us career girls and junior–Carrie Bradshaws are missing out on.

Because after being raised to do whatever we want, I know a lot of us are finding that we want more of what we were raised with—simple-but-civilized home-cooked meals, parties and celebrations that take place not in hip bars and restaurants but in warm living rooms, and a real feeling of home. What does that

word mean really? It's a place where you nourish your body and mind, and just take pleasure in being in a beautiful environment that's totally suited to your tastes. It's also a place where you can pamper people you care about and show friends a great time.

Now, creating this for yourself might sound like a huge undertaking, since when you're in your twenties and juggling a job or school and a social life, you usually don't have a lot of time or money to play around with. But with a little know-how and expert advice you really can achieve this feeling of home anywhere you are, on any budget at all. Once you learn a few basic homemaking skills—like how to light your living room so that everything in it looks more expensive, or have friends over for a delicious dinner without having an anxiety attack, or make a chic flower arrangement out of blossoms you scooped up at the supermarket—you'll get the confidence to attempt even bigger domestic deeds, and soon find yourself feathering your nest and creating mouthwatering things in your kitchen without thinking twice about it.

But to get started you need to let go of the idea that homemaking requires this obsessive zeal and perfectionism. On the contrary, getting with the true spirit of it requires accepting that you're not going to do everything perfectly. You're doing this not because you want your domestic life to look like something arranged for a *Martha Stewart Living* photo shoot, but because you want it to have the feeling those images are meant to evoke. All you need is dedication to making where you live a place you find soothing to come home to and are happy to welcome people into. This is something all of us can and should do for ourselves.

To assist you in this mission, I've quizzed experts in just about every relevant field for their best advice on how girls can learn to decorate, cook, clean, entertain, and just generally improve their homes. Now, some things can only be learned by trying them yourself, but I really believe in passing up that whole trial-and-error process whenever possible. If you can have someone fill you in who already knows how to do it right, it makes the whole thing much more fun. So, turn the page to start soaking up the wisdom these pros have generously shared with us, and let your domestic-goddess education begin.

Feathering Your Nest

1

RULES FOR DECORATING YOUR SPACE
SO IT'S STYLISH, SERENE, AND TOTALLY YOU

So you're ready to let your dormant domestic side wake up and thrive? The first and most essential step is to make your living space one you *want* to awake in every morning and return to at the end of the day. Your apartment or house should be a place where your needs for both physical comfort and mental peace are met. It should also be a place you're proud to welcome friends into—not because you've spent a ton of money to fill it with impressive stuff, but because you've put effort and creativity into making it a wonderful place to hang out, one that expresses who you are.

As you've noticed by now, some homes are just really inviting—and others aren't. I first really learned about this from observing my friend Amy. When I was in my early twenties, it seemed as if everyone I knew decorated their apartments in one of two styles: sloppy-dorm redux (the category my first apartment fell under); or spanking new, one-hundred-percent Crate and Barrel. The first look was comfy but a little bit depressing, and the second seemed really grown-up but impersonal and soulless. But Amy's place was neither of these, and it was inevitably the one we'd all hang out in for hours. With a little ingenuity (but without spending any more money on décor than the rest of us) she managed to turn her alcove studio apartment (a fifth-floor walk-up, no less) into a really warm, welcoming little home. Her recipe for an inviting room had simple ingredients: cushy sofas and

chairs, soft lights, lots of little tables to rest drinks on, and cool wall-hangings and other unique touches that really expressed her personality.

The next time I moved into a new apartment and set about decorating it, I very deliberately tried to copy the look of Amy's place. I didn't go so far as to buy the same throw pillows, or anything too *Single White Female* like that. But I paid very close attention to what I liked about her place. Because she had a lot of softly lit lamps, I ditched my big bright halogen one in favor of a few table lamps. I observed that she had a very tight color scheme, camel and crisp white accented with pale blue, so I pared down my color scheme to just three or four hues—and packed away the multicolored tapestries and jewel-toned vases that didn't fit into the scheme. Yes, I felt a bit weird about apartment-stalking my friend, but I wound up with a look that was much more stylish than that of the place I'd been living in before. The essential principles I picked up from copying Amy aren't complex or difficult to comprehend, but it's unlikely you'll stumble upon them yourself when you're decorating for the first time.

Now's the time for you to brush up on these basics so you can turn your own home into a haven. Maybe your current place is just the spot where you sleep and store your stuff, with décor you don't even think about or just sort of tolerate. Or maybe you've put a lot of effort into making your living space look great, but still feel it comes up short. In either case, there's a whole lot you can do to make your pad a place you can't wait to get back to, because it makes you so damn happy when you walk in the door.

Of course, during the starting-out stage of your life, decorating can seem really daunting. You're limited by your budget, and the need to spend on things like shoes and bags and trips and socializing seems much more pressing than the need to tend to your home. And since you're most likely living in a rented space, it's hard to get inspired to invest energy or moolah in how it looks—you don't know how long you'll be living there anyway. Also, it can be really tricky to decide what style you want to achieve—contemporary and trendy? Mid-century modern? Traditional and luxurious? Do you want it to feel like a sleek mod party pad or a cutely disheveled country-style haven, or posh and fit for a Park Avenue princess? It's so hard to choose, and especially confusing since you're not starting totally from scratch—you've probably inherited a bunch of furnishings (from parents, ex-boyfriends, former roommates) you can't afford to replace.

But no matter what sort of stuff you're starting with, and regardless of how little you've got to spend, there's still a ton of things you can do to get your place looking

like that fantasy pad in your head. Here I've pulled together the most helpful advice I've heard from interior design pros. First, I'll share their insights on how to decide your decorating goals and then upgrade the fundamentals of your space. It's important to get major elements like the walls, rugs, and windows right before you move forward. Then I'm going to share their wisdom on choosing the right furniture or making over the stuff you already have, and their rules on how to light your space in the most flattering way. Once you've got all that down, you can add the fun finishing touches, the little things that express your style and mark your home as your own. All the experts I cite here are cool modern women like you (who just happen to have killer taste and super-successful careers in design), and I guarantee that if you follow even a tiny portion of their pointers, you'll wind up with a home you're much more into and, hopefully, totally proud of and passionate about.

Step One: Decide Your Decorating Goals

So once you're committed to mastering your domestic domain (we're talking living rooms here for the most part) and making your place look great, you need to focus on what that means for you. When you're first decorating, deciding on your personal style can seem so baffling, and I still go through bouts of style schizophrenia. I'll walk into someone's fancy, traditional Upper East Side home and think, "Ooh, I wish my place looked like this!" but then the next week when I see a minimalist downtown loft, I'll think, "No, I wish my place looked like *this*!" But you need to realize that just because you love a certain style in theory doesn't mean that that style is the best one for you. It's like how a smart girl shops for clothes. If the trendy pants cuts for a given season include both slouchy men's-style trousers and fitted cropped ones, she doesn't buy both styles. Instead she decides which of the two styles fits her attitude and flatters her butt, and then she stocks up on just that style and mixes it with the classics she already owns. You need to bring that kind of self-knowledge and shopping discipline to your decorating. Figure out the looks you love the most, then determine which of these styles works best in the space you've got, and stick to it.

To learn about which looks speak to you, flip through decorating magazines and tear out pictures of the rooms you're really drawn to (of course, most of the homes in high-end magazines look insanely good, so only rip out the ones you're

crazy for). Super-chic young interior designer Celerie Kemble points out, "You wouldn't decide to start cooking for the first time without a recipe, so if you're just starting to decorate, you need a reference, you need to educate yourself about what's out there and what you like." Put your favorite magazine pages in a notebook or folder and, after a few months of research, look through your tear sheets in search of common threads. Patterns will emerge—you'll realize you're most drawn to richly hued walls, or sleek geometric lines, or lots of luxurious textures. This will help you understand that even though you may appreciate different styles, there's one standout look you're really eager to have in your home.

Next, before you get started making over your space (whether you're thinking just little tweaks or a top-down do-over), you should make a list of what you're out to achieve. Many of your goals will be individual, specific to your tastes and how you use your apartment. Here are a few of the types of questions to ask yourself.

Do you frequently have friends over?

If you're into entertaining, you need to make your place party-friendly, with lots of extra seating and tables to set drinks on, and maybe a dark rug that won't stain when those drinks inevitably get knocked off those tables. Your investment item should be a top-quality sound system.

Are you a homebody?

If a typical night finds you hunkered down happily in front of the television, make it a priority to find a comfy couch that's big enough for you and your boyfriend to snuggle on, a coffee table sturdy enough to rest your feet on, and a side table where you can place a bowl of popcorn and the remote. Instead of sinking money into your stereo, spend it on the best flat-screen TV on the market.

Do you work hard and party hard?

Girls who mainly use their apartments to crash in during breaks in their packed schedules need to focus on making their bedrooms really divine. Invest in great sheets and blankets and a stellar closet-organizing system, so you can easily access the outfit you need for your next engagement.

Do you have slob or packrat tendencies?

Be honest—if you can't beat the urge to hoard things or are lacking the neat gene, a sleek, minimalist look isn't going to work for you. You need lots of bookshelves, armoires, and multitasking items. Invest in trunks you can use as side tables, and buy storage ottomans instead of extra chairs.

But regardless of your specific tastes and needs, there are three goals every girl should have for her home.

1. **You want it to be warm and welcoming.** Set out to create one of those pads that people always seem to gather in and like to linger in for hours. Such places usually aren't the fanciest or most perfectly decorated ones, but they're inviting and easy to hang out in.

2. **You want it to look polished and feel "together."** For you and others to feel really serene in your space, it's got to have a good visual balance and be set up in a way that's easy to move through and live in.

3. **You want to make it both beautiful and personal, reflective of who you are**. Of course, ultimately, you want your pad to be really amazing looking—not in a precious way, but so your eyes have lots of attractive textures and colors and shapes to gobble up. And it needs to feel like yours and nobody else's. Even if you fill it with pricey stuff from the most fabulous shops and set things up with the skill of an interior designer, your space will just resemble a high-end hotel room if it lacks a personal touch.

Now, the key problem that keeps us from giving our spaces a look we love is that we usually can't afford to replace more than a few things at once. The following guidelines are designed to help a girl deal with what she's got, so she can make it look just like what she wants, whether she's got a big ol' budget or a bitsy one.

Step Two: Improve the "Envelope" of the Room

Whether you're moving into a new place or making over one you're already living in, you need to begin your decorating mission by thinking about the "envelope" of each room. Before you start obsessing over the furniture and accessories, work on the things that surround them—the walls and trim and floors and windows. Once these fundamentals are in top form, everything else will appear to be more fab, but the inverse is true too—even really expensive furnishings won't look great if the backdrop isn't polished.

Your very first step in sorting out the style of any room is deciding on the color of the walls, and to do that, you need to have some sense of what your color scheme will be.

Creating a Gorgeous Color Scheme

A mix of eye-catching colors is required to make a room fun to look at and live in. But if you have too many colors in a space, it won't look polished and put together. The trick is to pick a color scheme that works, without going overboard in any one direction—you don't want a total cacophony of contrasting colors, but on the other hand, too matchy-matchy is almost as bad. There are so many ways to work color in—painted walls, furniture, rugs, curtains, and extras like pillows and throws. By far the easiest thing to do, especially when you're building your décor bit by bit, is to create a fairly neutral base and add the exciting colors in the form of acces-sories. So paint the walls a subtle, simple hue, and keep your big-investment pieces of furniture in flexible colors such as brown, cream, gray, and khaki. Then add bursts of color us-ing smaller, cheaper pieces like pillows, lamps, little ot-tomans, throws, vases, and things like that, which you can replace pretty easily if you change your mind about your color scheme. That said, if you've already got a red sofa you love, or are dead set on cobalt blue walls, that can work too; it just takes a little careful planning with the other colors you add.

> "Well-painted walls make everything in a room look more expensive."
>
> —*Tracey Benton, New York City interior designer*

The first decision you need to make is what color the walls will be. A room's never going to feel well-decorated if you don't paint them. Even if you're sticking to white, you shouldn't settle for the white the place came with, and if you're seri-ous about creating a stylish abode, you'll want to add at least a little bit of color.

Playing House

A Primer on Painting Your Walls

● If you're moving into a new place that's freshly painted, the paint will most likely be low-quality and have a dull finish, so even if you just want basic white walls, you should redo them in a spanking new coat. Interesting fact: "A quality paint shouldn't smell for more than two or three hours after you paint it," says Boston interior designer Heather Wells. "But most rented apartments smell for days after the landlord paints them because the paint is so cheap."

● Every single decorator I've ever asked recommends Benjamin Moore paint. It has the best color selection and isn't ultraexpensive. Check out their Web site to see the more than one thousand shades they offer (benjaminmoore.com).

● Highlight the details of a room by painting the doors and windows and the trim (the windowsills, baseboards, doorframes, and any molding) a bright white.

● Paints come in different finishes—what you want for your walls is a "matte" or "satin" finish, but paint the trim in a "high-gloss" finish. Even if you're keeping the walls white, painting the trim a high-gloss white will enhance the structure of the room and make it look nicer.

● If you want a rich wall color, Heather Wells suggests you choose from Benjamin Moore's "Historical" color line. It contains softer versions of strong hues. "A red from the regular line can look like nail polish on the walls, but the red from this line will be more gentle and subdued," she says.

● If you want a very pale pastel, pick from Benjamin Moore's line of whites. They have whites with undertones of blue, pink, yellow, and so on that show up as pastel tints on the walls. Remember that paint hues

(continued on the next page)

always look much stronger on the walls than they do on the chips, so if you want just a hint of yellow, you should probably play it safe and start with a yellow-toned white.

• If you think you want some bright color on your walls but are nervous that it will be overpowering, use it on just one "accent wall," balanced by a pale neutral on the other three.

• While of course you can paint a room yourself, it takes a lot of patience (or so I've heard) and, to do it well, some experience. Your best bet is to find someone who knows what they're doing and will do it for $300 or so. Ask your friends for references, ask your super if he paints, or look for ads on an online community message board like Craigslist.

• Unless you feel absolutely certain about a hue, the safest thing is to buy the smallest amount you can and paint a couple square feet of wall with it. Many brands sell small sample cans just for this purpose. Benjamin Moore sells two-ounce samples, which is enough to cover a two-by-two-foot stretch of wall. Do it on a Friday night and then live with it all weekend, observing how the color looks at different times of day and in different light. If you decide it's not right, you can just paint over it with a new color.

Nothing makes a place look more "done" than well-painted walls, particularly if you paint the trim a contrasting shade, which makes the wall color really pop.

But how to choose a paint? One pretty reliable way is to look through interiors magazines in search of a color you like. Often the copy or captions accompanying photos of a home will say what paint color was used. But before you commit to anything, check out the list of basic wall-painting rules above.

Color Strategies You Can Count On

Okay, one of the trickiest parts of decorating is getting the color scheme right. Combining colors in a way that really works requires both science and instinct, and often takes a little trial and error. I find there's lots of advice out there, like "Be playful!" and "Mix and match colors you love!" that really isn't helpful at all. Mixing colors together without a plan is a recipe for a room that's wacky at best and butt-ugly at worst.

I like this formula—I can't even remember who told it to me, but it seems like a virtually fail-proof way to put together a great-looking color scheme: Start with a neutral base (think brown, khaki, mushroom, white). Then choose a main color to be used on one or two big elements like the walls or the sofa or the curtains. Finally, pick an accent color that's next to your main color on the color wheel but has a different intensity (by *intensity* I mean whether it's a pale, deep, or bright shade). Then sprinkle the accent color around the room in the form of pillows, throws, lamps, and small pieces of furniture like chairs or ottomans.

So let's say your main color is pale blue, then your accent color could be either green or purple (since those are the colors on either side of blue on the color wheel); but the accent green could be an electric lime or a rich emerald, and the accent purple could be a vibrant Easter-egg violet or a rich amethyst. Mix your neutral items (you should probably limit them to two neutral colors, say a rich chocolate and a pale cocoa, plus as much white as you want) in with the big pieces of blue and the green or purple accents, and you've got a great, tight color scheme.

It's not that you can use only two colors in a room—you can have tiny bits of others in places—but your base and accent hues should be dominant. It's especially important to have a controlled color scheme when you've got a small space or are working with a mixed bag of furniture. It really pulls it all together, and too many colors in a small space make it look cluttered.

Another, more conservative way of doing a color scheme is to choose a color and use lots of different shades of it (mixed with neutrals of course)—for example, a mix of

"Distribute color in your home the way you'd wear it in an outfit. You usually wear one color on top, another on bottom, and then touches of a third in your accessories— that's basically the number and proportion of colors you should have in a room."

—*Heather Wells, Boston-based interior designer*

Tip Sheet on Making a Small Apartment Look Less Bitsy

Don't go for supersized furniture. "The biggest mistake I see people make in small spaces is to have furniture that's too big and bulbous," says Heather Wells. "An overstuffed sofa is meant to be in a big house, not a small apartment, and it will look like a monster that's going to eat up all of the other furniture."

But don't fill it entirely with tiny furniture either—a bunch of really delicate things will create a "doll's house" quality that emphasizes a room's diminutive dimensions.

Limit the palette of materials and colors from room to room to make the apartment feel more unified, since in a small pad you can often see more than one room, or all the rooms, from a single vantage point.

Strong color contrasts can visually chop a space up and make it look smaller, whereas a more monochromatic color scheme will stretch the space.

Create visual depth by getting an area rug that covers most of the floor but leaves a foot or so of space between its edges and the walls.

Think mirrors, mirrors, mirrors—nothing expands a space like them. Place three large matching ones alongside each other, brasserie-style, or group together a set of three to six in different shapes and sizes. Use them in dark areas—they'll magnify whatever light source is available.

Create the illusion of "windows" by hanging large nature prints on the wall, suggests Karen Reisler. "That's a great way to 'blow through' the walls of a small room," she says.

A note on color and small spaces: I've asked a ton of experts, and there seems to be two schools of thought on what to paint the walls of a small space. The conventional wisdom is to choose a light hue—cream, butter yellow, wheat, pale blue—to keep it from looking cavelike. But I've heard many designers say that rich, dark paint colors actually make a room look more spacious, especially if you place a large mirror on one wall and have lots of soft light sources. So I'd say you should paint your bitsy room whatever color you choose, and just follow the rules above to keep it from feeling claustrophobic.

The best way to make anyplace look more spacious: "Just edit, edit, edit," says *Elle Decor* editor in chief Margaret Russell. "Give things away and just keep the things you love to have around you. If you simply can't let go of things, consider renting a storage space. You don't have to live with everything you own at any given moment—that's one of the biggest mistakes people make with small spaces."

cobalt, azure, and baby blue, or kelly green with grass green. This is a safe but elegant alternative to trying to create an exciting mix of colors.

Now, I'm not saying that this is the only way to do it, or that you have to have some strict color formula, but I think these guidelines help when you're trying to pull together something great-looking without a lot of guesswork. You can also totally ignore formulas and follow New York interior designer Karen Reisler's easier, more intuitive advice on pairing colors: "If it works in nature, it will work in your home," says Karen. "If you want to know if khaki and pale blue will work together, think of how great the sand and sky look at the beach, and if you love hyacinths in the spring, you know purple and green could be a great pairing for your apartment."

Put Something Sweet Under Your Feet

Interior designer Laura Newsom told me that when pros create a room from scratch, they figure out what the floors are going to be before almost any other decision is made; that's how important floor-covering is. Now, when you aren't

Rules About Rugs

• If you're using a medium-sized area rug under a grouping of furniture, don't think that all the furniture has to be entirely on top of the rug. Sofas and big pieces can be partially on it, partially off. Lighter pieces like occasional chairs should be entirely on top of the rug so they don't feel lopsided.

• An area rug is a great way to define different sections of a room if you're using it for more than one function, whether it's a studio apartment that your entire life is in or a big open space that serves as both living room and dining room. Put an area rug just under the "living room" to set it apart from the "dining room."

• If you want a wall-to-wall look but can't afford carpeting, just measure your room and get an area rug that ends six to twelve inches from the wall—it will have the same effect.

• Use an area rug to define a seating area by getting one that's just big enough to go under your cocktail table and a couple of the surrounding seats.

starting with a totally blank slate and don't have the budget to tear the floors of your place out and replace them, you've gotta make the floors you've got somehow work with the room you want.

First of all, even if you're lucky enough to have beautiful wood floors, making a room truly feel cozy and look polished requires some kind of rug or carpet. They add warmth (think how much more snuggly a rug feels under your feet than wood does) and create a layered effect that makes a room look more appealing. And even if your place came with wall-to-wall carpet, layering an area rug over it is still a good idea, because it adds depth and visual interest to the room. See the roundup of rug-purchasing pointers above.

So what type of rug should you buy? Most designers recommend that a decorat-

ing beginner on a budget get a big rug in a natural fiber like sisal, jute, or sea grass, bound in tan or brown or black. You can get one for $200 or $300, they coordinate with almost any style—whether contemporary or traditional—and they tend to make your space look bigger. Wool sisal is usually the most expensive, but it's the softest and the easiest to clean. Nylon faux sisal is a great option because it's super-stain-resistant and feels soft like wool (but costs less money). Jute and sea grass are a bit rougher under the feet, but they give a great textured look to the room.

While you can't really go wrong with this look, it's been so big for the past few years that in a few more it's probably going to look a bit trite. Lately thicker, plusher rugs from Nepal and Tibet have been in style, as have rugs with vibrant patterns. The easy thing about covering your floors with a big neutral-hued natural-fiber rug is that if you find another great area rug with a color or pattern or texture you love, you can just throw it on top.

$$-**Saving Strategy:** Call a big carpet and rug store near you and see if they have a remnant department—where they sell pieces of carpet that are left over after they custom-cut floor-covering for other customers. You can find good deals at these places, and they're especially great sources for pieces to fit odd-sized spaces like hallways.

Make Sure Your Windows Are Well Dressed

You need window coverings for privacy and to keep the light out when it's too bright, but they're also essential to giving your space polish. Because they add another layer of texture, well-dressed windows do a huge amount to make a place look warm and complete.

Your basic options are shades, curtains, and blinds. Curtains have the softest effect, blinds give a room more of a no-nonsense utilitarian feel, and shades fall somewhere in between. Shutters, quality blinds (and you don't want any other kind), or any kind of pricey, complicated curtain setup aren't worth it if you're renting or know you're not going to be in the same home in three years (since you don't want to invest in window coverings that might not fit your next place). Instead, go for simple shades or panel curtains. You can get some that look really chic for fairly cheap, and they're easy to hang yourself.

Roman shades (the kind that fold up neatly on themselves when you raise them) are a clean-looking, can't-go-wrong option that coordinates with any type of décor. You can get them in a variety of fabrics and patterns, but in general windows aren't

the place to get adventurous with color or design unless you're really sure of yourself, style-wise. Shades that are straight across the bottom create a crisp, tailored look, while soft shades, which dip lower in the middle, or balloon shades, which have a poufy, scalloped effect at the bottom, give a more luxurious or formal feel to a room.

One great option for the first-time decorator is Roman shades in a natural material like bamboo or woven straw. It is a look that goes with every type of décor, from minimalist to traditional, is really stylish, and adds texture to a room. On their own these materials usually don't block light entirely, so if necessary get them lined on the outside with a fabric that keeps out light but doesn't affect the look of the shade from the inside. This is a great place to start with your windows, and you can always layer curtains on top of the shades if you decide you want a more cozy, heavily decorated effect. (Resources for these and other window coverings are listed at the end of the chapter.)

If you'd prefer classic curtains, but don't want to invest in expensive ones, your best bet is panel curtains with pocket or tab tops, which are the kind you just slip over a curtain rod. If you want to get a bit fancier, you can get a double rod and hang two layers of curtains—sheer inner ones that give you some privacy during the day but still let the light in, and heavier outer ones that totally block the light. As with shades, you probably want to keep your curtains a neutral color, so you can play around with the rest of the colors and patterns in the room without worrying about them clashing with the curtains.

There are three basic lengths for curtains: they can fall at the windowsill or right at the floor or spill onto the floor. The first look is pretty casual and only really right for a kitchen or a bedroom, and the last look is more fussy and formal and only really works in a luxurious, traditional style of home. So you generally want the curtains in your living room to break right at or just before the floor, without puddling on it.

Finally, if your place comes with cheap blinds (like so many rentals do), don't just sit there and take it. Though you don't want to rip them out for fear of losing your security deposit when you leave, you can instead put Roman shades right over them and leave the blinds pulled all the way up where you can't see them.

Smart-Girl Secret: The taller your windows appear, the more spacious and elegant the room will feel. If your windows

"Try to only buy things that make you giddy to think about—if you do that, you'll never regret the purchase."

—Celerie Kemble, New York City interior designer

don't go all the way to the ceiling, use this trick to give them the illusion of more height: Hang both curtains and a Roman shade, placing the curtain rod as high as possible, and putting a Roman shade underneath it. This will hide the fact that the curtains are hung above the top of the window—to the eye, it will seem as if the area under the Roman shade is all window too.

Step Three: Stepping Up the Style of Your Furniture

Once the floors, walls, and windows are looking awesome, you can turn your attention to what they surround. Here's what the pros have to say on finding new furniture and working with what you already have:

Furniture-buying Advice

When you're buying new things for your place, you want them to be as cool and special as possible, of course; but since you probably don't have more than a Saturday or two a month to spend seeking this stuff out, sometimes you're going to have to go the simple route and head to a big furniture store or track down your décor online during the workday. Don't look at that as a cop-out—nearly every interior designer I talk to says that mass-market stores today have some super-chic stuff. So you should never feel insecure about buying things from companies like Pottery Barn and Crate and Barrel. (For a list of resources, see the end of this chapter.)

How do you ensure you'll choose furniture you'll be happy with and have for years? First, do a lot of research. The Internet is the easiest way to check out all the options, but try to see big purchases in person. You need to be able to touch a piece of furniture and test it out before committing. When possible, bring home swatches before you buy. Most stores and even catalogs will give you swatches of fabric or samples of wood (often for a deposit of a few dollars) so you can see how they look in your place before you commit moolah.

Second, keep your big pieces classic, so they will look great for years to come. Trendy styles will feel stale in a year or two. "Invest in a great sofa with simple lines and you won't grow tired of it," says Margaret Russell. "You can always re-upholster it down the road if your tastes change. And if you know you'll be moving, don't buy a really big sofa—it may not fit in your next space." With major items you should also look for pieces that can blend well with different styles. Who knows where you'll be living next, or how your tastes will change?

Finally, think carefully about how you will use the furniture. Do you tend to eat dinner in front of the television? Then a white sofa is not for you, since that would make every drip and spill a big drama. Have a white cat who likes to snuggle? Then a dark fabric is a bad call because it will show every bit of fur.

Now, even though they're the easiest option, you can't furnish your place floor to ceiling with stuff from mass-market stores. "You have to mix and match your basic chain-store items with old pieces and special things," points out Laura Newsom. "Round out every room with a few really unique pieces, something old with character, and a few items you've spent a bit more on." Those unique purchases are particularly important, and can't really be planned. Cool old maps, glass vases in your favorite color, and wacky items that for some reason just speak to you are usually the sort of things you stumble across when you're not looking, so you need to be prepared to scoop them up. Don't be afraid to buy something a little bit out-there; as long as it brings you joy to look at, it won't be a mistake. "It's the oddball purchases that become a part of who you are and stay with you forever," says Celerie Kemble.

Never, Ever: Buy anything you don't love just because it's on sale! If you're not thrilled with it, you'll never be happy with it. You need to remember that this is not like buying clothes, when you can just hide a regrettable purchase in the back of your closet and pretend it doesn't exist. This stuff will be out where you have to look at it every day, and it will probably take you a while to replace it. "It's amazing how long it takes to get rid of furniture!" says Heather Wells. "So only buy things you know you'll love for a while."

Tips on Transforming Stuff You're Stuck With

Of course, you can't afford to replace every single thing at once, and there's probably at least one piece of furniture in your space that's screwing up your whole vision. But don't resign yourself to just living with it—there is a lot you can do to transform those ugly-stepchild pieces so they're actually appealing and work with the look you're going for. Anything upholstered can be slipcovered, almost anything else can be painted, and accessories like blankets and throw pillows can disguise a lot. Here are some pro tips on working with what you've got: "Make an old, boring sofa unique by replacing the back pillows or recovering them in a different color or pattern," says Laura Newsom. "If tables are too high, cut the legs down. If you don't like the color, lacquer it—or paint it white," says Celerie Kemble. "Most everything brown and lame can come alive in a new way if you just

How to . . . Paint a Piece of Wood Furniture

Only paint in a well-ventilated place far away from anything flammable. Wear gloves to protect your hands. Place the furniture in the center of a big stretch of tarp, a thick layer of newspapers, or an old bedsheet you don't mind ruining, then lightly sand the item all over using a piece of fine-grit sandpaper. Thoroughly wipe away any dust with a soft rag. If you're painting a dresser or chest, remove the drawers, being careful not to get them out of order. Using a paintbrush, coat all the visible surfaces (including the faces of the drawers) with a water-based primer. This will ensure that the paint goes on evenly. Let the primer dry (which should take about two hours, but check the instructions on the primer you're using), then lightly sand the item again.

Start painting it with a water-based paint, working from the top down. Paint in even-sized strokes, going with the direction of the wood grain. Let it dry for at least three hours; then apply another coat. It should take about two days for the paint to dry entirely. If the item has drawers, don't reinsert them during that time.

paint it white!" "You can't always have a matched set of dining room chairs, so just buy mismatched ones and paint them all the same color, like a cream or a pale green," suggests Los Angeles interior designer Heather Whitney. "You're not pretending they match, but you're making them coordinate and drawing attention to their unique shapes. That way mismatched furniture looks stylish rather than sad." Inherited some white wicker furniture that's sabotaging the chic urban look you're going for? Paint it black! "You can totally transform wicker by painting it an unexpected color," says Karen Reisler. "Try it; you won't recognize it."

Arranging Furniture Right

There aren't rigid rules for how to place your furniture; you have to do it according to how you use the room. If you love to plop down in a certain chair with a book and a cup of tea, you need to place a good reading lamp and a side table within easy

How to ... Improvise Slipcovers

Doing a no-sew slipcover is an inexact science, and you'll probably have to play around with it a bit to get it to look just right. All slipcovers are like that really, these just more so. The most important thing is to buy a big enough piece of fabric. Definitely err on the side of buying too much, since you can always cut off the excess or pin it under; but if you don't buy enough fabric, you'll be stuck. Note: You can get great, pretty inexpensive slipcovers from brands like Surefit (which is sold at target.com, among other places), so unless the furniture you're covering is an unusual shape or you're dead set on covering it in a specific fabric, it's probably cheaper and easier to buy ready-made slipcovers than to improvise at home.

First, measure the item you want to cover, using a soft measuring tape. Start by running the tape from the floor behind the item, up the back, then go over the highest point of the back, and down and across the front of the seat to the floor, keeping the measuring tape flush with the item the entire way. Write down that measurement—this is the minimum width of fabric you'll need if you're covering a sofa, and the minimum length you'll need if you're covering a high, narrow chair. Next, measure starting at the side of the item, going from the floor at the farthest back corner and running the measuring tape over the highest part of the seat back, then along it and down to the floor on the opposite side. Write down that measurement. Finally, place the end of the measuring tape on the floor below the arm of the item, then run it up the side, over and down the arm, across the seat, over the opposite arm, and down to the floor on the opposite side, keeping the tape measure flush with the item the entire time. Write down that measurement.

Of these second and third measurements, the larger one is the minimum length (for a sofa) or width (for a tall chair) you need your piece of fabric to be. Once you've figured out the minimum length and width of fabric you need, add eight inches to each number, so you'll have enough fabric to create hems and ensure that you're not caught short. If you're covering something with seat cushions, add four more inches to the length (of a sofa) or the width (of a chair) so you'll have excess fabric

to tuck into the crevices of the cushions if you choose to. (To make a slipcovered item with seat cushions look more polished, cover the cushions separately and place them on top of the seat cover.) You should consider washing the fabric before you use it, so it will be preshrunk and won't shrink further with future washings.

The ideal fabric for slipcovers is durable and washable and thin enough that it will mold easily to the form of the furniture. Ask the salespeople at your fabric store for suggestions. As you should when choosing any fabric, take a swatch home with you and hold it up next to other items in the room to make sure it works. If you're covering something with a strong color or pattern, you need to be sure your slipcover material is opaque enough that the original fabric doesn't show through.

Once you've draped the fabric over the furniture, spend some time adjusting it until you've got it the way you'd like it to look. Use a few straight pins or tacks in low-visibility spots (like the sides of the back) to secure the fabric to the item. "Hem" the edges of the fabric by pinning them up to the level you'd like, then gluing them in place using fabric glue and removing the pins.

To gather fabric in the back of a chair—both to neaten up the look and add a decorative tie detail—take two strips of fabric or ribbon and glue one end of each to opposite edges of the chair back, directly across from each other. Once the glue is dried and the pieces of the tie are secure, bring the free ends together and tie them in a bow.

The cheap, easy way to cover the cushions separately is just to wrap each one in fabric as if you're wrapping a gift, with the seams and folds on the bottom. Pin the folded fabric together tightly on the underside of the cushion, then place it over the slipcovered base.

reach. And if you plan to entertain a lot, be certain to place your living room seating close together enough that your guests will be able to hear each other talk. Passionate about music? If you make frequent trips to the CD player, you don't want your sound system to be in a corner blocked by a cumbersome chair. Really think

Tips Specific to Studios

Studio apartments present the mother of all furniture-arranging challenges, since you want to make it feel less like one room. To divide a room in two, get an area rug and put it on one side of the space. If you place the rug just under your sofa, chairs, coffee table, and TV stand, it will mark that area as the "living room," as distinguished from the "bedroom" or "kitchen" along the opposite wall. Another way to break up a space is to place the sofa in the middle of it, so that the area behind the sofa's back feels like a separate room. You can also do this with a bookcase or other long, large piece of furniture. Folding screens are an easy way to divide up a room as well.

If your "kitchen" is just one wall of your living room, place a curtain or folding screen in front of it a few feet out from the counters. That way you can cook while friends drink and chat on your sofa, and they won't be able to see all the culinary drama going on. Also, you won't have to stare at the sink every time you're in the room. But when you do want to open things up, so you can watch TV while doing the dishes or whatever, just pull the curtain or screen back.

In a studio or not, it might make sense for you to put the furniture on casters. That way you can easily move it and transform a room for different functions. When people are coming over, you can move your bed or other in-the-way furniture over to a corner to clear some mingling space. And casters allow you to easily try endless furniture-arrangement options. Tip: Be sure to buy casters that lock, so your furniture doesn't move when you don't want it to.

about the paths you typically take when you move around the room, and even try out a few different setups to see what works best for you.

Never, Ever: Put too many different styles in one space. It's tempting to buy everything you like, but everything you like isn't going to look good all together. Although mixing items of two different eras or design styles is a great way to give a

How to . . . Play Around with Patterns

Every room needs some pattern, and it's a fun thing to get creative with. Test out fabrics before you commit by bringing home swatches or scraps and laying them on your sofa or over a lamp for a few days to see whether you're truly into them. Or, make sure a patterned item is returnable and then just buy it and decide if it works once you get it home.

You can mix patterns, but they should be connected somehow. If they're different styles, they should have a common color scheme. If they're different colors, then they should have the same visual feel. So, mix a prim floral with a zigzaggy geometric pattern only if they have the same key colors. But you can mix a floral with a paisley without worrying so much about whether the colors match. As a rule, stripes look great with everything, and plaids usually do too. If you already have two very different patterns in a room, tie them together with a striped pillow that contains a color found in each of them.

room a unique look (say, a seventeenth-century-inspired Louis chair next to a Lucite coffee table, or a Victorian chandelier over a sleek twenty-first-century sofa), throwing too many disparate styles together will make a room look cluttered and confused. Again, think of a room like an outfit—you wouldn't wear all your favorite accessories at once, so why buy everything that catches your eye and try to make it work in your living room?

Perfectionist Tip: Get Custom-made Throw Pillows

Pillows are the easiest, most fun and noncommittal method for adding touches of color, pattern, and personality to a room. And you can find beautiful ones everywhere these days. But to truly make your space feel personal, consider having a few made. It's not very expensive, and you'll love knowing they were created just for you (a feeling that's prohibitively expensive to achieve with furniture!). Either

"Necessity is the mother of furniture arrangements—there are no rules. Do what works in your space."

—*Karen Reisler, New York City interior designer*

Feathering Your Nest

How to . . . Deal with a Dud Purchase

It's pretty inevitable: Even if you follow the advice here and resolve to buy only furniture you're passionately in love with, at some point you're going to spend an entire paycheck on a piece you almost immediately regret. If you can't return it, there are two schools of thought on how you should cope. Many people would advise you to just get rid of it ASAP, and ease the financial pain a bit by selling it on eBay or at least donating it to a charity thrift shop so you can get a tax deduction. But if you're truly on a budget—which really almost everyone is, just with different ideas about what that word means—you should try to find a way to make the offending object work.

Think about it—let's say the bad purchase is a pair of chairs for your living room that you bought on sale, can't return, and have decided are all wrong. If you get rid of them, you'll have to drop a lot of dough to replace them and spend time looking for those replacements. But wouldn't it be more fun to keep the so-so chairs (which probably aren't as bad as you think they are, since you do have decent taste) and instead spend some of that money on a couple of beautiful throw pillows to put on the chairs, and a cool photograph to hang on the wall behind them? That way you can come out ahead, moneywise, and have some fab new things in the room, without spending any more time obsessing over finding the perfect chairs. So rather than getting all mired in regret, try to look at a mistake as an interesting challenge and just keep moving on with your decorating mission.

have fun searching fabric shops for colors and patterns you love, or use a favorite piece of fabric you've already got. I took an old batik sarong I'd been wearing to the beach for years and had it made into two square pillows for my sofa. I was crazy about the print and didn't find anything just like it in the stores, and now I get to look at it in my living room. Legend has it that Jackie O, that idol of style-obsessed women, had some favorite Liberty-print scarves turned into pillows. To find a great pillow-maker, ask around—at the fabric store, or when

Do It Posh: If you've got some dough to invest, you'll never regret buying an awesome sofa. They're the focus of the living room and need to be as comfortable as possible. In general, a cheap sofa looks it, but a fancy one will take everything else up two notches.

Do It on Pennies: For the price of a nice sofa you could have about ten $200-a-pair shoes (or twenty at $100-a-pair!). If you'd rather have the shoes, try a daybed instead of a sofa. They're much cheaper, take up less room, and look really stylish in an exotic, laid-back sort of way when you pile lots of comfy throw pillows on them. You can even turn an old twin bed into one by placing it against the wall with a bunch of big pillows on top of it.

talking to friends who know decorating. I'm not saying you shouldn't scoop up adorable, cheap pillows from Pottery Barn or places like that, just suggesting that you should mix those mass-market pillows in with a few custom ones that'll give your place a really personal touch.

$$-Saving Strategy: Create a Cocktail Table

Since affordable cocktail tables can be hard to find, transform a taller table into one by chopping off its legs so it's the same height as the seats of your sofa and chairs. A small kitchen table or a slightly wide side table could work great for this, or you could do it to a pair of end tables and have two little cocktail tables instead of one big one. Even an old desk might work—you could store coasters and cocktail napkins in the drawers! Look for one at flea markets and thrift stores (there seem to be way more side and end tables at these places than cocktail tables), and just stain or paint it the color you crave.

Step Four: Getting the Lighting Right

Interior design experts are obsessed with lighting, because absolutely nothing makes or breaks the feel of a room like how it's lit. This seems really obvious, but it can be easy to overlook until you've had it drilled into you.

Do It Posh: To bathe your space in a warm glow, replace all your stark white or dark lampshades with ivory or amber ones.

Do It on Pennies: Switch all your clear lightbulbs to frosted ones—they produce softer light and don't cast harsh shadows on the ceiling. Pink and amber-hued bulbs create especially nice light (but you won't notice the color).

The essential principle of good lighting is that many soft light sources are better than one or two bright ones. This is not a case where you want to get the job done with the fewest tools necessary. So, a bright ceiling light in your living room or bedroom is a bad idea. If your place comes with one and you're not motivated enough to remove it, you should leave it off and rely on lamps and area lights when you're trying to create a nice atmosphere. And buy only lamps with dimmer switches. Seriously, any decorator or design expert you talk to will tell you this. Soft light is more comforting, more welcoming, and, of course, more flattering.

So if you're currently relying mostly on an overhead or a blindingly bright halogen lamp, it's time to add more, softer lights to your space. First, put a floor lamp in one corner and a couple table lamps in the others. Then maybe add a wall-mounted sconce (as a general rule, these should be sixty-six inches from the floor) or an up light on the floor. "Up lights" are small floor lights that point upwards—you can buy a plain one for around ten dollars and then hide it behind a sofa or table, or place it in an inconspicuous corner, so it gives off great light but you don't really notice the light itself.

Improving the lighting is one of the easiest parts of decorating, because getting it right yields an instant payoff, and you don't need to spend a lot on lamps. Even really old or ordinary ones can be made to look elegant if you simply upgrade the shade.

Perfectionist Tip: To really neaten up the look of a room, hide the cords of table lamps by taping them along the back of one leg of the table.

Playing House

Tips on Switching Up Your Lampshades

A spanking new shade has the power to instantly revive a lamp that saw better days long ago. In fact, lamps are something you really don't need to shell out cash for—cheapies, parental hand-me-downs, and yard-sale finds can look almost like new once you replace the shade. Here are a few pointers about making over your shades:

Ideally you should take the lamp with you when shopping for a shade, to make sure they'll work together. A shade should be big enough to totally cover the lightbulb and its socket, but it shouldn't be so big that it swallows up the lamp, either.

Make a lamp that's a little too old-school look more modern by topping it with a clean paper shade, and make a mousy lamp look fancier with a silk shade.

If your lamp has a place for a finial (one of those screw-on thingies that attach the shades on certain styles of lamps), have fun with it and get something eye-catching—like one in colored glass or a wacky one shaped like your favorite animal.

Check out how a shade looks both lit and unlit before you buy, since they can appear really different when lit up.

When buying a new shade, ask about the "maximum wattage" it can handle in a bulb—putting in a higher-wattage bulb could burn the shade.

You can give a plain-wrap shade cool trim by supergluing a colored grosgrain ribbon around the rim (as long as the wattage of the bulb isn't too high—or the glue could melt).

Step Five: Balancing It Out and Mixing It Up

Even if you fill a room with beautiful things and light it perfectly, it might still be missing that "factor," that hard to define quality that sets some rooms apart as really stylish. The tricky part is getting your rooms to look cohesive but not matchy-matchy, and giving your eyes enough beautiful stuff to take in without overwhelming them. Getting a room right is all about balance, but being able to look at a space and quickly see what's out of whack and how it should be remedied is a skill interior designers have and most beginners lack. Luckily, this can be learned. Here are four things pros know to consider when putting together a room.

Four Tricky Balances You Need to Achieve

If there's something that feels a bit off about one of your rooms but you can't pinpoint what it is, or if you're just convinced it could look better, stand in the middle of it for a while and ask yourself if it's well-balanced in each of these areas:

Texture

Every room requires a mix of hard and soft, shiny and matte, cozy and cool. So when you're buying something new, make sure it has a nice little contrast with what you've already got, both in look and touch. Place a shiny silver lamp on a wood side table, an Ultrasuede chair next to silk curtains, a beaded pillow on a twill slipcovered armchair. And just as they're great for adding touches of color and pattern, pillows and throws are easy, cheap tools for bringing new textures into a room. A cotton upholstered sofa gets more inviting when you throw a mohair blanket over it, a wood chair is made much prettier with a little brocade pillow tossed on it, and that sort of thing.

Also, look at the lower portions of your furniture and make sure there's a good mix of hard legs and soft upholstery. If your sofa and chairs all have exposed legs (versus upholstered skirts), and all the tables do too, the overall effect can get too leggy, and adding a fabric ottoman in place of a cocktail table would make it look much more balanced. But if your sofa and chairs are covered in fabric that hits the floor, you wouldn't want to put a big old ottoman in the middle of that—it would look better to add a cocktail table with spindly legs to the mix.

Visual "Weight"

Think about the height and heaviness of each piece and aim for a balance of big and small, light and dense, towering and low to the ground, in each area of a room. Heavy or tall pieces—bookshelves, an armoire, a large desk—placed next to each other will look too imposing, so separate them. And using too many delicate, precious little pieces will make a room feel wimpy.

Visual "Volume"

Let just a few attention-grabbing things do the talking, and mix them with stuff that's more soft-spoken. Otherwise, a room can make your head spin. "The most beautiful interiors don't have too many items competing for your attention—your eye shouldn't bounce around the room trying to decide what to rest on—so limit it to a few exclamation-point items," says Heather Wells.

Tone

You don't want a space to be dominated too much by either dark colors or light ones. So if you've got a lot of rich, heavy hues, be sure the room is brightened up by some bright white or pastel accents, and if your space is all done up in whispery pale hues, add some darker ones in the form of, say, dark wood picture frames. In general, the accent colors you choose should balance out the tone of your walls and your larger pieces of furniture—so if you've got deep crimson walls and a brown sofa, you need to add some paleness in the form of white or cream or a complementary pastel, and if you're working with a restrained base of pale beige and khaki, you need to add an exciting bright.

Smart-Girl Secret: Place a photograph or painting of a landscape on one wall and a mirror directly across from it, suggests Karen Reisler. The landscape will look like a window on the outside world and be reflected in the mirror, opening up the whole room. The ideal picture for this is a landscape that shows the horizon and gives a sense of distance.

Secrets to a Bedroom That's Sexy and Serene

Your bedroom isn't just another room. Since it's the place you retreat to relax, sleep, and make love, and the place you start and end each day, it's subject to some special rules. You really want to make it feel as serene as possible. Now, that means

How to . . . Pull Together Mismatched Pieces

The most frustrating thing about trying to style your space on a budget is that—even if you're the craftiest, most intrepid bargain-hunter out there—sometimes you just don't have enough cash to replace pieces of furniture that don't go together. If your room is at risk of looking more like a yard sale than a coordinated living space, try some of these strategies. They'll help you pull together even the most motley mix of hand-me-downs and flea-market finds, so they look polished and maybe even posh.

If you've got a bunch of wood furniture in all different shades from pine to mahogany, stain one or two of the lighter ones to match the darker ones, so you've got less variety; or paint one or two of them in a bright lacquer, so they don't look like wood at all; or paint some white.

Just as you don't want too many different types of wood, too many different metals create a chaotic effect. It's not that you must stick to all silver or all gold-toned metals, but it's important that any metals you mix have the same degree of shininess. So copper and nickel, for example, would look okay coexisting, since they're both a bit muted.

Make some of the little elements in the room, like the picture frames or the plant or flower pots, consistent—this will help prevent that dreaded yard-sale style. So, have all your photos in silver frames, rather than having a mix of metals and colors and styles. Karen Reisler points out that you can easily paint wood frames. "To give them a more traditional look, use gold-leaf paint, or paint them black to make them more simple and modern, or use a fun color," she says. "People don't realize how easy this is, but once you touch the paintbrush to the frame, you won't believe it."

When the colors of two upholstered items don't coordinate, you should cover one with a slipcover in a neutral hue, or, if that's not possible, add another item to the room that contains both colors. For example, if

you've got a blue sofa and a green chair, find a throw pillow in a pattern that contains both the blue and the green, and place it on the sofa.

A quick way to make any room look balanced and "together": Display a few items in pairs. Place two matching lamps at either side of a bookshelf, or bracket a sofa with identical side tables. "If you're scouring flea markets or vintage stores and find a pair of lamps or a pair of vases, buy them both," says Tracey Benton. "You'll never regret a pair."

Choosing one accent color and scattering touches of it around can really tighten up the look of a room. A lime green lamp on a side table, a lime green pillow across the room thrown on a chair, and a lime green vase on the bookshelves help the furniture they're resting on look like it was meant to go together.

different things to different people—for some, serenity is a simple platform bed and minimalist décor with a Zen feel, whereas for others it means lots of soft, feminine ruffles. But here are a few rules that apply no matter what your style and that will help make your bedroom a comforting, calm retreat you always feel spoiled in and never want to leave.

First, it's really important that you keep the bedroom as organized and uncluttered as possible. Put things where they belong, and don't make the room a storage space. If you must store homeless things in there, put them in wicker or wood boxes and stack them neatly in a corner. Keep the palette restful. Anything bright just isn't conducive to sleep, so do the walls in a soft neutral hue or a soothing pale blue or green, and keep the major pieces of furniture either neutral or very softly colored. Skip any sort of high-energy patterns.

As for the furniture, choose things you love that are soothing to you, whether that means frilly or austere. Steer clear of bedroom sets—where the headboard and dresser and side table all match. Unless you have a really beautiful or unique one, you'll risk making your room look like a Holiday Inn Express. If you've already got an unexciting one, paint one or two of the pieces a different color.

Make It Feel Like an Island Idyll

One idea Karen Reisler gave me that I just fell in love with is to do your bedroom in a Colonial West Indian Caribbean style, so you feel like you're in a posh resort on Mustique whenever you wake up. She decorated Katie Couric's bedroom along these lines—since Katie's obviously a busy woman who has to wake up at some unfathomably early time every morning, she needed her bedroom to feel especially like a peaceful retreat. Regardless of whether we're that busy, we also deserve a blissful bedroom, and luckily this look doesn't require a Katie-style paycheck to pull off. It may sound fancy but is actually fairly cheap and easy. The ingredients:

- A white color scheme, maybe accented with colors that evoke the sea
- Furniture in dark wood or wicker
- Floor covering the color of sand—a natural fiber rug, like sisal or sea grass
- Windows covered in wood shutters, natural shades, or filmy white curtains
- White bed linens in crisp cotton
- A few touches with a slightly tropical feel—a throw pillow with a seashell design on it, or a stool upholstered in a palm-tree print

$$-Saving Strategy: Don't want to invest in a proper bed right now? Just buy a freestanding headboard. They're cheap and will totally create a "bed" look out of your mattress-and-box-spring combo. Or get a paneled screen and place it flat against the wall behind your bed, to create a headboard effect.

$$-Saving Strategy: Need a new duvet cover? Try this bargain trick Heather Whitney suggests: Take two inexpensive flat sheets and have them sewn together on three sides; then have a zipper or buttons sewn on the fourth side. Just slip your duvet in between them.

Do It Posh: Although they can set you back a grand or more, high-quality sheets are worth the extra dough. They'll last forever and get softer every time you wash them.

Do It on Pennies: So what if they'll last for fifteen years—if that's how long it'll take to pay off a set of Pratesis on your credit card, you're not going to sleep easy on them. So start by purchasing just a pillowcase or a top sheet of the fancy stuff—something that touches your skin—and mix it with inexpensive bedding.

•••

Easy Rules for Elegant Kitchens and Bathrooms

Kitchens and bathrooms are more about business than aesthetics, so you don't need or want a heavily "decorated" feel in them—they should be function-oriented. Mostly you want them to feel very clean. Obviously this is easier if you actually clean pretty often, but they should be visually clean as well.

The best way to add beauty to your kitchen is to make sure the functional stuff that's in there looks great, rather than add a lot of orna-ment in other ways. So get pretty dish towels and hang one next to an oven mitt in the same color, and then put a coordinating jar on the counter to hold cooking utensils and a coordinating teakettle on the stove. They now make blenders and other appliances in all sorts of great colors, so a couple of those on your counters is really all you need in the way of kitchen décor.

Wall hangings in the kitchen can be more casual and playful. Frame and hang a colorful poster, maybe one relating to a culinary event in your hometown or some-where you've traveled, like the Sonoma County Heirloom Tomato Festival, or the Nantucket Wine Festival, or your hometown's annual chili cook-off.

As for your bathroom, since it's a small space, little things count, and deter-mine whether it feels calm and spa-like, or more unsavory. So it's really important that you keep it streamlined and clean.

There's no excuse for not getting a real cloth shower curtain! They cost only maybe $50 and make your loo look about a hundred times nicer. And they can last for years; you just have to replace the liner every year or so if it gets mildewy.

Feng Shui for Your Bedroom

Perhaps no other room is as important to get right from a feng shui perspective. A few bedroom-specific pointers from Catherine Brophy: Don't hang a mirror in front of your bed, and don't have the television there either. If you must have either of these things, cover them up at night—they stir up energy and could hurt the quality of your sleep. If you're single and you don't want to be, don't push your bed up against one wall; it doesn't invite a relationship in. (Also, don't fill your bedroom with a ton of family photos, it makes it feel as if there's no room for anyone new in your life.) And don't store things under your bed—it traps chi. (This last one is something I can in no way abide by myself, given the storage situation in New York apartments, but Catherine says that if we insist on storing stuff below the bed, we should at least keep it neatly organized in sealed plastic containers, not just stuffed under there haphazardly.)

"Often simpler choices are better. So instead of that entertainment center, prop your television on an old chest. Be courageous and get rid of stuff, edit!"

—*Heather Whitney, Los Angeles interior designer*

Limit (or eliminate) tchochkes or statement-making wall hangings. The room where you wash and take care of bodily functions is not a place for a lot of fussiness.

Buy a nice bathroom rug. It's really important for your feet to touch something soft (and not the cold tile) when you step out of a hot shower.

A matching set of fluffy towels is key, and you should have a separate set of fancy hand towels for when guests are over.

Keep some nice hand soap in there, especially in the guest bathroom (if you've got one), but in your main bathroom too. Those plastic bottles of liquid soap are sort of icky—pretty hand soaps are much nicer. Just use little ones so they don't last for months and get gross looking.

How to . . . Buy Fit-for-a-Princess Bedding

I asked Sandra Marx, owner of Southern California's Between the Sheets boutiques, to explain the difference between so-so bed linens and the super-high-quality kind that feel like heaven against your skin. Now, keep in mind that she has very high standards, and if you're sleeping soundly in four-year-old flannel ones, you don't need to make a change. But when you're ready to turn into a total sheet snob, here are the six things you'll need to look for.

1. **Weave:** How the cotton is woven determines how it feels. A sateen weave is super-silky, and percale has a crisp texture. Sateen is considered more luxurious, and most high-thread-count bedding is sateen, but some people prefer percale.

2. **Thread count:** If bedding is labeled as "400 thread count," it means each inch of fabric contains at least four hundred threads. You want as many threads per inch as possible—however, you also want the threads to be long and carefully plied together. Those two qualities in conjunction with high thread count are what make a fabric awesomely silky (and super-durable too). A few years ago the thread-count thing really got into the heads of the bedding-buying public, and the market became flooded with sheets labeled "400 thread count" that don't have the long, plied threads required to be truly high quality.

3. **The variety of cotton:** Look for Egyptian cotton, which has longer fibers than other kinds, so it's softer and more durable.

4. **Country of origin:** Europeans do it better. Look for a label saying the sheets were produced in Italy, France, or elsewhere right across the Atlantic. Avoid sheets made in Asia.

(continued on the next page)

Feathering Your Nest

33

> 5. **The look and feel of it:** "If bedding is sealed, walk away," says Sandra. You need to be able to touch the fabric and look at it up close. It should look lustrous and feel silky but strong.
>
> 6. **Price:** A four-piece set (flat sheet, fitted sheet, and two pillowcases) should cost at least $500, and a truly amazing set will cost upward of $1,000. "You're not going to find a luxury product at Target or Bed, Bath and Beyond," says Sandra.

Place a little scented votive candle near the toilet, to clear the air when somebody needs to.

Step Six: The Fun Part—Accessorizing!

A room's accessories are where you really express your personality—with color and pattern and pictures and mementos that show off your passions. No matter how perfectly arranged and coordinated and polished your home is, it won't look truly fabulous without little bits of eye candy—unique things that give it your personal touch or just look damn good. Here are some of the key ways to put your stamp on your space.

Photographs

Pictures of your friends and loved ones are one of the main things that make your place feel like home, so don't scrimp on them. You can either create a big group of them on a coffee table, side table, or bookshelf, or you can scatter them around the room. Try to get your frames to coordinate. If they don't match exactly, at least keep them in neutral territory—metals, woods, and other natural materials like mother-of-pearl and faux tortoiseshell all look great together.

Put a Little Faith in Feng Shui

Lots has been written about feng shui (pronounced *fung shway*) in the past few years, especially about three or four years ago, when there seemed to be a flurry of media features on it and books written about it. In case you haven't been paying attention to that type of thing, it's an ancient Chinese philosophy on how to arrange your home, and the name loosely translates to "the art of placement." Adherents believe that the way your living space is arranged either helps or hurts the flow of chi (or vital energy), and can determine the success or failure of everything from your love life to your financial status to your health.

Sure, some of the feng shui dictates you've heard in the past may sound fairly absurd—things along the lines of "put a goldfish and wind chimes in the northwest corner of your home" (I can't imagine what would block my "chi" worse than a poor little fish stuck in a corner with hippie-dippy wind chimes hanging precariously over its head). But a lot of it makes great sense, whether you buy into the mystical aspect of it or not. So I decided to quiz New York feng shui consultant Catherine Brophy on what basic principles a hip young girl can really use to improve the chi in her pad, without doing major remodeling or purchasing a new pet.

Catherine has lots of stories of people whose lives were transformed—fortunes made, pathetic love lives turned passion-filled, that sort of thing—once they got the right type of chi flowing in their homes. She emphasizes that, to really give your space a chi makeover, you need to do a lot of research or hire a feng shui consultant; but even though it's hard for her to make one-size-fits-all dictates, I convinced her to reveal some basic rules for girls like us, which I'll pass along to you now.

• Most seats in a room should have a view of the door. In the living room, the primary seat (the sofa or love seat) should be placed so that it faces the entrance to the room. Try to arrange the other seats so that

(continued on the next page)

they have at least a peripheral view of the entrance. People feel more at ease when they can keep an eye on the space through which new people might be entering the room (even though this is unconscious and irrational, since nobody threatening is going to be entering your living room when the front door is locked). Likewise, if you have a desk that you work at a lot, don't position it so that your back is to the door when you're seated at it.

• Get rid of clutter! Too much clutter traps chi and makes it stagnate. Really assess the stuff you own and ditch what you don't need. Of course you've heard this a thousand times, but what's better motivation than freeing up chi so that you can make more money, improve your love life, and all around have things go your way?

• The entrance to your home should be welcoming. Put a little table there holding a beautiful bowl you can drop your keys in, and hang a mirror or a painting above it. If, as is the case with many apartments, your front door opens straight into a hallway or a room, you should still try to make the entrance feel special in some way. If there's no room for a table, at least put a mirror on the wall next to the front door, and don't make the entrance a place where bags of old newspapers sit waiting for recycling day. If you have a proper foyer, this is a great place to paint the walls an interesting color. Anyone entering your home should feel comfortable and welcome the second they walk through the door—and this includes you too. A clean, cared-for foyer signals that the person living inside cares about guests and herself.

• Be careful where you use mirrors—they activate chi. It's especially useful to put them in places that need to feel opened up, like narrow hallways.

• Plants are great for the flow of chi, but you have to take care of them. If a houseplant dies, replace it with a living one.

- Dried flowers are a big *don't*—they totally keep chi from flowing.

- There may not be a whole lot you can do about this, but it's a very bad thing to have a windowless bathroom in the center of your place—it's bad for your finances, bad for relationships, just bad all around. When Catherine told me this, I realized I lived in such a place for two years in my early twenties, and it was definitely not the easiest two years of my life, on the money or love fronts, or any fronts at all really (but then, those post-college years are often a little rocky, regardless). One of the suggested cures for this is mirrors. Hang one on the outside of the bathroom door (to deflect bad chi) and hang an extra mirror in the bathroom, directly opposite the one that's already there.

- If you're interested in getting more into feng shui, Brophy recommends you read one of these books, both of which are good for beginners: *Feng Shui Step by Step*, by T. Raphael Simons, and *Feng Shui Demystified*, by Ulrich Wilhelm Lippelt. You can use these books to find out where the love and money corners of your home are, so you can use them to bring you more luck in those areas. You're supposed to put a pair of something (two vases, for example) in your love corner, to promote relationship harmony, and put something valuable in your money corner, to bring more of the green stuff your way. There are other corners too, but love and money are the ones we're all most urgently concerned with, aren't they?

Travel Memorabilia

Always try to bring back something beautiful from your travels—things like vases, decorative bowls, candleholders, and little tchochkes will feel more special and look more stylish if you've picked them up somewhere far-flung. You'll love knowing you won't find things just like them at the local mall or in the apartment next door.

Have a Signature Thing

Try to find a way to work your favorite things into your décor. My friend Lindsay has always loved frogs, and you can find frogs scattered throughout her apartment—on candlesticks, coasters, and a little floor lamp. My friend Catherine's mom has rabbits throughout her home (I'm not sure if that came about before or after she had nine children). And since I grew up a block from the ocean and am nuts about anything beachy, I have touches of things related to the sea throughout my place—prints of sailboats, a throw pillow with a coral design on it, china with a shell pattern, candleholders that look like sea urchins. Maybe you once lived in Spain and you work Spanish things into your aesthetic, or you're a musician and you have things throughout your place that relate to music and performers and instruments—whatever your passions are, express them with the stuff that surrounds you.

You do have to be careful with this though, because if you go overboard, it can look too theme-y and silly, and you risk getting sick of it. Ideally, your signature should be something that brings you pleasure and makes you feel at home, but doesn't hit other people over the head when they enter your place. It should only be noticeable to someone who's really paying attention.

> "You would spend $800 on clothes you can wear only for a year or two, but for that same amount of money you can get fabulous sheets you'll enjoy for a decade."
>
> —Sandra Marx, owner of Southern California's Between the Sheets

Scent

Giving your space a subtle aroma—by regularly lighting scented candles or putting some posh potpourri in a corner—is another way to really make it feel like home. Every time you walk through the front door and catch a whiff of your scent, it will hit your senses that you're home, which is such a great feeling. So use the same scent of candles or potpourri for months (or years) at a time, to get it really lodged in your memory. Or, switch scents according to the season. I used to use Votivo's Red Currant scented candles in the fall and winter and Deep Clover, which has a grassy smell, in the spring and summer, which I loved because it helped me feel really centered and present in the season—something that's hard to feel when you're busy and spend most of your life in a temperature-controlled office building.

Decking the Walls

Your place will look naked until you've got some great wall hangings, and there's no better way to express yourself and show off your interests than with art, photographs, and other beautiful or intriguing things displayed there. So say sayonara to that museum poster you've been hanging on to since college. When you want to graduate from posters but can't really afford the sort of gallery-style works of art you aspire to, there are all sorts of in-between options. Here are six ideas for super-cheap wall hangings.

- Blow up your own photographs so they're big enough to make dramatic wall art. Most photos of your friends will seem too dorm room, so frame photographs of architecture or nature—just head out one day with two or three rolls of film and snap away. You're bound to come away with a few great ones, and they'll look wall-worthy once you have them enlarged to five-by-sevens or eight-by-tens. This is one great idea I heard and am always meaning to try: If you live near some great public sculpture, whether it's in a museum courtyard or park or outside an office building, take photographs of that and frame the best one. That way you can bring a world-class work of art into your home almost for free. Or, elevate ordinary objects to the realm of the important by photographing a group of them and framing it—photos of three chairs, for example, or close-ups of three sunflowers. (For advice on making your snapshots look professional, see "How to . . . Make a Snapshot Look Gallery-Quality," on page 45.)

> "When people are on a budget, they tend to fear giving things away, because they're afraid they won't ever be able to afford new furniture. But you will, and by getting rid of excess, you're making room for the perfect things to come into your life. They eventually will, often at a bargain."
>
> —*Heather Whitney, Los Angeles interior designer*

- Find a calendar with beautiful images and frame the pages. My friend Lauren did this with a calendar of architectural prints. She had three of

them double-matted and placed in gold-leaf frames, and they look really special, even though the calendar they came from cost about $15. When your wall hanging is something nice-looking but not at all rare or precious (like these calendar pages), it's great to have a series of three or more. Their beauty will be more apparent in a group, and it will give them an air of importance.

• Prowl used bookstores for old books with cool botanical prints you can cut out and frame, suggests Margaret Russell.

• If you've got a niece or nephew or some other great little children in your life, frame some of their finger paintings or drawings. There's a decent chance their work will look cooler than what you saw the last time you were in an art gallery, and it will give your space a wonderfully personal touch.

• Go to your local wallpaper store and look for a pattern that's really beautiful or interesting, then take a sample and frame that.

"If you're on a budget, I'd suggest spending a bit more on nice pillows and lamps, and save on the furniture. You can get away with a T-shirt and jeans sort of apartment if it's got great purses and earrings."

—*Celerie Kemble, New York City interior designer*

• Try to buy cheap street art when you're traveling—it will feel special, since you know you bought it in an exotic locale.

Perfectionist Tip

Have two sets of "accessories" for your living room—one for spring and summer, and one for fall and winter. For example, in the warm months give it a more airy, casual feel by using throw pillows in crisp cotton or linen and light colors or tropical prints. Then during the cold season, stash those pillows away and replace them with pillows in warm textures, like mohair, velvet, or suede, and a richer color scheme.

Finally, Never Stop Feathering Your Nest

The thing about doing your home that you should come to terms with is that you're never going to be totally finished. I mean, you should work as quickly as possible to make things look so good that you're happy to live there, but decorating is an ongoing process. Your lifestyle will change over time, and you're always going to be getting new ideas or finding things you love and want to add to the mix, which then requires you to take something else away to balance it all out again.

Most important, don't get discouraged! It may take a while to get it right, but even if things aren't perfect, your home will be so much more beautiful and serene and homey because you made the effort. It's essential that you do set some extravagant style goals, even if you're on the most austere of budgets. As Karen Reisler says, "If you have a clear vision, it becomes easier to attain something great—fantasy is so important. Never let your budgetary restraints get in the way of your decorating ideals."

Shopping Guide

Where to Find Furniture and Fulfill Your Decorating Needs

I broke these stores down by price according to how much their sofas go for. Places in the $ category sell sofas for under $1,000, companies designated $$ sell sofas with price tags between $1,000 and $2,000, and places with the $$$ designation charge over $2,000 for their sofas—though in this last category there's a wide range. At Calico Corners, for example, you can get a sofa for just over $2,000, depending on what upholstery you use; whereas sofas from Design Within Reach run $4,000 and even higher. You can purchase directly from most of the Web sites selling the less expensive stuff, but many of the pricier ones just display the goods and direct you to a store or showroom where you can buy them, since few people want to spend 4 Gs on a sofa without sitting on it first.

$

ANTIQUE/USED FURNITURE STORES: Used furniture stores are the very best way to find unique, stylish furniture at a bargain price. It often takes some work to find the right thing when you go this route, but if you stumble

upon that perfect fifties coffee table you've been dreaming about, it will all feel worth it.

CB2, CB2.COM: A hipper, less expensive arm of Crate and Barrel, this new site is definitely worth checking out. In addition to furniture, they sell table-top items, barware, and party accessories.

THE CONTAINER STORE, CONTAINERSTORE.COM: Whenever you start to freak out about your space being too small, visit the Container Store for a solution. They sell all sorts of storage boxes, racks, hooks, kitchen and bathroom containers, closet systems, everything!

IKEA, IKEA.COM: Before you buy any basic home item anywhere else, check out Ikea's version. A lot of their stuff looks just as good as pricier options, but it's insanely inexpensive. Now, their things aren't known for their durability, and an entire room done in Ikea purchases might look cheap, but filling in with their pieces can be a smart money-saving strategy.

LA-Z-BOY, LAZBOY.COM: You probably don't know it, but this brand makes a whole lot more than grandpa-style recliners. Check out their sofas, chairs, tables, and funky designs by Todd Oldham.

> "Books are one of the best accessories. Piles of favorite books add warmth and character to a room."
>
> —*Heather Whitney, Los Angeles interior designer*

OVERSTOCK.COM: This site is hit-or-miss—you can find great deals on furniture and other home goods, but you'll often have to sort through a lot of icky stuff in the process. But when you do stumble upon something you like, it will be between 40 and 80 percent off retail, and they'll ship it to you for just a few dollars, no matter how big it is or how much it costs.

PEARL RIVER MART, PEARLRIVER.COM: This online version of New York's legendary Chinatown department store sells inexpensive bamboo blinds, room dividers, and lots of cool Asian-style accents—this isn't stuff that will last forever, but it can add a little spice to your space on the cheap.

How to . . . Hang a Picture

1. To hang a single frame, first decide how you want to center it—in the middle of a wall or over a piece of furniture—then measure that expanse and divide the measurement in half to determine where the center is, and mark that spot lightly with pencil.

2. Next, determine how high to place the hook on the wall. The standard height for a wall hanging is sixty-six inches from the floor, which is about eye level for most people—that's roughly where the center of your picture should fall. Hold the frame up at about eye level and decide exactly how high you want to hang it. (Ideally, you should have a helper when hanging a picture, so he or she can hold the frame against the wall and you can step back and decide.) Take a pencil and very lightly trace a line an inch or two along the center top of the frame.

3. Take the frame away from the wall, and figure out the "drop" between the top of the frame and the wire hanger attached to the back of it. Pull the wire up toward the center of the top edge of the frame until the wire is taut on both sides. The number of inches between the top edge of the frame and the point on the wire closest to it is how much higher the top of the frame will be from the hook. Let's say this number is three inches. Then you take a ruler and place it against the wall so that it connects the first pencil mark you made with the "top of the frame" line you just drew. Measure three inches down from the top-of-the-frame line—that is where you want the hook to be—and mark with an *X*. Hold the picture hanger at that spot so that the hook is at the *X*, and nail it into the wall (on picture hangers the place for the nail is above the hook, so be sure you're inserting the nail above the *X* spot, so that the hook falls right on it).

How to . . . Hang a Group of Frames

If you've got a set of two or three same-size wall hangings in matching frames, a straight vertical or horizontal row is the most classic, can't-go-wrong way to go. If you're hanging a group in a horizontal row, you need a tool called a level to make sure they'll be absolutely even—you can find a level at any hardware store.

But two matching frames can look good arranged diagonally to each other, and if you have a group of frames in different shapes or sizes, they can look really cool together as well. To decide the best way to arrange a group of framed material, first lay a big patternless sheet on the floor and move them around on it until you find a grouping you like. It helps to choose one to be the focal point of the group and then arrange others around it. Measure the height and width of the frames as a group to learn how much wall space they'll take up, and use that info to decide where the "focal point" work should be placed on the wall. Once you've decided on your favorite arrangement, hang the focal-point artwork at eye level and centered on the wall, then carefully hang the other pictures around it. Just make sure that all the frames are the same distance apart, at their closest points, from the ones bordering them.

TARGET, TARGET.COM: The red-bull's-eye guys sell inexpensive slipcovers in a variety of fabrics (including denim, velvet, and faux suede), colors, and sizes. Target is also a great place to scour for other decorating needs. They've got a surprising amount of good-looking furniture, as well as kitchen and entertaining implements, and they have special lines by respected brands and designers like Shabby Chic, Michael Graves, and Cynthia Rowley's Swell line.

URBAN OUTFITTERS, URBANOUTFITTERS.COM: While too much from Urban will steep your pad in post-college style, it's a great place to score a few funky accessories when you want to punch up a room with something new. These pieces are cheap enough that if you grow sick of them in three months, you can send them to the Salvation Army sans guilt.

How to . . . Make a Snapshot Look Gallery-Quality

If you've taken a gorgeous photograph that's as good as or better than anything you could purchase, then treat it like the artwork it is and show it off on one of your walls. Boston-based photographer Cheryl Richards provides these how-tos.

• Have it developed at a custom lab. They'll do a much better job than your local drugstore or one-hour developing shop. They can make it any size you want, but the standard sizes that fit into ready-made mats and frames are $3" \times 5"$, $5" \times 7"$, and $8" \times 10"$.

• Ask them to print your photo on fiber paper, and go for a matte or semimatte finish. Glossy finishes can make the images hard to see in direct light or from a distance.

• If you're on a budget, use ready-made mats and frames (visit exposuresonline.com for great options), but if you truly love the photo and want to preserve it for years, do it right and get it custom framed. Ask local galleries which framers they use, to find a framer who is good and reasonably priced. Choose whatever sort of frame goes with your décor; but in general, black-and-white photos don't look great with gold frames.

• If you do get it custom matted and framed, ask for matting that leaves three inches or more on each side of the photo—this will give it more of an arty, important look. Have them make the matting a little wider (about half an inch) underneath the photo. Your eye won't notice the extra space, and if you don't do this, it might look as if the photo is too low in the frame.

• If you plan to hang your photo in an area with lots of natural light, you'll need a frame with nonglare glass. Otherwise you won't be able to see the photo when the sun is shining, and the sun will fade the photo over time.

How to . . . Buy Art

Few things will make your space feel as grown-up and elegant as having a favorite work of art hanging on the wall. But few purchases are as intimidating. Here, gallery owner and former auction-house specialist Trudy Rosato gives advice for girls thinking about starting their first collections.

● Buy art because you love it, not because you think you might be able to sell it for a profit one day. You can hope a piece will skyrocket in value over the years, but since the art market fluctuates, art is not a guaranteed investment. So buy things you're thrilled to have on your walls, and if down the road it turns out you discovered the next Jackson Pollock, that will just be a bonus.

● Before you even think about shelling out money for art, you need to invest time in educating yourself and figuring out what you like. "Go to museums, go to galleries, pick up a few art magazines—once you surround yourself with quality art, you'll develop an eye," says Trudy. If you've never paid a lot of attention to art—or haven't since your college art history class—you'll notice that your tastes change when you're immersed in it.

● Once you know what styles of art you're most passionate about, find out what is available in your price range. There are three main sources of art: primary-market galleries, which sell brand-new art from living artists; secondary-market galleries, which sell older, previously owned art; and auction houses.

● When you get infatuated with a work, investigate the artist before you buy. Ask the gallery or seller if the artist has been included in any exhibitions, and if any prominent collectors have bought his or her work. If it's an older or deceased artist, find out how much his or her stuff has sold for at auction. Looking at past auction prices will give

you a general idea of what you should consider paying for his or her new stuff.

- Auction houses can offer great bargains, and most of them show their wares on the Internet. If you spot something you like that's up for auction in your city, go check it out in person. If you can't make it to the actual auction because of, say, your job, you can arrange to bid over the telephone.

- Art fairs are great places to shop, because they bring a lot of different galleries together to show off their goods in one space.

- If you're a fan of a painter who's way out of your price range, ask the gallery if the artist has made prints or lithographs, which are much less expensive.

- Chat up gallery owners. Once galleries know you're serious about purchasing, many of them will let you take a painting home to see how it looks in your space. And often they'll work out a payment plan with you if you don't want to turn over the full purchase price right away.

WEST ELM, WESTELM.COM: Reasonably priced with a hip, urban feel, a new item or two from West Elm will inject a room full of old furnishings with a dose of modern style.

$$

BERNHARDT, BERNHARDT.COM: Upholstered furniture, tables, bookshelves, dressers, and other furniture in a mainstream style, including the Martha Stewart Signature line. It's not cutting-edge, but the pieces are solid basics.

CRATE AND BARREL, CRATEANDBARREL.COM: Of course you know these guys, but you may not know how many top interior designers are fans of this store's stuff. They do a great job of knocking off much fancier furniture.

Priceless Advice From the Previous Generations

"To give a home an instant makeover, replace the switch plates, electrical outlet plates, and cabinet knobs." —MICKEY, 63, MEMPHIS, TENNESSEE

"This is something I picked up from a friend who has homes around the world: Have a plan for one decorating project a year, whether it's new slipcovers, upgrading picture frames from Pottery Barn to custom framing, fabulous linens for bed and/or bath, serious cooking equipment, or new end tables for the living room. First of all, it makes you think about what your decorating scheme really is, and it keeps a 'look' fresh."

—LUCINDA, 60, NEW YORK, NEW YORK

"Large green plants are the easiest way to make an interior warm and inviting." —NORMA, 62, ANN ARBOR, MICHIGAN

"I learned from my mother that with decorating the emphasis should be on creating an inviting and cozy room that makes guests feel comfortable. Always have fresh flowers around and books on tables. Keep the seating focused around the fireplace, and keep the sofas and chairs grouped closely together, and cover them with soft down-filled cushions you can sink into. Also, rugs are better than carpets, and wood floors should be stained a rich, dark brown." —LAURIE, 60, LAKEVILLE, CONNECTICUT

MITCHELL GOLD, MITCHELLGOLD.COM: This may be the single best source of mid-priced sofas and other upholstered pieces. They have a huge selection, including mini-sofas they call sofettes, which are much more chic than a love seat, available slipcovered or upholstered in a wide variety of fabrics.

POTTERY BARN, POTTERYBARN.COM: This one you definitely already know. While you don't want to do a room floor-to-ceiling in Pottery Barn goods, most of their pieces are versatile enough that you'll rarely make a mistake with a purchase from there.

RESTORATION HARDWARE, RESTORATIONHARD-WARE.COM: One-stop shopping for furniture, bedding, bath accessories, fixtures, rugs, window-coverings, and lighting, all in simple, classic styles. I've found them to have fab customer service.

ROOM AND BOARD, ROOMANDBOARD.COM: This is an awesome furniture source for the hip chick—their things will make any room look really stylish, but are basic enough that you can pair them with less chic pieces and the effect will still work. They also have a collection called Retrospect, which contains more traditional styles designed in a way that makes them easy to mix with modern.

> "Even the top designers go to places like Urban Outfitters, Pottery Barn, Crate and Barrel, and Ikea—either to fill in a room or do a casual setting like a beach house."
>
> —*Margaret Russell, editor in chief of* Elle Decor

$$$

BAKER, KOHLERINTERIORS.COM: Chic, luxurious furniture, some of it on the contemporary side (such as lines from top designers like Bill Sofield), and others, like the English Regency and Historic Charleston lines, more traditional. Baker is a great place to look for inspiration, and then seek out cheaper versions of these pieces from the vendors listed earlier.

CALICO CORNERS, CALICOCORNERS.COM: This company provides one of the most accessible ways for a girl to order custom furniture. They have a big selection of sofas, chairs, ottomans, and chaise longues, and loads of fabrics to choose from. They also sell slipcovers and fabric window treatments.

CASSINA, CASSINAUSA.COM: Classic twentieth-century designs by masters like Le Corbusier, Frank Lloyd Wright, and Charles Rennie Mackintosh, as well as cutting-edge contemporary stuff from Philippe Starck and other designers.

DESIGN WITHIN REACH, DWR.COM: The prices are hardly "within reach" for most of us, but DWR is the place to access designs from the masters of the

twentieth century, as well as brand-new designs from the Alvar Aaltos and Isamu Noguchis of tomorrow.

INTERIEURS, INTERIEURS.COM: The sleek, simple lines of this furniture make it easy to mix into either a traditional- or contemporary-style room.

KREISS, KREISS.COM: A big furniture retailer with stores throughout the country, Kreiss has a huge selection of stuff in a variety of styles.

LIGNE ROSET, LIGNE-ROSET-USA.COM: Ultramodern, clean-lined pieces perfect for an urban abode (or any space you want to give a "downtown" feel).

MCGUIRE, MCGUIREFURNITURE.COM: This San Francisco based company focuses on pieces made of exotic material like rattan, bamboo, and teak, and has lines from top designers like Barbara Barry and restaurant designer Adam Tihany.

STICKLEY, STICKLEY.COM: Go here to browse and find out where to buy classic wood furniture in the Arts and Crafts or Mission styles.

Insider Tip: Interior design pros rely on a site called Homeportfolio.com, which is like a Google for furniture and décor items. Looking for a side table that goes with your sofa? Just type "side table" into the site's search engine, and it will retrieve about eight hundred options. Now, most of the furniture in its database is expensive, and often it's to-the-trade only (meaning you need to be working with a licensed interior designer to buy it), but when you're not quite sure what you're looking for, checking out the variety of styles on Homeportfolio can help you figure it out, so you can seek out a similar one someplace affordable.

Sources for Your Windows and Walls

EXPOSURES, EXPOSURESONLINE.COM: Everything you need to display art or photos, including wall frames, table frames, ledges, and hanging tools.

GREAT WINDOWS, GREATWINDOWS.COM: A variety of blinds, shades, shutters, and curtains, all at great prices.

HUNTER DOUGLAS, HUNTERDOUGLAS.COM: In addition to showcasing their wide variety of window coverings, this site offers lots of advice.

LARSON-JUHL, LARSONJUHL.COM: This company makes beautiful custom frames. The site shows you all the options and can direct you to a framer in your area who uses their products.

SILK TRADING CO., SILKTRADING.COM: They sell beautiful silk "drapery-out-of-a-box" sets that are a cinch to hang. You can also find pillows and other finishing touches on their site.

SMITH AND NOBLE, SMITHANDNOBLE.COM: A *great* resource for window coverings—many interior designers I've spoken with recommended their matchstick blinds. Look in magazines and high-end catalogs for stuff you like, then try to knock off the look here. They have a great rug selection and upholstered furniture too.

> "Even if they're way beyond your budget, it's smart to familiarize yourself with what's for sale from the expensive vendors to develop your eye for great design. Then you'll be able to pick out the really chic pieces from Ikea, Crate and Barrel, or your local used furniture store."
>
> —Karen Reisler, *New York interior designer*

Bed and Bathroom Sources

BED, BATH AND BEYOND, BEDBATHANDBEYOND.COM: You'll find basic, inexpensive versions of anything you could need for your boudoir or your loo.

BETWEEN THE SHEETS, BETWEENTHESHEETSINC.COM: Sandra Marx, the owner of Between the Sheets, is obsessed with high-quality linens and has

sought out the most meticulous European sources to create her line of bedding, towels, and table linens (in addition to the site, there are also three stores in Southern California). While they're not cheap, they cost less than big-name brands like Pratesi and are arguably just as posh.

FLOU, FLOU.IT: This Italian company sells sleek, sometimes funky beds, bed frames, and platforms—including options in leather, fabric, metal, and wood—plus mattresses, linens, pillow fillers, and bedroom accessories.

GARNET HILL, GARNETHILL.COM: If you're into really styling your bed with color and pattern, and adding accessories like pillows and throws, then Garnet Hill is a great resource for you. Each season they create trendy new patterns, so if your bedroom can use an update, buying two stylish shams here is a cheap way to do it.

LIZ VICTORY DESIGNS, LIZVICTORYDESIGNS.COM: It's rare to find shower curtains that have a little style but aren't tacky at all, but Liz Victory's—which come in preppy-cool patterns like stripes, gingham, toile, patchwork, and piqué—fit the bill perfectly.

WATERWORKS, WATERWORKS.COM: Everything you need for a kitted-out commode, from fixtures to towels to soap.

YVES DELORME, YVESDELORME.COM: I love this French company's luxurious bedding and gorgeous table linens.

Making Food That Tastes Delicious

EASY WAYS TO ENSURE EVERYTHING CREATED IN YOUR KITCHEN COMES OUT JUST RIGHT

2

I realized I needed to get serious about learning how to cook the night my boyfriend had to teach me how to chop herbs. I'd been dating him for about six months and decided it was about time I made him a meal. It didn't strike me as an obstacle that I hadn't cooked anyone a proper meal in ages, not even myself. I figured I'd just pick a tasty-looking recipe from a cookbook, follow the instructions, and dazzle him with the results.

I can't remember the exact recipe I attempted, but I believe it was pasta with scallops. I do remember chopping flat-leaf parsley to garnish it with, because my boyfriend, who apparently knew a whole lot more about cooking than I did, paused from taking a sip of his beer when he saw what I was doing. In a tentative tone he said, "Uh, sweetie, it's usually better if you don't use the stems." Then he explained, while trying hard not to sound ungrateful for my culinary efforts, and probably trying to mask his fear of the meal he was about to eat, that you're supposed to use only the leaves of fresh herbs—I had been chopping the stems as well, and was ready to toss them liberally over our dinners—because the stems have a bitter taste and tough texture.

My humiliation over the stem slipup wasn't mitigated once we began eating the scallop pasta. It was undeniably so-so. The scallops were a little bit tough, the pasta sauce a little watery, and the whole dish was just pretty blah. I'll never know

why—maybe it was just a bad recipe, or maybe there were crucial steps I missed out of cluelessness. But rather than scaring me out of cooking again for another five years, the incident inspired me. I decided it was finally time to make friends with my kitchen, and set out to teach myself to cook. With help from good cookbooks, professional chefs I quizzed on the subject, and patient tutoring from that boyfriend (who somehow became my husband despite my inferior kitchen skills), I grew to be competent and confident in the kitchen, and to even enjoy cooking.

So if you haven't made friends with your kitchen yet, I'd argue that now's the time—and since you picked up this book, you probably agree. After years spent dining out or grabbing takeout, you're a little bored and dissatisfied with the options out there. Or maybe it's just occurred to you that you could save a lot of dough if you started dining at your own table.

There are some other compelling reasons to cook for yourself. For one thing, since you decide what ingredients to use, it's going to be so much healthier than eating restaurant or takeout food all the time. Even if you make something with a hearty dose of butter or sugar, you know it's pure butter or sugar (not trans-fatty acids and high-fructose corn syrup, which are so bad for you and lurk in a lot of food made by other people), and it won't have a bunch of preservatives and flavor-enhancing chemicals you can't pronounce. But more important than that, food you make yourself really tastes better, or at least it will once you're armed with a little know-how. Cooking at home means you get to have your food just the way you like it, in the comfort of your own home, without having to tip anyone before you leave.

But if you're the type of girl who mostly uses her kitchen just as a place to eat cold cereal in the mornings and open a bottle of wine in at night, it's likely that you approach cooking with a bit of unease. It's not that you can't cook at all—you own a few cookbooks and have pulled off some successful dishes in your day—but you can't cook without consulting a recipe every few seconds.

The thing is, as I learned on the night of the herb-chopping incident, making a great meal isn't usually as easy as just following a recipe. Of course you need a recipe to try something new, but you also need some background know-how to make it turn out the way it's supposed to. Even great cookbooks usually assume you know things that you may still be clueless about, and then many recipes are slightly flawed in some way—they forget to instruct you on little moves that make a big difference, or they're just not that good. So you need to brush up on the basics that cookbooks don't tell you, and practice cooking enough that you're able to tell a solid recipe from a suspect one just by reading it. And once you've got some experience under your belt,

you'll often be able to bypass recipes altogether and just hit the store after work, pick up some of whatever strikes your fancy, and whip up an easy, edible meal.

When you cook only on special occasions, the scenario can too often go something like this: You decide you want to cook dinner, maybe for your favorite man of the moment or a group of your friends, so you open up a posh-looking cookbook, or troll for recipes online, and put together a menu of things that sound absolutely scrumptious. You're pumped about the delish dinner you're about to cook and set out for the store. Your enthusiasm lags a bit as you're roaming the aisles looking for hard-to-find ingredients and feeling your cart get increasingly heavy, and then your balloon is almost popped at the cash register when you find out the cost of your ingredients hovers around the one-hundred-dollar mark. But you silence that nagging thought that you could have bought dinner for two (with a damn decent bottle of wine!) at one of your city's nicer restaurants for that sum. No, you tell yourself, it's so worth it because this dinner is going to be so stellar.

Cut ahead to your kitchen a couple hours later, when you've got sweat on your brow, there are slivers of chopped onion all over the floor, and every bowl and cooking tool you own is out and spread around your kitchen (and if you live in a really small apartment, there's a strong chance your salad spinner has wound up on your bed—I know because it's happened to me). Your dinner guests are due any second, and you're feeling crazed and confused, and not at all like the gracious hostess you'd like to be. Who knew the recipes you chose would take so long? And who knew they'd require you to dirty every cooking implement you own, leaving your kitchen looking like a poltergeist had been playing in it?

So when you finally sit down to eat this meal you slaved over, it may be simply divine and even worth all the work and stress and expense that went into it. But then, it could be just fine. Or even just so-so—maybe there were some key little moves that you missed because the recipe just assumed you would know to do them. Or maybe it was just a crappy recipe—there are a lot of them out there, even in cookbooks by famous chefs. When that's the case, it's totally discouraging and can be enough to turn you off cooking entirely, or at least for another few months, until you forget this experience and decide to repeat it.

But those days of kitchen confusion can be over! This chapter is designed to help you learn to cook without consulting anyone's recipes but your own. I've pulled together a bunch of basic culinary tips and expert wisdom that'll soon have you cooking with confidence. Although it's filled with instructions on how to make a bunch of basic dishes, they're not really recipes; they're more formulas you can

commit to memory, and practice and play with until you find the way you like them best. All the stuff I've included here is fast to prepare and doesn't require a lot of ingredients or a ton of cleanup. Because to make cooking dinner a semiregular habit, you need to be able to hit the store after work for just a couple ingredients, then be eating within no more than two hours of when you left your workplace.

Every single ingredient involved here is easy to find and pretty inexpensive. The only exception is that good quality meat and fish get a little pricey. Still, with these recipes you'll be spending less than you would eating out almost anywhere (with the obvious exception of fast-food joints, which don't count as truly eating), and you'll get the satisfaction of knowing you prepared your meal yourself and can feel good about the knowledge that you didn't add any more fat or sugar or MSG, or any of the other things restaurants may add to make your food taste better.

Step One: Equipping Your Kitchen

Before you can get started, you need to make sure you've got the right pots, pans, and tools necessary to make a variety of basic dishes. But that doesn't mean you need to spend five hundred dollars at Williams-Sonoma on fancy gadgets. Most of the basics are things you already own, and if you don't have them yet, you can rest assured that you won't regret buying them. Here are what pro chefs say are the essentials and the extras.

Pots and Pans

This is what to acquire for your stovetop, whether you're only buying the basics or are able to shell out for some extra options.

The Bare Essentials

These are the minimum cooking tools you need—you can do almost any basic dish (and lots of complex ones too) with just these.

Two skillets: One nonstick and one regular cast-iron or stainless-steel, both about 10 inches in diameter. You need a nonstick pan for when you want to cook with minimal fat or when frying eggs and sautéing delicate fish. Use the cast-iron skillet for pan-grilling meat, searing tuna, and any time you need a lot of heat.

One stockpot/pasta pot: Get one that holds 8 quarts, which is big enough for pasta, with a steaming rack that fits into it.

If you're going to invest in only one type of pan, you should probably make it a regular stainless-steel or cast-iron one, not a nonstick. Nonstick skillets, which are coated with a Teflon-type surface that keeps food from sticking to them, make it amazingly easy to cook things without a lot of fat. With a regular iron or stainless-steel pan, you need a decent amount of oil or butter to keep the food from getting stuck to the pan (the exception is items like steak, which have a lot of fat in them already and don't need the nonstick coating). Cooking omelets in them is a snap.

But most of the chefs I've asked say they never use nonstick pans, because they don't get hot enough and don't give food the same nice brown crust that a regular pan does. Plus, there's evidence that the chemicals in nonstick surfaces are a health hazard—when they're heated to high levels (anything above medium heat on the stovetop), they emit fumes that are deadly to pet birds. Even if you don't have a bird around, some health experts advise you to be careful not to get them too hot, for your own protection, and even to avoid them altogether.

One medium-size saucepan with a lid: You'll use this to cook sauces and heat medium amounts of liquid, as well as to cook grains like polenta and couscous.

Extras to Add

When you've got a bit more to spend, round out your kitchen equipment by adding these helpful items to the basic arsenal listed above.

A sauté pan with straight sides and a lid: These are handy for cooking things in liquid, and the lid lets you steam things at the same time you're sautéing them.

A butter warmer: These tiny saucepans are perfect for melting butter or heating any small amount of liquid.

A Dutch oven: These heavy, lidded pots can go on the stovetop and in the oven and are great for cooking stews, soups, pot roasts, or anything you cook in liquid.

A smaller nonstick skillet: An 8-inch one is ideal for making omelets, so if you can spring for a second nonstick pan, that's the size to get.

Do It Posh: Cookware snobs only buy pots and pans from pricey brands such as All-Clad, Le Creuset, and Mauviel. "It's worth it to invest in top-quality skillets and sauté pans, because cheap ones can be too thin and can scorch your food or make it cook unevenly," says David Walzog of New York's Strip House and Michael Jordan's the Steak House N.Y.C.

Do It on Pennies: On the other hand, Jeff Armstrong of Houston's 17 Restaurant says you don't need to spend a mint for quality cookware. "I've bought cooking pans for my home from Ikea. They have a great line of stainless-steel pans that are a fraction of the price of the big-name brands."

Insider Tip: Make sure your skillets have metal handles, so you can move them from the stovetop to the oven when you're pan roasting (more on that later)—handles made of plastic can melt.

The Knives You'll Need

Chefs all have strong opinions about knives. Since they use them constantly, they need these tools to work really well. They usually go for pricey ones—some of the high-end brands they swear by are Wusthoff, Henckels, and Global, all of which can set you back seventy dollars or more, for just one knife. But you don't need to spend a grand on a whole set of precious slicers and dicers. Just buy one or maybe two pro-quality ones, and keep the rest inexpensive.

The Bare Essentials

If you're able to shell out for only one really nice knife, your first priority should be an 8-inch chef's knife. This is the big, heavy one you use to chop and do any tasks that require your knife to have a little heft. You'll also need a paring knife (the little ones you use to slice fruit and do other precise moves) and a serrated bread-slicing knife, but there's no need to spend more than a few dollars on either of those.

Extras to Add

If you want to go beyond that, you could get an 8-inch knife called a slicer, which is narrower and lighter than a chef's knife and can be used to slice through meat, fish, or just about anything. And if you're willing to really blow it out with your blades, you can get a whole set of good ones—including things like a deboning knife and even a special tomato knife—for about $400 (and it's cheaper to buy them as a set than individually, so you can ease the pain of that expenditure with the knowledge that, in one sense, you're saving money).

Insider Tip: Yes, dropping eighty dollars on a knife hurts like hell, because you could have a fabulous facial or a posh set of lingerie for roughly that much, but in the long run it's much more worth it than those other treats. Quality stainless-steel knives will last forever if you take care of them correctly. To keep them in top form, wash and dry them right after use and never put them in a dishwasher. And sharpen them every six weeks or so. The easiest way to do this is with a plastic-encased sharpener. Jacques Haeringer, of Virginia's L'Auberge Chez François, recommends a brand called Accusharp, which costs just a few dollars and is available in most cooking stores or at accusharp.com.

101 Info

There's nothing more annoying than getting into a recipe and realizing you're missing a necessary ingredient or tool—this used to happen to me all the time when I first began to cook. The way to prevent this, which is obvious but also easy to forget, is to carefully, carefully read through a recipe before you commit to it, so you know which tools are required and exactly which ingredients to buy. If it calls for tools you don't own, either buy them or choose another recipe.

Other Cooking Tools You Need in Your Cupboards

If you arm yourself with the basic implements listed here, you'll be able to make a wide array of dishes that are simple and reliably delicious. Most of them can and should be purchased for very cheap at Target, Kmart, or similar discount stores.

> "Expensive knives are nice, but the most important thing is that your knives are sharp. Knives that have dulled are going to make your life miserable."
>
> —*Maire O'Keefe, owner of Thyme Catering in Los Angeles*

Making Food That Tastes Delicious

A wire whisk
A vegetable peeler
A liquid measuring cup
Measuring cups for dry measurements
Measuring spoons
Tongs
A cookie sheet
A 9" × 13" glass baking dish
An 8" × 8" or 9" × 9" metal baking pan
A metal spatula
A slotted spoon (for transferring things out of liquid)

A wooden spoon (essential for sautéing and stirring on the stove, because they don't conduct heat and don't scratch nonstick pans)

Two cutting boards: one cutting board for meat and fish, and one for everything else (This reduces your risk of getting food poisoning from the harmful bacteria that can linger in meat and fish. Plastic cutting boards are considered somewhat safer than wood because they're less likely to harbor harmful bacteria.)

A set of small clear bowls (to hold ingredients in when you're doing prep work)

Kitchen scissors (for slicing through the skin of raw fish fillets when your knife fails you, and anything else you'd need scissors for)

A grater (The most basic option is a four-sided box grater, the kind that stands up and has different-sized teeth on each side. I also love the graters by a company called Microplane. They have really sharp teeth, and their zesters reduce things to tiny bits in seconds. But they don't, to my knowledge anyway, make a four-in-one box grater yet, so start with one of those and add a Microplane if you're curious.)

An instant-read thermometer (for taking the temperature of dishes so you'll know when they're done)

If You're Stuck with an Electric Stove

Electric stoves are considered inferior to gas ones because they don't respond as quickly as gas ones do. When you turn the heat up or down, there's a lag before the burner responds. But if you're stuck with an electric stove (since you're not at a point in your life where you're going to replace the stove your kitchen came with), don't despair. You just need to take the stove's slow response time into account. When you're heating a skillet, wait an extra minute before adding ingredients, and, if you need to turn down the heat on something swiftly, move it to another burner set to low heat, rather than wait for the burner it's on to cool down.

A blender (for making salad dressings, soups, and smoothies)

An oven thermometer (to let you know when your oven's done preheating and is ready to roast. And since you're probably using the oven your place came with, you have no idea how long it's been there or how well it works. To ensure it runs true to temperature, you need to leave a thermometer in there and check it from time to time.)

A salad spinner (not totally necessary, but really helpful to have)

A potato masher (again, not an essential, but nice to have for making mashed potatoes and peas, as well as creating bean dips)

A roasting rack (if you plan to roast chicken and big pieces of meat)

$$-Saving Strategy: Hit restaurant supply stores to get bargains on basic cooking tools—the prices are often wholesale.

Step Two: Learn to Pick Quality Ingredients

The quickest shortcut to preparing great food is having high-quality ingredients to start with. They won't need a lot of flavor enhancement and are very hard to screw up.

Fruits and Vegetables

The signs that a piece of produce is a good one vary slightly depending on the item, but in general you should look for fruits and veggies with even color and firm textures. You don't want them to be squishy, but they shouldn't be rock-hard either. Another generalization: the more intensely colored the fruit or vegetable, the stronger its flavor will be. Often, locally grown and/or organic produce will be better than something grown on a factory farm and flown across the country (though this is not always the case). And, although frozen fruits and veggies are generally a pale imitation of the fresh, in the case of spinach, corn kernels, shelled green peas, and berries, the frozen produce really does taste almost as good as the fresh when cooked in a recipe, and it's cheaper and easier to work with. Finally, don't buy large quantities of produce prebagged (like potatoes often are). You aren't able to inspect them carefully, and there may be some bad ones lurking in there. And if you buy them individually instead, you can choose ones that are all close in size, which will be easier to cook.

Meat

If you're a passionate carnivore, you should take the time to find a quality butcher and form a relationship with him. He'll be able to tell you what's good, and once he knows you as a regular customer, hopefully he'll steer you away from any meat that's less than fab. If your local supermarket doesn't have a butcher counter, and your only option is to buy prewrapped meat, you can still ask to speak with the butcher about your options. Ask him if the meat has been frozen (if so, it won't have the same flavor as meat that hasn't been). Don't think of this as diva-ish behavior; he'll probably be excited you're taking an interest. When picking out chicken, try the organic, free-range variety if you haven't already ("free range" means the chicken wasn't kept in a cage all its life the way many big-farm chickens are). It tastes entirely different, and so much better, than the regular kind. If you can't find free-range, kosher chicken is the next best thing.

Fish

As with the butcher, make a habit of frequenting the same fish counter so the guy behind it gets to know you and you can ask him what his best offerings are on any given day. Ask if the fish has been frozen—ideally it hasn't been—and always ask to smell the fish before you buy it. It should only smell faintly like the sea. If it smells fishy at all, it's old. This applies to shellfish too. The old conventional wisdom was that you shouldn't buy fish on a Monday because you'll be getting the weekend leftovers. If you live in a big city or just shop at a busy market with lots of fish eaters, you can probably ignore this, because these days fresh fish can be flown in any day of the week. But if you live in a less-populated region, you might want to heed the no-fish-on-a-Monday rule.

Dairy

Always look for the dairy products with the latest expiration date (often new and older dairy goods will be mixed together on the shelves, so don't just grab one blindly), and buy the ones that are in the back of the refrigerator case—they've been kept colder because they were closer to the refrigerated air. Choose yogurt with live active cultures. They're good for you, and yogurt that contains them is usually better quality (if it contains live cultures, it will say so on the container—Stonyfield Farm is one brand that does). As for cheese, the most richly flavored is labeled "raw milk," which means it wasn't pasteurized. The point of pasteurization is to kill off bacteria, but bacteria is what gives cheese its flavor, so pasteurization destroys a lot of the cheese's taste. By U.S. law, raw-milk cheeses have to be aged over sixty days, after which most of the bacteria have died off naturally. So they're safe to eat but have lots more flavor than the nuked kind. (They're also, not surprisingly, more expensive.)

Eggs

Always open a carton of eggs to check them for cracks before you put them in your cart. Scan them with your eyes, then twist each one slightly—if one won't twist, that means it's cracked on the bottom and sticking. If you wind up bringing home an egg that's cracked, always throw it out, even if it's just a hairline crack. It could be infected with dangerous bacteria.

Smart-Girl Secret: Never store milk inside your refrigerator door. It will be exposed to the warm air of the room every time the door is opened and go bad more quickly as a result.

Smart-Girl Secret: When shopping for vegetables and fruit to cook, try to buy ones that are similar in size. It will be easier to cook them evenly, and they'll look nice on the plate if they're fairly uniform.

Five Essential Ingredient Upgrades

Getting quality produce, meat, or fish is super-important, but the good stuff usually costs more, and often it isn't possible to find absolutely delicious raw ingredients on a daily basis. So it's probably even more important that you stock up on high-quality staples—good salt and pepper and herbs and oil are amazing at enhancing the flavors of whatever you put them on.

Switching from garden-variety seasonings and staples to these more-gourmet versions will ratchet up the taste rating of your food a lot. You'll notice an instant improvement. They're only slightly more expensive than the regular stuff, and very worth the few extra bucks.

Quality Salt

Never use iodized salt—this type of salt, which is what we think of as common "table salt," has had all the minerals stripped out of it. Kosher salt is a bit better than iodized, but sea salt is what you want to be using, because it's left in its natural state, and it tastes infinitely better. Within the category of sea salt there are lots of variations: tiny grains that look like regular salt, coarse gray crystals, flaky white crystals, and fleur de sel salt, which the sea deposits naturally on rocks along the northern coast of France. I'm personally obsessed with Maldon salt, a flaky crystal sea salt from England.

Better Butter

Look for butter that contains more than 80 percent butterfat. It tastes better, blends better, and really makes a difference in your dishes. Jacques Haeringer loves Vermont Cultured Butter from the Vermont Butter and Cheese Company, which has 86 percent butterfat. "It has a slightly cheesy, nutty flavor—it must be one of the best butters on the planet," he says. Other butters chefs love: Plugra butter and Kerrygold Irish butter.

Freshly Ground Pepper

If you don't own one yet, you've got to acquire a pepper mill (they cost ten dollars or less at Target and places like that). You put whole peppercorns in there and grind them fresh every time you use pepper. The flavor is way more vibrant than that of preground pepper you find in a shaker.

Fresh Spices

Ideally, you should buy them whole and grind them fresh—either keep an extra pepper mill on hand for this purpose or grind them in an electric coffee-bean grinder. If you're not quite that motivated, be sure to replace your spices every three to six months, or else they'll go stale and sabotage the flavor of your food.

Fresh Herbs

If you use dried, bottled versions of basil, thyme, rosemary, garlic, or any other herbs, your meals will taste tremendously better with this one move: Replace them with fresh ones. I once heard a celebrity TV chef say dried herbs often make food taste worse. Now, that's not always true—some recipes specifically call for them—but fresh herbs make food taste so great that you really want to use them at any opportunity. For tips on working with herbs, see the box "All About Herbs" (page 96).

> "Quality ingredients are key. If your raw material is good, your technique can remain very, very simple."
>
> —*Edward Lee, chef at 610 Magnolia in Louisville, Kentucky*

Making Food That Tastes Delicious

When to Splurge on Organic Produce, When to Save Your Pennies

"Organic" fruits and vegetables—those grown without pesticides or chemical fertilizers—are undoubtedly better for you and the environment, and they're becoming increasingly available at supermarkets. However, they're often much more expensive than their conventionally grown counterparts. To help you decide when it's worth it to shell out for organic, and when you may as well save your money, memorize these two lists from the Environmental Working Group (ewg.org). They tested all sorts of non-organically-grown produce to find out which varieties have the most lingering toxins in them and which are relatively unaffected by chemicals in their environments.

The twelve fruits and veggies found to have the *most* lingering pesticides and chemicals when not grown organically:

Apples
Bell Peppers
Celery
Cherries
Grapes (imported)
Nectarines
Peaches
Pears
Potatoes
Red Raspberries
Spinach
Strawberries

The twelve fruits and veggies found to have the *lowest* amount of lingering pesticides and chemicals:

Asparagus
Avocados
Bananas
Broccoli
Cauliflower
Corn (sweet)
Kiwi
Mangoes
Onions
Papaya
Pineapples
Peas (sweet)

All About Oils

In the past few years the variety of oils on the store shelves has totally exploded. It can be a bit overwhelming, but since you're using oil almost constantly when cooking, it's worth it to understand the options.

OLIVE OIL: Oil extracted from olives is mostly made up of monounsaturated fat, which means it's really good for you. Although it has roughly the same number of calories as butter or any other type of fat, it's been shown to lower your bad cholesterol and raise your good cholesterol. But all you really need to remember is that Italian women tend to have gorgeous skin even as grandmothers, and they slurp up gallons of olive oil over their lifetimes.

Basic olive oil is great for cooking at medium heat, but since it has more of a flavor than other oils, almost tasteless oils like canola are better when you don't want your oil to affect the flavor of your food. Also, olive oil has a relatively low smoke point (meaning it burns more quickly than some other oils), but you can get away with quickly sautéing something in it.

Even though you think of Italy when you think of olive oil, most of the chefs I've talked to say some of the best olive oils today are coming from Spain.

Extra-virgin olive oil: This is higher quality than regular olive oil and, of course, more expensive. It's delicious in salad dressing, drizzled over cooked food, or for dunking bread into. But it's not the best choice for cooking because it has a low smoke point, which means it may give off a lot of smoke and start to taste icky if you cook it for too long or at too high a heat.

CANOLA OIL: Like olive oil it's filled with monounsaturated fats. It's fairly flavorless and has a higher smoke point than olive oil, which makes it a good choice for general cooking.

GRAPESEED OIL: This pricey oil has a very high smoke point, so it's great for frying and cooking things at high heat. It has a neutral flavor and is good for your heart. It's sort of a posh cousin to canola.

PEANUT OIL: This is also mostly monounsaturated fat and, like olive oil, has a bit of a flavor, which is delicious in Asian dishes when you want

Playing House

70

some nuttiness to come through in the food, but you may want a more neutral oil for your everyday meals. You need to be careful when using it in dishes for others because a lot of people have nut allergies.

SESAME OIL: High in polyunsaturated fat, great to give an Asian flavor. It has a shorter shelf life than other oils.

CORN, SOYBEAN, SAFFLOWER OIL: These are all polyunsaturated fats, with fairly neutral flavors, and fine for cooking, but if you've got canola oil on hand, there's no reason you'd need them.

NUT OILS: Walnut, hazelnut, pistachio, pine nut, and almond oils are all strongly flavored and taste delicious in salad dressings or drizzled over already-cooked food. Since they're expensive and strongly flavored, you don't want to cook with them.

OTHER OILS: Palm kernel oil, palm oil, and coconut oil are all high in saturated fats, which means they're just about as unhealthy as butter. But butter is tastier.

Making Food That Tastes Delicious

Insider Tip: For salad dressings, Edward Lee of Louisville's 610 Magnolia uses a line of nut oils by the French company J. Leblanc. They make walnut oil, pine nut oil, pistachio oil (which is great drizzled on desserts), and, says Edward, "the best peanut oil you've ever tasted."

101 Info

Oils should be stored in a dark place and should be refrigerated if you're going to have them for more than three months. Even though the temptation is to buy the biggest bottle of oil you can find, since it's usually cheaper that way, it's really better to buy them in fairly small quantities. If it doesn't come in a dark bottle, definitely refrigerate it. Some oils turn solid in the fridge, but that's okay—they'll quickly turn to liquid again at room temperature.

Smart-Girl Secret: Have an arsenal of two or three oils on hand. You definitely need one neutral, all-purpose oil for cooking (like canola or grapeseed) and one delicious extra-virgin olive oil for salad dressings and dressing up finished

dishes. To those basics you can add sesame oil for giving things an Asian flavor and a pricey nut oil for special salad dressings.

Pitfall to Avoid

Try not to use margarine or any fat labeled "hydrogenated" or "partially hydrogenated." Both are packed with trans-fatty acids, and scientists have recently discovered that these are really terrible for you. They clog your arteries and are actually worse for you than butter and other saturated fats. Even if you're young and don't need to worry about heart disease quite yet, there's no need to abuse your bod with this stuff, since butter and olive oil taste better anyway.

The Main Cooking Methods Defined

Sautéing

Cooking food on the stovetop in a little bit of fat. This method should leave food slightly crispy on the outside. "Stir frying" is essentially the same thing as sautéing, except the term is usually used to describe Asian-style dishes in which a number of different ingredients are chopped up and cooked at once in very hot oil.

Roasting

A term used for cooking in the oven. ("Baking" is also oven cooking, but describes cooking things that contain a lot of liquid, flour, and/or eggs.) Because all the air in the oven heats up evenly, the heat is diffused (as opposed to the direct heat of a stove burner) and food cooks all over at the same rate, since the hot air hits it from every angle. Many foods can dry out during roasting if they're not basted with liquid or covered with a rich coating during the process.

Frying

Cooking food on the stovetop in a lot of fat. *Pan-frying* is similar to sautéing, except more fat is used, and *deep-frying* involves immersing the food entirely in hot fat.

Boiling and Poaching

Cooking food covered in boiling or simmering water or some other liquid. *Poaching* uses a simmering liquid that just barely covers the food, and *boiling* means that the food is plunged into a larger amount of liquid.

Braising and Stewing

These methods also involve cooking in water, but over lower heat, so the food cooks more slowly. With *braising*, you first sauté the food for a few minutes, then add liquid and cover the pan. *Stewing* involves more liquid. They're good methods for cooking lean meats and fish, because the moisture keeps them from drying out, and for softening up slightly tough pieces of meat.

Steaming

In this technique, the food is cooked by being placed over a simmering liquid—usually water or stock. It's one of the healthiest ways to cook because no fat is required, and steamed foods generally retain more flavor than boiled ones.

Broiling and Grilling

These methods expose food to direct heat—there are only a few inches between the food and the flame of the grill or the broiler. The result is a crisp, brown crustiness on the outside and a tender interior.

Pan-Roasting

A favorite technique of many chefs, this involves cooking meat or fish in a pan on the stovetop just until it browns, then sticking the pan in the oven to finish the job. Searing them in a pan or skillet seals in the juices, caramelizes the outside, and creates a nice crustiness, while the time in the oven lets them get evenly cooked in the center.

Pan-Grilling

Cooking on the stovetop over high heat using little or no fat. It works for steaks and other pieces of meat that have enough fat of their own to prevent them from sticking to the skillet.

The First Course: Stepping up Your Salad Skills

To me, dinner doesn't seem complete without a salad. Eating crisp, fresh greens just feels healthy, and their texture provides a good counterbalance to whatever cooked foods you're serving them with. You can serve salad before an entrée, at the same time as the entrée on the side, or after the entrée but before dessert (which is the traditional French way to do it). And, of course, a big salad spiked with protein can be a meal in and of itself.

But most of the time a salad's going to be your first course, and it's the best first course for a beginning cook because it doesn't require much work or, obviously, any stove time. The key things to think about with salads are the greens and the dressing—with flavorful greens and a good dressing you don't need to add anything else. For the greens, the classics are iceberg and romaine, but there's a growing variety of greens available in stores, so you should acquaint yourself with all the delicious options out there.

An easy way to make a salad more interesting is to use at least two different types of leaves. Those premade mesclun mixes you can find in supermarket produce sections are a busy girl's best friend, because they include an assortment of different leaves already cut to salad size and combined. (*Mesclun* is a blanket term for a mix of young lettuces and other greens like arugula, radicchio, frisée, and so on.) But if you want to go beyond the premixed stuff, get to know the individual greens that go into it in the box on the next page.

The Formula for a Restaurant-Style Salad

Though greens are good by themselves, when buzzed-about restaurants put salads on their menus, they never limit them to greens. They know that to get you to spend ten dollars of your date's hard-earned money, they better make the salad a really scrumptious experience. Salads at stylish eateries always seem to contain some variation of this formula: fruit (whether dried or fresh), nuts (or seeds), and cheese. Edward Lee explained to me that these salads are so perfectly palate-pleasing because they contain a balance of sweet (the fruit), salty and crunchy (the nuts), and soft and rich (the cheese). At Louisville's **610 Magnolia**, he serves a salad of Bibb lettuce, fresh peaches, house-made blue cheese dressing, and spiced pecans. The possible combinations are endless—here are some other restaurant-style salads to try:

ARUGULA: This green, which is sometimes called *rocket,* has delicate leaves and a slightly peppery flavor.

ENDIVE: These tangy white leaves are a good way to give a little bite to a salad.

ESCAROLE: Has curly green leaves and a white base. It's a bit thicker and heartier than lettuce and has a nutty taste.

FRISÉE: Its curly, skinny leaves are great at holding bits of cheese, and dressing sticks to them, so they can pack lots of flavor without getting soggy. (It is also sometimes called *chicory* or *curly endive.*)

RADICCHIO: A head of radicchio looks like a little red cabbage. It's crunchy and adds a beautiful color to salads.

WATERCRESS: Has small leaves and a sharp, peppery flavor.

Toasted walnuts, goat cheese, fresh figs

Toasted pumpkin seeds, dried cranberries, blue cheese

Blue cheese, hazelnuts, sliced pears

Green apples, manchego cheese, toasted walnuts

Orange slices, shaved pecorino cheese, almonds

DIY Dressings: Why and How

Dressings are just *sooo* much better when you do them yourself. Most bottled dressings are packed with sugar and preservatives, so making your own dressing is healthier—plus it's cheaper and tastes much better. Once you get the hang of it, mixing one up takes no time. And the better your ingredients, the better your dressing will taste—you *must* use a decent extra-virgin olive oil, sea salt, freshly ground pepper, and a good quality vinegar.

Classic Vinaigrette

You can make a basic vinaigrette by mixing any oil and any vinegar, along with a little salt and pepper, but the proportion of oil to vinegar is up for debate. It's something you should decide for yourself after trying out a few variations. If you're

using a strongly flavored vinegar like balsamic, you'll want to use a bit less than you would with a soft red wine vinegar. I tend to use less vinegar than most dressing recipes call for because my mother once told me that the less vinegar you use, the more compliments you'll receive on your dressing. But there are lots of differing opinions on what mix makes the perfect dressing.

The fundamental formula: Whisk together 3 parts oil and 1 part vinegar along with salt and pepper. Usually some chopped shallots and a dab of Dijon mustard are added to classic recipes.

The extra options: Play with the proportion of oil to vinegar to find what you like the most. You can substitute fresh lemon juice for all or part of the vinegar, and add any of the following: finely minced garlic, lemon zest, a bit of honey, chopped fresh parsley, or any type of herb you're into.

Insider Tip: When you're making a dressing, add salt and pepper to the vinegar before you add the oil. "Otherwise the seasoning won't be as well-distributed in the dressing," says Maire O'Keefe.

Three Special Salads to Master
All these make about 4 servings.

Healthy Asian-Style Slaw
This crisp version of coleslaw is superhealthy and a refreshing change from a standard salad. Add it to a menu that's coming up short in the crunchiness department.

The fundamental formula: Chop one head (or about 6 cups worth) of red cabbage into thin slices; mix with $1/2$ cup chopped scallions (green parts only) and 2 julienned carrots; and dress it with a vinaigrette of 2 tbs sesame oil (the plain kind, not the dark, toasted sesame seed kind), $1/4$ cup soy sauce, $1/4$ cup rice wine vinegar, $1/2$ tbs sugar, and $1/4$ cup toasted sesame seeds*—plus salt and pepper to taste.

The extra options: You can add julienned bell peppers to this too, or any crunchy veggie you have on hand.

*To toast sesame seeds, place them in a skillet over medium high heat, shaking and flipping occasionally, for 3–4 minutes or until they brown slightly.

Chopped Salad

Something about chopping a salad into a bunch of little pieces makes it seem way more fun—maybe because the flavors really blend together when all the bits are the same size, or maybe just because it's easier to eat than all those big leaves in a standard salad. This is a very California-style dish that can easily be a meal in itself. You can turn just about any salad into a chopped salad just by slicing its individual elements into same-sized pieces, but here is one basic version.

The fundamental formula: Chop up all of the following: 4 cups shredded romaine lettuce or mixed greens; 1 cucumber, peeled and seeded; 1 bell pepper (ideally a yellow or orange one, to add color); 1 large tomato or 2 small ones, 1 small red onion, and 1/2 cup black olives. Then toss with your favorite vinaigrette and top with chopped flat-leaf parsley.

The extra options: You can add fresh corn when it's in season, a firm avocado, shredded cheese, pieces of chicken or shrimp, or absolutely anything else you think sounds tasty.

Caesar Salad

This is a great salad for dinner parties because everybody loves 'em but people associate them with restaurants, so they'll be pleasantly surprised to get served one at your pad. Handling anchovies grosses me out, so I skip them and the dressing still tastes great. But a true, honest Caesar does require them, so they're included here.

The fundamental formula: Beat 2 eggs with a fork; then gradually add 2 tbs of fresh lemon juice and 6 tbs of extra-virgin olive oil, beating continuously (or blending in a blender). Stir in 2 tbs of minced anchovies and a dash of Worcestershire sauce. Add a 1/2 tsp of pepper, and salt to taste. Toss with 8 cups of torn romaine lettuce, adding a bit of the dressing at a time so you don't overdo it; then add 3/4 cup freshly ground Parmesan cheese and toss again.

Ideally, you should make the dressing in the blender, and slowly, slowly drip the olive oil in through the top. When you slowly add olive oil to a mixture that's being swiftly beaten or blended, it emulsifies, which means the oil gets totally suspended within the other liquid, rather than sticking to itself the way it would if you just poured it in there all at once. If you do this with a Caesar dressing, it will have a great thick consistency.

General Salad-Preparing Pointers

You need to wash greens really thoroughly, since any dirt or grime that's stuck on the greens will totally ruin the salad; and once you're done, you need to dry them completely, because dressing won't adhere to wet leaves. It's beyond worth it to buy a salad spinner if you don't already have one, as they make this task super easy. Just place the greens in the colander, and place the colander in the larger plastic container. Fill it with water and let the greens soak, swishing them around with your hands a bit (this gets more grime off than just rinsing the greens would). Then remove the colander, dump out the dirty water, and spin the leaves dry. If you don't have a spinner, blot salad leaves dry with paper towels.

One pound of salad serves between four and six people, depending on the size of the salads and the type of leaves you're working with. In the case of mesclun and other leaves that are cut and ready to serve, a pound equals more usable salad than, say, two heads of romaine or four heads of radicchio that weigh a pound, since with the latter you don't use every bit.

Put the dressing on a salad at the last possible moment, because if you do it too early, the leaves will get soggy and limp. This is especially true if you use sugar or honey or a lot of salt in the dressing, because those ingredients will make the greens wilt more quickly.

To revive salad greens that have gone a bit limp while sitting in the fridge, soak them briefly in a bowl of very cold water—they should perk right up.

An easy way to add flavor to a salad is to chop or shred fresh herbs and throw them in. Basil, flat-leaf parsley, and chives all add great flavor, but just about any herb will work. (This is a smart way to use up herbs that are leftover from an earlier dinner and languishing in your fridge.)

Start by dressing a salad with one tablespoon of dressing per three cups of salad, then add more to taste. It's obviously way easier to add more dressing to an underdressed salad than it is to rescue one that's been too heavily doused.

Putting Together a Perfectly Balanced Menu

You know how some meals just leave you utterly satisfied, while others leave you a little bit off—kind of bored or let down, even if you consumed more than enough calories to keep your stomach full for hours? To make the first sort of meal, the kind that leaves your taste buds totally content, you need to design a menu that has a good balance of different elements. No single flavor or texture should totally dominate, and each of these pairs of elements should be balanced out:

creamy and crisp light and heavy

salty and sweet spicy and mild

This means, for example, if you're serving pasta in a heavy cheese sauce as an entrée, your starter has gotta be some crisp greens in a light, tangy dressing (and no cheese!), and dessert should be fruit-based or a lemon sorbet, or some other slightly acidic, not creamy, treat.

Also, when you're cooking an entrée with some of the flavors from a particular culture or part of the world, it makes sense to use some ingredients or flavors from that same culture in your side dishes or starter. So if you're serving soy-and-ginger-marinated steamed fish as an entrée, skip the arugula salad and serve cold sesame noodles as a starter instead. It's not that each dinner should have a theme (if you have Spanish night on Monday and Chinese on Tuesday, you'll soon feel like you're living at Epcot Center), but classic cultural pairings just make sense. They're classics for a reason: they naturally balance each other out. The different elements play off each other to highlight the best aspects of each individual dish.

You also have to think about timing when you're planning a menu. My mother always says (as I'm sure your mother, as well as half the mothers in the country, probably says) that the hardest part of cooking a meal is getting everything ready to be served at one time. Before you get started, think through the order everything needs to happen in. With some forethought, you can figure out how to get the food to the table all at once before the hot items go lukewarm on you.

On to the Main Event: Mastering Awesome Entrées

Though all the little things are important, it's your main dish that makes or breaks your meal. The entrée's "deliciousness factor" is what anyone you're feeding will use to assess your culinary prowess.

You can generally manage to pull off a great dish if you've got a reliable cookbook and time to follow all the little details of a recipe, but what follows here isn't really recipes—they're simple formulas for making yummy food with minimal fuss, and they're meant to be memorized and tweaked to fit your personal taste. I've pulled together strategies for cooking the three basic types of protein—chicken, steak, and fish—and for each of those I've given preparation tips for three types of meals:

Ultra-Simple Strategy: These cooking methods are for those nights when you're just making dinner for yourself or for you and a friend, and you want to keep things pretty healthy and inexpensive. They're not going to impress anyone to pieces, but they're easy enough that you can make them often and keep tweaking them until you know how to do them exactly the way you like.

A Style Guys Will Love: I chose these dishes for times when you're cooking for a guy you want to make really happy. They're more mouthwatering, and richer than those in the first category.

Great for a Group: When you're cooking for four or more people you need a special strategy. All these meals are things you can do without spending a bundle, or spending the entire night at the stove.

Now, I admit that the "guy-friendly" category is a sweeping generalization, since your guy might be really into his physique and more calorie-conscious than you are. But I labeled these dishes with the stereotypical hungry-man in mind. And if you're just starting to cook for a guy, you don't want to take chances and serve him up something healthy that leaves him hungry—you want to wow him and do that proverbial win-his-heart-through-his-taste-buds thing (or at least keep him around for a while after dessert).

And the categories do overlap a bit. Even the most basic recipes are good enough for dinner guests or a special guy, and all the entertaining entrées are sim-

Chicken-Buying Basics

There are four edible parts of a chicken: the breasts, thighs, wings, and legs (also called drumsticks). Each chicken has two of each, of course, so if you're buying a whole chicken, it will be divided into (or else you'll carve it into) eight sections. The breasts and wings are white meat, the thighs and legs are dark meat. Dark meat has a stronger flavor and contains more fat than light meat, but neither kind is inherently better-tasting than the other. It's just a matter of personal preference.

One thing that's important to know: white meat cooks much more quickly than dark meat. So if you're cooking both breasts and thighs in the same pan, you generally need to start cooking the thighs a few minutes before the breasts, so all the pieces will be done and ready to eat at the same time. The breasts and thighs are the big pieces with the bulk of the meat on them. The wings and drumsticks don't have enough meat on them to make a meal, but they can make great appetizers if you cook up a bunch of them.

ple enough that you can easily make them for yourself on a Tuesday night if you're inspired to.

Three Ways to Make Chicken Really Delicious

These first two cooking methods deal with boneless breasts, which can be the best friend of a girl on the go, because they cook faster than bone-in pieces and are just easier to deal with. And the third is for classic roast chicken, which is a bit trickier but worth mastering, because it's so universally liked.

The Ultra-Simple Strategy: Sautée 'em

Sautéing skinless, boneless chicken breasts in a little oil is the beyond-easy, healthy, every-night way to cook 'em. This recipe is for two people.

The fundamental formula: Heat 1 tbs of oil in a skillet; season the chicken breasts with salt and pepper; and cook them over medium-high heat for about 3 minutes, or until they start to brown. Reduce the heat a bit and keep cooking for

Important Chicken Tips

Chicken is done when the meat is opaque and the juices run clear when you poke it with a knife.

Wash chicken with water, and then pat dry, before cooking. (But don't wash fish or meat, because it rinses off some of the oils that are important for their flavor.)

Chicken can easily infect your kitchen with sick-making bacteria if you don't handle it properly. Make sure the temperature of the fridge you store it in is **40** degrees or below, and don't leave it out on the counter for too long before cooking it.

3 more minutes; then flip the breasts and cook for about 5 more minutes until browned on that side and just cooked through.

The Possibilities to Play With

Do a 15-minute marinade: "Marinate" doesn't need to mean for hours and hours. Placing those breasts in a large Ziploc bag (or two small ones) with one of these three marinades for just 15 minutes will give 'em a whole lot of flavor.

- 3 tbs of olive oil, $1\frac{1}{2}$ tbs of vinegar, and 1 chopped garlic clove.
- $\frac{1}{2}$ cup of soy sauce, 2 tbs sesame oil, 1 tbs minced ginger, and $\frac{1}{4}$ cup chopped scallions.
- 3 tbs oil, 2 tbs fresh lemon juice, 2 tsp of chopped fresh herbs—like rosemary, thyme, oregano, or herbes de Provence—and lots of fresh pepper.

Note: You can mix any of the above ingredients together in just about any combination you want, really. Have fun trying out different marinades to discover which ones you like the most.

Give 'em a rub: Rubbing or brushing both sides of the breasts with a light olive oil and fresh herbs or spices before cooking is a super-simple way to give chicken

flavor. Create a rub with any combination of the following: herbes de Provence, five spice powder, finely chopped lemon zest, chopped fresh (or dried) oregano, or chopped fresh thyme.

Stuff them: You can stuff boneless breasts by pounding them with a small mallet or the underside of a heavy pan so they flatten out a bit, then slicing into the side of each breast as if it were a piece of pita bread. Season the inside pockets with salt and pepper; then stuff them. You can stuff each with about $1/8$ cup of cheese and another $1/8$ cup of anything else you want, including fresh or sautéed spinach, basil leaves, or bits of bacon or prosciutto. Then just cook them according to the basic recipe, and drizzle a sauce of extra-virgin olive oil and lemon juice over them if you'd like.

101 Info

When you're cooking something on the stovetop and a recipe tells you, for example, to heat it over medium heat, they mean that the pan should already be hot before you put the food in. Never turn on the heat and plop in the food without waiting for the pan, and any oil or butter you've added, to get hot first.

A Style Guys Will Love: Pan Roast It

Every guy (and many a girl) loves classic roast chicken, and this recipe gives chicken breasts a bit of that whole-roast-chicken effect without your having to make an entire bird for just the two of you.

The fundamental formula: Preheat the oven to 400 degrees. Use boneless breasts with the skin still on. Rub them with olive oil and salt and pepper, and cook them skin-side down in a hot skillet for about 4 minutes or until that side gets nice and brown; then flip them and brown the other side for about 3 minutes. Flip the breast once more so the skin side is down, and put the skillet in the oven. They should be done after about 10 minutes or when the juices run clear.

The Possibilities to Play With

Rub them with herbs first: Use any of the herbs suggested for sautéed chicken. Since you're cooking these breasts with the skin on, you can slip fresh herbs, lemon zest, and pepper underneath the skin, so that it leeches into the bird while it cooks.

Make a pan sauce: After you remove the chicken from the skillet, set it aside and cover it loosely with foil. Add $1/2$ cup dry white wine and 1 tbs chopped onion or shallots to the skillet, and heat it over medium heat. Stir them while scraping the bottom of the pan until the liquid is reduced; then add $1/4$ cup of chicken stock

or ¼ cup of heavy cream, *or* both, and keep stirring until the sauce is reduced to under ½ cup. Season it with salt and pepper and, once the chicken is on plates, drizzle it over them. *Note:* This is just one simple pan sauce, but there are all sorts of other variations you should explore.

Give them a savory crust: For this one, use skinless, boneless breasts and cut each breast in half lengthwise. Preheat the oven to 450 degrees. Season the 4 breast halves with salt and pepper, and brush them all over with olive oil. Mix 1 cup bread crumbs and ½ cup grated Parmesan cheese on a plate and dredge (coat) the chicken in the mixture. Cook them in a little oil over medium heat for 3 minutes; then flip them just once and put the pan in the oven for about 8 minutes.

Great for a Group: A Classic Roast Chicken

This is one dish just about everyone loves, and it's a great dinner party treat, because few people make it for themselves. You do need a roasting rack for this—it allows air to circulate all around the bird, which makes it cook more evenly and get more crispy than it would just sitting in a pan. You can find cheap ones for about $15. A typical chicken will serve four people.

The fundamental formula: Preheat the oven to 450 degrees. Take a whole chicken that weighs 3–4 pounds, wash it inside and out with water; then pat it dry. Season the inside of the cavity with salt and pepper. Mix 3 tbs of olive oil with 2 chopped garlic cloves and 2–3 tbs chopped fresh herbs—like rosemary, thyme, or oregano—and a little bit of salt and pepper. Coat the outside of the chicken with this mixture using a basting brush or by drizzling it on with a spoon. Place the chicken on the roasting rack, breast-side up, and let it roast for 15–20 minutes or until it starts to brown. Then lower the heat to 350 degrees, baste* the chicken with the juices that have wound up in the pan, and add ½ cup of white wine to the pan. Baste the chicken with the pan juices every 15 minutes or so for another 30–40 minutes. The chicken is done when an instant-read thermometer inserted into the thickest part of the thigh reads 165 degrees and the juices run clear when you prick it with a fork. Remove the chicken from the rack, put aluminum foil over it, and let it sit for 5 minutes. Pour the pan juices into a glass and spoon off whatever fat you can; then drizzle them over the chicken once it's plated, or serve it alongside the chicken in a small pitcher or gravy boat.

**Baste* means to drizzle or brush liquid over something as it cooks. If you don't have a baster, use a basting brush or a spoon.

How to . . . Carve a Roast Chicken

You want to learn to do this swiftly, because roast chicken tastes best when it's served right away.

Step 1: Turn it on its back and slice straight down the middle along the breastbone, from top to tail; then cut through so the bird is in two pieces.

Step 2: Separate the legs from the breasts by holding the knife right alongside the breasts and slicing into the skin that connects them to the legs.

Step 3: Separate the wings from the breasts and the legs from the thighs.

A Possibility to Play With

Add a touch of lemon flavor: If you'd like a lemony flavor, before putting the chicken in the oven place some thin slices of lemon, or even a whole lemon you've poked a few holes into, inside the cavity of the chicken and add lemon juice to the olive oil mixture you put on the chicken.

Three Ways to Work Red Meat

The Ultra-Simple Strategy: Stir-Fry It

This is a great method for getting a red meat fix without feasting on an entire steak. It's pretty healthy, and since you're mixing it with veggies, you can buy one ½ pound of steak (use a strip steak or top sirloin) and split it between two people.

The fundamental formula: Heat 1 tbs of oil in a skillet over medium heat, and sauté 1 minced clove of garlic and 1 tbs grated fresh ginger until fragrant; then add chopped veggies such as broccoli, bell peppers, pea pods, and anything else you'd like, and sauté them for 5 minutes or until they're done to your liking. Remove the veggies from the skillet and set aside. Take a ½ pound steak and slice it, across the grain, into slices that are ⅓ inch thick. Turn the heat to high, and sauté the steak for 2–3 minutes, after which it should be medium rare. Then stir in the veggies just until they're heated, season with salt and pepper, and serve.

The Possibilities to Play With

Do a 15-minute marinade: Marinate the sliced beef in 2 tbs soy sauce *or* teriyaki sauce, 2 tbs sesame oil *or* canola oil, $1/2$ tsp honey, and $1/2$ tsp Dijon mustard.

Do it with Asian noodles: Bring a pot of water to a boil, salt it, and add $1/2$ pound of dried rice or wheat noodles. Cook the noodles for 5 minutes or until they're tender. Drain them, toss them with a little sesame or peanut oil, and add them to the skillet once the steak and veggies have been removed. Turn up the heat and let them sit for a minute or until they brown; then stir-fry for another minute and combine with the beef and veggies.

A Style Guys Will Love: Pan-Grilled Steak

Of course, most guys are going to love a great piece of red meat no matter what, unless you totally screw it up. Master this method to guarantee it's truly off the charts. Use two rib-eye or strip steaks that are about one-inch thick.

The fundamental formula: Season both sides of the steaks with salt and pepper, heat 1 oz of oil in a skillet (a regular one, not a nonstick) over very high heat, and cook the steaks for 3 minutes, or until they're brown and crusty on one side. Then flip them and cook them for 3 more minutes. This should give medium-rare results, but to be sure, you should check with a meat thermometer (a reading of 135 degrees indicates medium-rare). After you remove the steaks from the heat, it's key that you cover them with foil and let them rest for 4 minutes or so, to let the juices settle back into them. If you slice into a steak when it's hot off the stove, all the juices will run out and you'll lose a lot of flavor.

Essential know-how: When you're pan-broiling steaks, it's essential that you don't turn them too early, or you won't get the browned crustiness you're after.

Insider tip: Although most recipes say you should heat oil in the skillet first,

How to . . . Pick the Right Cut of Meat

You need to cook beef differently depending on what part of the cow it came from. The tenderest, tastiest, most expensive cuts come from the center of the cow, in its rib area, and the toughest, least expensive meat comes from the muscular chest, shoulder, and rump regions. Here are the basic cuts to know about.

Rib-eye: Most chefs consider this to be the best type of steak, which comes from the center ribs of the cow and is super-tender. It can be cooked rare or medium rare. A roast from this area is called a *rib roast*.

Tenderloin and New York strip steaks: Both of these cuts come from right behind the rib area and are tender, flavorful, and pricey pieces of meat. A steak from the tenderloin area is called *filet mignon*.

Flank: Meat from this area, the cow's underside, is very flavorful, but slightly tough, so it can benefit from a marinade and definitely shouldn't be overcooked.

Sirloin: This meat, which comes from the part of the cow's loin that's just in front of the rump, isn't usually as delicious as the pricier varieties, but can still make a respectable steak, roast, or stir-fry.

Chuck or round: Chuck comes from the cow's shoulder area, and *round* refers to its rear end. Both types of meat are tough and require more cooking to soften them. Both are good ground up for burgers, chili, or stews.

David Walzog, who heads up a mini-empire of steakhouses, recommends you brush both sides of the steaks with oil but don't put any more oil in the skillet.

The Possibilities to Play With

Spread an herb butter on them: Make an herb butter (also called compound butter) in advance and have it ready to spread on the steaks right before you remove them from the heat. For how-to's, see "How to . . . Make Herb Butter" on page 88.

Make a pan sauce: Once you take the steaks out of the pan, make an easy sauce using some of the juices in the pan. Pour out most of the fat, add 1 tbs of butter

> ### How to . . . Make Herb Butter
>
> Butter mixed with herbs and other tasty stuff, which is also called *compound butter*, is super-easy to make ahead and is a brilliant thing to have on hand, since spreading some on steaks, chicken, or fish instantly gives them tons of flavor. To make it, combine 4 tbs room-temperature butter with roughly 1 tbs of any, or all, of the following, chopped into tiny pieces: parsley, chives, garlic, shallots, tarragon, olives, capers, lemon zest, or anything else you think would taste great.

over medium heat, and, when it melts, add $1/4$ cup of chopped shallots. Sauté them for a few minutes; then add 1 cup of red wine and turn the heat up until it boils rapidly. Stir the liquid and deglaze the bottom of the pan (which means scraping up the leftover bits on the bottom of the pan with a spatula to work them into the sauce). Wait until the wine is reduced by half; then add salt and pepper, and serve with the steaks.

Extra option: To make a blue cheese sauce, replace $3/4$ cup of the red wine with $1/2$ cup crumbled blue cheese and $1/4$ cup chicken broth.

Give them a pepper crust: Coarsely grind pepper until you have about $1^1/2$ tbs on a plate, and press the steaks into it, so there's about a teaspoon of pepper on each side of each steak, before cooking. Although you can get the pepper pretty coarse by setting your pepper mill at its loosest level, it's better to smash whole peppercorns by putting them in a Ziploc bag and pounding them with whatever heavy thing is handy.

Great for a Group: Broil 'em

One of the easiest ways to do steaks for a crowd (other than on an outside grill, which, chances are, you don't have) is to broil them. To keep from going broke when feeding so many people, use a somewhat less expensive cut of meat like flank steak. This just requires a little advance prep, because flank steak needs to be marinated for about an hour in advance to tenderize it. For four people, get about $1^1/2$ pounds of steak.

The fundamental formula: First, marinate the steak for at least 1 hour. One great basic marinade: $1/3$ cup oil, 2 tbs soy sauce, 1 tbs fresh lemon juice, 1 or 2

Red Meat Mandates

Take meat out of the refrigerator a half hour before you cook it. It will cook faster and more evenly that way.

"Try to buy meat that's antibiotic- and hormone-free," says Jacques Haeringer. "It tastes a lot better in the short run, and it's healthier in the long run."

When you're cooking steaks, you might want to take the battery out of your fire alarm until they're done. A decent bit of smoke can occur, and there's nothing more annoying than dealing with a wailing smoke alarm when you're right in the middle of cooking. Just place the battery in a prominent place—like next to your bed—so you remember to put it back in before you go to sleep.

"For doing steaks on the stove, you really need a cast-iron skillet," says David Walzog. "You just can't get a stainless-steel sauté pan hot enough."

chopped garlic cloves, and fresh pepper. You can also add chopped herbs, chopped scallions, or chopped chili peppers. Then, when you're ready to cook it, heat the broiler and salt and pepper the steak. Place it on the broiler tray (if you can adjust your broiler tray, place it as close as possible to the flame) for about 3 minutes on each side. Leave the broiler door open, and keep an eye on the steak to make sure it doesn't get overdone. When done, slice it into individual servings, cutting at an angle (to create more surface area) across the grain. "It's essential you remember to cut across the grain of the meat," says Paul Virant, of Chicago's Vie restaurant. "If you slice with the grain, it can be as tough as the bottom of a shoe."

Insider tip: Remember that people who like their meat rare will always eat it medium too, but people who like medium probably won't touch it rare. So when you're cooking it for a group, play it safe and make the meat medium!

How to . . . Tell When Meat Is Cooked to Perfection

Instant-read thermometers are the best way to tell when a piece of meat is done. Williams-Sonoma sells a good one that costs $12. Stick the thermometer into the thickest part of the meat. Chicken is considered done when its internal temperature is between 160 and 165 degrees. Memorize what these temperatures mean for beef:

125 = Rare
135 = Medium-rare
140 = Medium
155 = Well-done

If you don't have a thermometer, you can slice into the piece of meat and look at its center, but in doing so, you let some of the juice escape, and it's not as accurate as a thermometer.

Smart-Girl Secret: Preheat your dinner plates. It's something every restaurant does that really makes a difference. If the oven is still hot from something else, pop them in for three minutes or so. If it's not, preheat it to 200 degrees; then turn off the oven and pop the plates in. This is especially important for dinner parties.

Three Ways to Create Delish Fish Dishes

The Ultra-Simple Strategy: Steam It

This is a really healthy, really hard-to-screw-up way of cooking fish. It works best with fairly lean, mild fish like halibut, striped bass, or red snapper. Since you're not using any fat in the cooking process, steamed fish can be a bit bland, so you definitely want to try one of the variations to dress it up.

The fundamental formula: Bring about 3 cups of water to a boil and season the fish with salt and pepper; then place it in the steamer basket above the boiling water and put the lid on the pot. Lower the heat to medium, and steam it for be-

tween 5 and 10 minutes—how long it takes to cook depends on the type of fish and how thick the fillet is.

The Possibilities to Play With

Do a 15-minute marinade: Place the fish in a Ziploc bag with a mix of soy sauce, sesame oil, chopped scallions, and ground pepper, and let it sit for at least 15 minutes before steaming it.

Add a sauce: Steamed fish can be a bit bland without a sauce, so dress it up with one of the all-purpose sauces described on page 93.

A Style Guys Will Love: Pan-fry It

Cooking fish on the stove with some fat or a crust makes it heartier, enough to satisfy a hungry guy. If he's really into meat, serve him the pepper-crusted version, because it's similar to steak au poivre.

The fundamental formula: Heat 2 tbs of oil in a skillet over medium heat. Pat the fish fillets dry and place them in the pan, and cook for 2–3 minutes or until they're half cooked through. Then flip and cook for another 2 minutes. How long you sauté fish depends on the thickness of the fillet and the fat content of the fish you're working with. A thin piece of light fish might take only a couple minutes of

Making Food That Tastes Delicious

The Basic Types of Fish Explained

From a cooking perspective fish fall into three categories:

FATTY FISH: Examples are tuna, salmon, swordfish, and bluefish. These rich, hearty fish contain a higher amount of fat than other varieties (but it's the healthy kind of fat you're supposed to eat more of). And because of their natural fat content, you don't need to add much, if any, butter or oil when cooking them.

FIRM-FLESHED WHITE FISH: Examples are halibut, striped bass, monkfish, cod, and grouper. This type of fish is sturdy and works well with many cooking methods, including steaming, pan-roasting, and sautéing. Knowing when it's cooked well enough can be tricky, because it can look done on the outside and still be undercooked in the center. To ensure it's cooked through, gingerly slice into it at its thickest point to see if it's opaque in the center.

THIN WHITE FISH: Examples are snapper, flounder, sole, flatfish, petrale, and sea bass. These mild-flavored fish cook quickly, so you have to be extra careful not to overcook them. Once the thinnest parts of the fillets look done—that is, opaque white and flaky—the thickest part will be done within seconds.

cooking on each side, whereas a thick piece of tuna might take as long as 5 minutes per side. You can get a sense of how much a piece of fish has cooked by looking at its sides to see how much of the middle has yet to turn opaque. If a thick piece of fish isn't cooking swiftly enough (and the other parts of your meal are already done), you can speed it up by placing a lid over it, to steam it a bit.

The Possibilities to Play With

A basic flour coating: Season 1/2 cup of flour with 1/4 tsp or so of salt and a little pepper, and spread it on a plate. Coat the fish fillets on both sides with the flour, shaking off any excess. Then cook as described above.

Make it "au poivre": Press very coarsely ground pepper onto both sides of the fish (set your pepper grinder to the coarse-grind setting, or pound whole pepper-

Two Super-Versatile Sauces

Both of these sauces work great with chicken, fish, or red meat.

ROASTED-RED-PEPPER SAUCE: Drain a 12-oz jar of roasted red peppers, and puree them in a blender with 1/4 cup white wine, 2 tbs chopped shallots, and 1 tbs or so of basil *or* parsley, *or* both. Pour the puree into a saucepan, and heat it over medium-high heat until it's reduced by half; then stir in 4 oz of butter until it melts.

CHIMICHURRI SAUCE: This parsley puree is like the Argentinean version of pesto. I've noticed it on more and more restaurant menus lately, but it's something that's really easy to do at home if you have a food processor. It can also be used as a marinade. Place one bunch of flat-leaf parsley, with most of the stems removed, and 6 cloves of garlic in a food processor and process until well chopped. Then add 3/4 cup olive oil, 1/4 cup chicken *or* vegetable broth, 1/2 tsp red pepper flakes, and a little salt and pepper, and process until well pureed.

corns in a Ziploc bag by hand). This works best on tuna or swordfish because they're meaty and strong-flavored enough to stand up to the pepper.

An herb and bread crumb crust: Combine 1 cup of bread crumbs with 1 clove garlic chopped super-fine, 1/2 tsp salt, 1/4 tsp freshly ground pepper, and 1 tsp dried herbs such as rosemary, thyme, or tarragon. Beat 1 egg and dip each piece of fish in it, coating both sides; then dredge them in the bread-crumb mixture and cook right away.

Great for a Group: Fish Baked in Foil

This is a super-easy way to cook fish—it's sort of like steaming, sort of like baking. It saves you a step and cuts down on cleanup, because you're making the sauce in the foil packet at the same time you're cooking the fish. It's also handy for entertaining, because the packets keep the fish warm until you get it to the table and everyone is ready to eat. (Few things are more gut-wrenching than when guests chatter away and delay digging in, and you can just feel the food losing heat by the second.)

The best fish for this is a firm white fish such as halibut, red snapper, bass, or cod. Serves four.

The fundamental formula: Preheat the oven to 425 degrees. Lay out four 12-inch squares of aluminum foil, place a 5- or 6-oz fillet in the middle of each, drizzle them with a bit of olive oil, and season them with salt and pepper. Add whatever flavorful herbs and veggies you want to cook with the fish (suggestions follow). Then fold all the sides of the foil together over the fish, leaving an air bubble in between the fish and the top of the foil (which should look like a tent). Place the packets on a baking sheet, and bake the fish for between 15 and 25 minutes, depending on how thick it is. Then carefully remove the fish from the packets and drizzle the contents of each packet over the fish.

The Possibilities to Play With

Do a butter-and-herb sauce: Mix together 2 large chopped shallots, 1/2 cup coarsely chopped flat-leaf parsley, 3 tbs chopped capers, 1 tbs chopped fresh tarragon (or 1 tsp dried), and 1 stick of melted butter. Divide the mixture evenly between the four fish packets.

Make it Italian-style: Mix together 3 minced garlic cloves, 2 cups chopped tomatoes (with seeds and juice removed), 1 cup finely chopped bell pepper, 1/2 cup chopped black olives, and 4 tbs olive oil. Divide the mixture evenly between the four fish packets. Serve topped with a dollop of pesto if you'd like.

Do an Asian-inspired version: Mix 4 chopped scallions (white and pale green parts only), 1/4 cup minced ginger, and 1 cup each of thinly sliced carrots and red bell peppers, with 4 tbs of sesame oil and 1 cup dry white wine or sake. Divide the mixture evenly between the four fish packets. Serve topped with chopped cilantro.

Eight Simple, Scrumptious Pasta Sauces

Pasta is one of the easiest things out there to do and was one of the first things many of us ever learned to cook for ourselves. I lived on it for much of college, since it's so cheap and hard to screw up. But just because you've been making it forever doesn't mean you can't learn to do it much better. The most important step in making more delicious pasta is to make your own sauces. Sure, some store-bought varieties are pretty good, but the freshness of something you make yourself can't be beat. These are the most dead-easy DIY sauces out there. (All of these recipes make enough sauce for a pound of pasta.)

Essential Fish Tips

As a general guideline, cook a fish fillet for about **10** minutes per inch of thickness at its thickest part. (So, **5** minutes if it's $^1/_2$-inch thick, **15** if it's $1^1/_2$ inches thick.)

You really don't want to overcook fish, or it will taste rubbery. When in doubt, err on the side of taking it away from the heat too soon. It will keep cooking for a while after it's removed from the heat.

Fish is done when it is opaque and just begins to flake apart when nudged with a fork. The juices (unlike with chicken) should be a bit white.

Skim your hands over the top of raw fish fillets to see if there are any remaining bones; then use tweezers to remove the bones once the fish is cooked. This is especially important when you're entertaining others, because bones can freak people out. Also, they're dangerous, because people can choke on them. If you're hosting and notice there's one piece of fish with a lot of bones, serve it to yourself and look out for them when eating.

Remove fish from the refrigerator **20** minutes before cooking.

Don't season fish with salt and pepper until right before you're going to cook it, otherwise the juices can get sucked out of it.

When shopping for just two servings of filleted fish, try to get a center-cut fillet. They're thicker and more even in width, and therefore easier to cook evenly than those from the tail.

All About Herbs

Some herbs require a lot of cooking to bring out their flavors; others quickly wilt under heat and should only be added right before a dish is served.

Many fresh herbs are really dirty—be sure to rinse them well (or soak them for a few minutes) to get them clean. Otherwise they could add a gross, grainy quality to whatever you use them in.

Herbs should be totally dry when you chop them into small pieces, or else they will become more like a gooey mass. After rinsing them, dry them with paper towels or spin them in a salad spinner.

While there's a contraption called an herb mill specifically made for chopping herbs, I find it easiest to just chop them with a large chef's knife or snip them into bits with kitchen scissors.

To keep herbs fresh in the fridge, treat them like flowers—cut the ends and place them in a glass of water, and trim the ends again two days later. Treated this way, flat-leaf parsley and cilantro should last for a week, though other herbs, like dill, usually only stay fresh three to five days at most.

Since you can't always get fresh herbs, it makes sense to freeze them when you do have them (since you usually have to buy them in batches that are larger than you need).

If you must use dried herbs, be sure to replace them every six months at least. Any longer than that and they start to taste like dirt.

Basic Tomato Sauce

Heat 2 tbs olive oil in a large, deep skillet over medium heat, and add ½ onion, chopped, and 2 minced cloves garlic. Cook for a couple minutes. Crush up the contents of one 28-oz can of whole plum tomatoes, and add them to the skillet. Cook for 10–12 minutes, stirring occasionally, until the mixture thickens and becomes saucelike. Add salt and pepper, and stir in some chopped fresh basil.

Simple Garlic-and-Wine Sauce

You can quickly make this sauce in the same pot you poured the pasta out of; just add a little oil to the pasta so it doesn't stick together while you make the sauce. Heat 2 tbs of olive oil in the pot or a skillet; then sauté 4 cloves chopped garlic and 3 tbs diced red onion for a couple minutes. Add ¼ cup white wine, and reduce it over medium-high heat for 3–4 minutes. Add salt and pepper, carefully stir in pasta, and fold in ¼ cup finely chopped parsley; then turn off the heat. Sprinkle fresh Parmesan cheese or toasted pine nuts over the pasta once it's plated.

Lemon, Butter, and Parm

In a skillet heat 3 tbs of butter, 3 tbs of olive oil, and ¼ cup fresh lemon zest (it will take about 4 lemons to get this much) over medium heat for 1–2 minutes. Combine this with the hot pasta and ¼ cup fresh lemon juice; then add ½ cup freshly grated Parmesan cheese. Serve with freshly ground pepper.

Alfredo

This classic sauce is so easy—and pretty cheap to make at home. (Yes, it's super-fattening, but that's okay on occasion.) Heat 1 cup of heavy whipping cream in a saucepan over medium-low heat and reduce it. (To find out when it's ready, use this trick from Jacques Haeringer: Quickly dip a spoon in the cream and then run your finger across the back of the spoon—if the line through the cream holds, rather than the two sides just running back together, then it's done.) Stir in ¼ cup grated Parmesan until it's melted, add salt and pepper, and serve. To give pasta alfredo a little color and extra nutrients, throw in ½ cup chopped raw tomatoes.

Goat Cheese

Take **6** oz of soft goat cheese, crumble it in a bowl, and thin it out with a little water. Just mix it through the hot pasta and add $^1/2$ cup toasted pine nuts or walnuts. Top with fresh basil.

Raw-Tomato-and-Gorgonzola Sauce

I learned about this combo from my friend Catherine, because a native Italian guy made it for her on a date once. You just chop up about four fresh tomatoes and combine them with a cup of blue cheese in a pasta bowl. When you add the hot drained pasta to them, the cheese melts all over the pasta and the tomatoes are warmed up. It's as delicious as it is easy.

Primavera

Cut up veggies like asparagus tips, red peppers, shredded carrot, and pieces of zucchini and sauté them in a bit of olive oil. Put a lid on for a few minutes to steam them. Then sauté them a bit more. Add fresh basil at the end, along with plenty of grated Parmesan.

Pesto

Most gourmet stores have great premade pesto, so there's no pressing need to make it yourself. But like most things, it does taste extra-delish if you do it with great ingredients right before you serve it. It does require a food processor (big or mini) to do it right, though. *The recipe:* Place **3** cups of fresh basil leaves, 1 clove minced garlic, $^1/4$ cup pine nuts, $^1/4$ cup extra-virgin olive oil, and $^1/2$ cup grated Parmesan in a food processor and process, gradually adding another $^1/8$–$^1/4$ cup of oil, as needed, until you achieve the consistency you like. Only use the minimum amount of oil you need to get a good consistency; too much oil will make the pesto bland. Add salt to taste, and adjust the flavor by adding more of whatever ingredient you think it lacks. You can substitute Italian parsley for some of the basil and use walnuts instead of pine nuts—walnuts are cheaper than pine nuts and healthier too.

Pointers for Perfect Pasta

1 pound of pasta = about 4 medium-sized servings or 2 large ones

Salt the water once it is boiling—if you salt it earlier, it will increase the time it takes the water to boil.

Don't put the pasta in the water until it is at a full, rapid boil. If it stops boiling once you put in the pasta, put a lid on the pot for a few minutes until it's boiling again—just don't let it boil over.

How to tell when pasta is done: You don't want it too soft, so check it a minute before the time listed on the box is up.

If you're going to serve pasta right away, don't rinse it after you drain it. But if you're going to be serving it later and reheating it, or making a pasta salad, rinse it with cold water, or else it will stick together.

When using dried pasta, always buy a brand made in Italy—DeCecco and Barilla are two favorite brands of chefs.

If you're going to make it ahead and serve it later, reheat it by putting it in hot (but not boiling) water for a few minutes, and then drain it again.

Pasta cools down pretty quickly, so if the sauce you're using isn't hot off the stove (as in the case of the raw-tomato/blue-cheese sauce), you should heat the bowls or plates you're going to serve the pasta on. Preheat the oven to 200 degrees and then put the plates or bowls in for about five minutes before putting the pasta in them.

Good, fresh-grated cheese is key to a great pasta dish, and it's worth spending a bit more for it. Look for true Italian Parmigiano-Reggiano (shakers of powdery "Parm" belong only in pizza parlors).

Picking the Right Pasta for the Sauce

Long, thin pasta works best with runny sauces that will coat every part of it. Short pasta shapes work well with chunky sauces. I particularly like fusilli, the spirals, and farfalle, the bow-tie shape, because they hold bits of sauce so well. Radiatore are great for pesto because they have lots of little crevices the sauce clings to. Few things are as frustrating as a delicious sauce that slides right off a piece of pasta before you can get it to your mouth.

Two Essential Egg Dishes

Like pasta, egg-based dishes are inexpensive and hard to screw up. The classics to master:

Omelets

If you're committed to making more of your dinners at home, omelets are a great solution. I know you associate them with breakfast and lunch, but with a green salad and a glass of rosé, they can make a really nice little weeknight dinner too. They've got the fact that they're quick, cheap, and protein-packed going for them, and they can taste all sorts of ways depending on what's in them. Making an omelet is the simplest thing to do once you know how, though it took me a while to get it right. The only thing that might hinder you is that you must have the right-sized skillet: A three-egg omelet, which is sort of standard, requires an 8-inch nonstick skillet.

The fundamental formula: Whisk 3 eggs together and season with salt and pepper; then add a bit of water, a little less than 1 tbs. Heat 1 tbs of oil in an 8-inch nonstick skillet over medium-high heat; then reduce the heat and pour in the eggs. Don't touch the eggs for a few seconds, to let them set; then use a spatula to pull the omelet's edges away from the skillet, and tilt the skillet so the uncooked eggs move toward the edges of the pan. Repeat until the center of the omelet is cooked and there's no more runny egg to swirl around. Sprinkle the filling evenly over the omelet, leaving a bit of space between the filling and the edges. Cook for another 20 seconds or so; then fold the omelet in half and remove it to a plate.

Excellent omelet fillings: 3 tbs of any chopped cooked veggie; 3 tbs of good-flavored cheese, chopped green onion, chopped chives, chopped ham, or chopped bacon.

Pitfall to avoid: Don't use chilly, straight-from-the-fridge eggs. Omelets are fluffier and other recipes just work better if the eggs are room temperature. (This is even more true in baking.) To warm up eggs quickly, fill a glass bowl with hot water—not boiling, but very warm water from the tap. Set the eggs in the bowl for five minutes before you use them.

Quiche

Quiche has such a boring reputation, but it's undeserved. I think this is one of the most underappreciated meal options out there. You can throw all sorts of things in them, which makes for a great way to clean out the fridge; plus they're pretty cheap, and leftover quiche tastes great the next day and even the next. Keep a few frozen pie crusts on hand so you can pull together a quiche on short notice.

The fundamental formula: Preheat the oven to 375 degrees. Heat about 2 tbs of oil in a skillet over medium heat and sauté any veggies you want to use. (Some good options are listed after this.) In a bowl, beat together 4 eggs, 1 cup grated cheese, 1/2 cup whole milk *or* low-fat cottage cheese, 1 tsp salt, and 1 tsp pepper. Add the veggies to the egg mixture and mix well. Prebake frozen pie crust in the oven for about 5 minutes; then spread the egg mixture into it. Bake for 40 minutes or until egg is set. Makes 4–6 servings.

Your options: As for which veggies to include, onions are a great basic, since they add flavor, and beyond that, you can add spinach, chopped red bell pepper, sliced mushrooms, chopped up asparagus, and sliced leeks. Use about 1 cup of sautéed veggies for the recipe above. You can use whatever cheese you want, with the exception of a fresh mozzarella or any other really watery cheese.

Insider Tip: To keep your eyes from watering when cutting up onions, try lighting a candle right next to your workspace. Also, cold onions are less likely to turn on your waterworks than room-temperature ones, so chill them for ten minutes or so before you start slicing.

Ten Simple Vegetarian-Friendly Side Dishes

All these recipes make 4 servings as side dishes, but you can make any two of them and have a great vegetarian dinner for two (whether you're a vegetarian or just

want a meat-free dinner). I picked these ten because, even though they're simple, they're elegant and scrumptious enough to serve to guests.

Roasted Stuffed Tomatoes

Stuffed tomatoes make a perfect side dish to pretty much any meal, and two or three can make a great light meal by themselves. You can stuff them with just about anything, but two easy options are sautéed spinach or sautéed mushrooms. It's hard to say how much stuffing you'll need, because it will depend on the size of your tomatoes. Even if you overstuff them or understuff them, they'll still taste great (assuming they're quality tomatoes—more on that in the box on the next page). Just drain either of these veggies and mix them with bread crumbs and a little cheese before stuffing the tomatoes with the mixture.

Preheat the oven to 400 degrees. Slice each tomato in half and scoop out the seeds; then stuff them with a bread-crumb-veggie mixture. Put them in the oven and bake for 15 minutes; then sprinkle with cheese and bake for another minute or so.

Sautéed Spinach

The thing to know about spinach is that it reduces to nothing when cooked, because when it releases its water, it shrinks right up. The first time I made sautéed spinach as a side dish at a dinner party, I realized once I cooked it that I didn't have enough, so I didn't serve myself any and hoped nobody would notice (someone did, and insisted I take some of hers, which was embarrassing). As a general rule, 1 pound of fresh spinach = about 1½ cups cooked spinach. Use baby spinach, if you can find it, to save yourself the time of having to cut up big spinach leaves.

The fundamental formula: Heat 1½ tbs of olive oil and sauté 3 or 4 cloves-worth of chopped garlic (depending on how garlicky you want it) for just 1 minute. Add 1½ pounds of spinach leaves, along with a fair bit of salt and a few twists from the pepper mill. Stir continuously, using a wooden spoon, for about 3 minutes, until the spinach is wilted. If the spinach starts to dry out while you're sautéing it, add a little water to the pan. Finally, add a few squeezes of lemon and another pinch of salt and serve right away.

Extra options: Though spinach is standard and so healthy, you can prepare pretty much any leafy green this way—try collard greens, beet greens, or mustard greens to mix it up.

Insider tip: Lemon juice can make spinach turn a bit brownish, so if you're

Tomato Tips

When choosing tomatoes, look for ones that are firm but give slightly when you press on them.

Vine-ripened tomatoes, preferably ones that are locally grown, are the way to go. Most other tomatoes are picked when green and then artificially ripened using chemicals. Those that have ripened naturally on the vine taste way better, but they are more perishable, so you have to use them soon after you buy them. As Edward Lee says, "If you buy a tomato and it still looks good in three days, it's not a good tomato."

If you can't find great fresh tomatoes for a recipe, canned plum tomatoes may be a better choice. They have more flavor than many fresh tomatoes. Plum tomatoes are often the best choice for cooking, because they contain less liquid than other tomatoes.

Never refrigerate tomatoes.

To peel a tomato, very lightly cut an X mark at both ends of it, plunge it into boiling water for just 15 seconds, and then remove it and place it in a bowl of ice water. You should then be able to easily peel off the skin, starting at the X marks.

Serrated knives tend to work best for slicing tomatoes. They just glide through the taut skin without making juice fly everywhere, as it can when a regular knife pierces the skin. There's a type of knife called a *tomato knife* that's small and serrated, but you can use a big serrated bread knife instead—it's a little unwieldy, but it works.

When you're cooking with fresh tomatoes, you usually want to remove all the seeds and juice and use just the flesh. The inner parts can add too much liquid to whatever you're cooking.

> "I'm a huge believer in farmers' markets and buying whatever's fresh. It's more fun to cook that way, and it usually tastes better too."
>
> —*Maire O'Keefe*, owner of Thyme Catering in Los Angeles

really into it looking bright green on the plate, you might want to skip the lemon or just serve it with lemon wedges.

Colorful Veggie Sauté

Place 1/4 pound of thin green beans in a metal pasta colander or steamer basket; then bring enough salted water to cover them to boil in a saucepan. Dunk them in the boiling water for 2 minutes; then drain them and set them aside. Take about 2 cups of carrots that have been peeled and sliced so they're about the size of the green beans and boil them for 1 minute; then drain them and set aside. Take 1 medium zucchini and cut it into strips that are about the same size as the green beans and carrots, cut one red pepper into strips that are half that width, and thinly slice half a red onion. Then place 1 tbs butter and 1 tbs oil in a skillet over medium heat and sauté the onion for about 5 minutes or until it's browned a bit. Add the rest of the veggies and sauté for 3–4 minutes. Add salt and pepper and a few squeezes of lemon juice. Sprinkle chopped fresh parsley on top if you'd like.

Broccoli-and-Cauliflower Gratin

Roasting veggies with some bread crumbs and cheese is an easy way to make them more scrumptious and indulgent.

Preheat the oven to 400 degrees and butter a 9 × 9-inch baking pan (an 8 × 8 would work too). Bring enough salted water to cover 3 cups of broccoli florets and 3 cups of cauliflower florets to a boil and boil them for about 3 minutes; then drain them. Heat 1½ tbs oil in a skillet and add 2 minced garlic cloves for about 1 minute; then take it off the heat and add the broccoli and cauliflower and 3/4 cup of grated cheese, and mix it all together. In a bowl, mix 3/4 cup of bread crumbs with 1 tbs olive oil, and add salt and pepper. Spread the veggies in the baking dish and top them with another 3/4 cup of grated cheese and the bread crumb mixture. Bake in the oven for 11–13 minutes, or until the crumbs are toasted looking.

Crispy Brussels Sprouts

If you're still frightened by brussels sprouts because of a traumatic childhood encounter with them, it's time you give them a second chance. Done right, they're really delicious and have a wonderful crunchy texture. Try to find baby brussels sprouts, which are really tender.

Cut 1 lb of brussels sprouts in half lengthwise. Heat 2 tbs oil in a large skillet; then add 2 sliced shallots and sauté them over medium-high heat for 1 or 2 minutes, until they're tender. Add the sprout halves to the skillet cut-side down, lower the heat slightly, and leave them there without touching them until they're brown and crispy on the cut sides and tender all over, about 12 to 15 minutes. Sprinkle them generously with sea salt and fresh pepper, squeeze some lemon juice over them, and serve.

Mashed Potatoes

Everybody just loves mashed potatoes, and while they do take longer than some things, they're surprisingly quick to make, especially if you leave the peels on. Plus you can make them in big batches and eat the leftovers later—to reheat them just stir in some more milk before you pop them in the microwave for a few minutes.

The fundamental formula: Take 2 lbs of Idaho or russet potatoes, cut into quarters,* and put them into a stockpot of boiling water (you should use just enough water to cover the potatoes). Cook for about 30 minutes, or until the potatoes can be easily pierced with a fork. Drain them; then heat 4 tbs of butter in the now-empty stockpot, over medium heat. Then turn off the heat, add the potatoes, and mash them. When they're well mashed, gradually stir in 1 cup of warm whole milk (you may want to use a little less or a little more, depending on what consistency you're going for). Season with salt and pepper.

Extra options:

Add garlic: Sautée 2 minced garlic cloves in the butter until they just start to brown, right before you add the potatoes back to the pot.

Add wasabi: Give this quintessentially American dish a spicy Asian vibe with wasabi powder (which you can find in the international-foods aisle of many supermarkets, at a Japanese market, or order online in the food section of Amazon.com). Just add 1 tbs of it to the milk and mix it well before adding the milk to the potatoes.

Add herbs: Stir chopped fresh flat-leaf parsley into the potatoes just after you remove them from the stove.

Insider tip: When mashing potatoes it's important that the milk you add to them be warm to keep the potatoes from clumping. Warm it slowly in a saucepan or in the microwave.

105

Making Food That Tastes Delicious

*You can peel them or leave them unpeeled—if they're unpeeled, it gives the finished dish more texture and adds fiber, which makes it a bit healthier; whereas making it with peeled potatoes will give it a creamier finish.

Roast Potatoes

This is a side dish you can't go wrong with—people will always gobble it up, and it goes great with any main dish. But there's a big difference between bland, soft roast potatoes and well-seasoned ones that are crispy on the outside, soft on the inside, which is what you want. This method gets them nice and crispy.

The fundamental formula: Preheat the oven to 400 degrees. Take 3 lbs of small potatoes and cut them into quarters, or other uniform-sized pieces. Coat them evenly with 1/4 cup olive oil, 3 tsp chopped rosemary, and 3 tsp chopped thyme, and plenty of salt and pepper. The best way to do this is to place them in a large Ziploc bag with the oil and herbs and work them around in there for a few minutes, but you can also put them in a bowl and mix them with your hands. Spread them across a 13×9-inch baking dish, making sure they're well distributed (if they're crowded together, they won't get nice and brown). Roast them for 45 minutes to 1 hour, mixing the potatoes every 10 minutes, using a spatula, so they get evenly crispy and browned and don't stick to the dish. If they're not as brown as you'd like when you take them out of the oven, place them under the broiler for a few minutes.

Extra options:

- Toss 1 cup of chopped leeks in with the potatoes about 20 minutes before you remove them from the oven.
- Add 2 chopped cloves of garlic 30 minutes before you remove the potatoes from the oven.
- Right after you remove the potatoes from the oven, mix in 3/4 cup of feta cheese and 1/2 cup of chopped flat-leaf parsley.

Couscous

Tiny spheres of pasta make absolutely the easiest side dish ever—it takes no time, is impossible to screw up, and you can add just about anything you've got on hand to it.

The fundamental formula: You don't need me to tell you this, because the instructions are on the side of every box. You just bring 1 1/4 cups of water and 2 tsp of olive oil *or* butter to a boil; then you stir in a cup of couscous, cover it, and remove it from the heat. Leave it covered for 5 minutes, and after that it will be all fluffy and ready to eat.

Extra options: Stir in one of these combinations right when you take the lid

off the finished couscous, or make your own couscous combo with whatever you've got on hand:

Grated Parmesan, chopped fresh basil, and diced tomatoes
Toasted pine nuts, dried currants or cranberries, lemon zest, and chopped flat-leaf parsley
Slivers of toasted almonds and bits of dried apricot
Feta cheese, chopped olives, and mint

White-Bean Puree

Mashed up cannellini beans are a super side for meat or fish when you want to take a break from the standard starches. And since beans are packed with protein, you can prepare it with a veggie side dish and make that your whole meal on a laid-back weeknight.

Heat $1/8$ cup olive oil in a large skillet and sauté 3 minced cloves of garlic just until the garlic is beginning to brown. Drain two 15-oz cans of cannellini beans and add them to the heated olive oil; remove from the heat and combine well. Then place the beans in a food processor, add salt to taste, and puree. If you don't have a food processor, put the beans in a bowl and mash them with a potato masher or just with a fork. If necessary, add a bit of warm water to make them creamier. The white-bean puree tastes great cold, but if you want to heat it up, just put it in a saucepan, add a tiny bit of water, and heat it for a few minutes.

Tip: This is also a fab dip for veggies or pita chips.

Creamy Polenta

I'm a huge fan of this classic Italian cornmeal dish. It's cheap, easy, and, when mixed with some cooked veggies, can be a meal in itself. *Note:* To do this speedily, you have to buy instant polenta, which has been precooked, and not plain cornmeal.

The fundamental formula: Bring $1^1/2$ cups water and $1^1/2$ cups chicken broth to a boil; then lower the heat to medium and very slowly add $3/4$ cup instant (or "quick-cooking") polenta, stirring constantly. Cook the polenta for 5 minutes, whisking it the entire time; then remove it from the heat and add $3/4$ to 1 cup grated cheese, such as Parmesan, blue cheese, or whatever you have on hand. Add 1 tbs butter, salt and pepper, and serve immediately.

Extra options: Add any cooked chopped veggie you'd like to the polenta. Either spread the veggies on top of individual servings once they're plated, or stir them through the polenta once you add the cheese.

Insider tip: If you're a vegetarian making a recipe that calls for chicken broth, use "no-chicken broth," a type of vegetable broth seasoned to taste like chicken broth. It has more flavor than regular vegetable broth.

Finally, Divine Desserts

All of these homemade desserts are perfect for a novice domestic goddess because they don't call for a lot of equipment. Most desserts require an electric mixer and a bunch of other special baking tools you may not want to have cluttering up your pad. With these recipes, you just use your regular cooking gear.

Smart-Girl Secret: Always keep a pound cake and a pint of vanilla ice cream in the freezer, so you'll have the elements of a perfect dessert on hand for last-minute guests (or whenever you deserve dessert). You can briefly toast the pound cake to make it warm and crispy, and add fruit or a sweet sauce.

Fruit Crisp

This is one of the easiest desserts ever, and everybody loves it—it's got all the flavor and comfort-food appeal of a pie, but it's infinitely easier. You can use apples (peeled and sliced), berries, peaches, pears, or a combination of them. Preheat the oven to 400 degrees and butter an 8- or 9-inch-square pan. Mix together $2/3$ cup brown sugar, 1 cup flour, and 5 tbs of butter (unsalted is best) with a fork. You can add any of the following to this mixture, but they're by no means essential: 1 tsp ground cinnamon, $1/2$ cup oatmeal ("old-fashioned," not the instant kind), and $1/4$ cup chopped nuts. Spread the fruit in the pan, and spoon the butter, flour, and sugar mixture over it. Bake for 35 minutes.

Baked Bananas

These are great paired with ice cream, whether vanilla or chocolate. Preheat the oven to 400 degrees, and butter a glass baking dish. Melt 3 tbs of butter in a skil-

let; remove it from the heat and roll 4 peeled bananas in the butter. Then cover them in 2 tbs brown sugar or 2 tbs maple syrup. (You can also add a little rum if you want to give them a kick.) Bake the bananas for 10 minutes, flipping them after the first 5 minutes.

Poached Pears

Serve this classic, elegant dessert with ice cream. Peel 4 just-ripe pears with a vegetable peeler, and, working from the bottom up, core them using a melon baller or small spoon to hollow out the center. Leave the top of each pear, with its stem, intact. Into a small saucepan that's just big enough to hold all the pears standing up, add 1 1/2 cups water, 1 cup red wine, 1/2 cup sugar, and the juice of 1/2 a lemon, and bring the mixture to a boil. Set the pears upright in the liquid, lower the heat so it's just simmering, and cover it for 15–20 minutes, or until the pears are very tender. Carefully transfer the pears to dessert bowls, and over medium-high heat, cook the sauce until it is reduced by half. Then pour it over the pears.

Lemon Custard

Lemon desserts are a safe bet for a dinner party because most people like them (but not everyone is a fan of chocolate). Coat the bottom and sides of an 8 × 8-inch baking pan with butter or cooking spray. Preheat the oven to 350 degrees. In a large bowl mix together 3 tbs flour, 1 cup sugar, and 1/2 tsp salt. Separate the whites from the yolks of 3 eggs, and place the whites in a big bowl. Remove the zest from 2 large lemons; then squeeze the juice of both lemons into another bowl and combine it with the zest, and then add 1 cup milk and 1 tbs melted butter. Add this lemon mixture and the egg yolks to the flour-sugar-salt mixture, and stir well to combine. Then, using a wire whisk, beat the egg whites until they are fluffy and you can make little peaks with them (this will take about 4 minutes of pretty vigorous whisking). Carefully fold the egg whites into the other mixture, but don't stir too much. Pour it into the pan and bake for 55 minutes. Serve with raspberries or a mini-pitcher of raspberry or strawberry sauce (see sauce recipes on pages 113–114) on the side.

Tiramisu

Everyone loves tiramisu, so I asked my friend Rosie, whose parents hail from Sicily and who's an amazing Italian cook, to give me her recipe: In a large bowl beat 5 egg yolks with 5 tbs of sugar until thick, lemon-colored, and ribbons form. Add

500 grams mascarpone cheese, and mix until thoroughly combined. Separately, beat 5 egg whites with ¼ tsp cream of tartar until they form stiff peaks. Fold egg whites into yolk mixture. One at a time, dip 12 ladyfingers in 1 cup of espresso and place them in a single layer in a square or rectangular serving dish. Sprinkle with sweet marsala wine. Cover with half the mascarpone mixture. Sprinkle with mini chocolate chips. Repeat with the other half of the mixture. Refrigerate at least 4 hours before serving.

Classic Chocolate Mousse

This is one of the simplest chocolate desserts you can make from scratch, and you can make it the day before you want to serve it, which is a bonus. In a small saucepan, combine 4 tbs granulated sugar, 2 tbs cornstarch, 1 cup water, and 2 eggs, and whisk together. Place the saucepan on the stove over medium heat, while continuing to whisk, just until the mixture comes to a boil. Then lower the heat to a simmer but continue to whisk for about 1 minute. Remove the pan from the heat and add 6 oz chopped quality chocolate (dark, milk, or a mix of the two) and 2 tbs Grand Marnier (or another liqueur of your choice), and stir until creamy. Dunk the pan in a bowl of ice-filled water and beat the mousse until it's cool. In a separate bowl, beat ½ cup heavy cream until stiff peaks form. Then gently combine it with the chocolate, and refrigerate, covered, for a least 1 hour. When you serve it, place a simple cookie or two in each bowl to add some crunch.

Chocolate Cake with Mocha-Anise Frosting

Nobody seems to make homemade birthday cakes anymore, so why not spoil a friend by baking up this gourmet one for her? Famous baker Elizabeth Falkner, owner of San Francisco's Citizen Cake, recommends this recipe.

For the Cake

Preheat the oven to 325 degrees. Although it's ideal to use an electric mixer for this, you can still do it by hand; you'll just need to give your arms a workout, because a lot of stirring is necessary to get everything smooth and well-blended. In a bowl cream 1½ sticks unsalted butter, 1½ cups brown sugar, and ½ cup regular sugar with a mixer for 2 minutes. Then add 4 eggs, one at a time, and then 4 oz melted bittersweet chocolate, and mix until smooth. Combine ½ cup whole milk and ½ cup whole plain yogurt in another bowl. Combine 1½ cups all-purpose flour, ½ cup cocoa powder, ½ tsp kosher salt, 1 tsp baking powder, and ¼ tsp

Baking Pointers from a Pro

I know very little about baking, but it seems like something a Domestic Goddess in Training should have under her belt, so I quizzed Elizabeth Falkner, the owner of the San Francisco bakery Citizen Cake, on what we need to know to get started. She gave me these key bits of wisdom.

- Baking is chemistry, and little details of how you do things will affect how the finished product tastes.

- The quality of the ingredients impacts the finished product just as much as it does with other cooking. Falkner uses organic ingredients whenever possible.

- Never use baking soda or baking powder that's been sitting on your shelf forever; replace them every six months. A key part of baking is capturing air bubbles, and baking powder or soda is essential to that. Old stuff doesn't work as well.

- The same goes for the spices—stale spices taste like dirt, so replace them every six months.

- The state of your eggs is important. The fresher the eggs, the better the cake will taste! Try to buy them from a farmers' market.

- Temperature is important—if a recipe says eggs should be room temperature, make sure they are.

- When you're mixing ingredients together, the temperatures of those ingredients shouldn't be too different. Don't add icy, straight-from-the fridge milk to room-temperature flour, for example—let the milk warm up a bit first.

(continued on the next page)

- Use a high-quality cane sugar (never beet sugar, which isn't as good). She likes an English brand called Billington's (look for it at zingermans.com and alexander-essentials.com).

- Knowing that your oven is the right temperature is essential, so buy a reliable oven thermometer.

baking soda in a third bowl. While mixing, add half the dry mixture to the creamed butter and sugar; then add the yogurt-milk mixture; then add the rest of the dry mixture, and keep mixing until smooth. Line the bottoms of two 9-inch round cake pans with parchment paper (which prevents baked goods from sticking to pans, and can be found at any supermarket), and spoon the batter into them. Bake for 20 minutes; then remove and let cool completely.

For the Frosting

Heat $1/4$ cup plus 1 tbs brewed coffee and $1/2$ cup cocoa powder in a small saucepan over low heat, stirring constantly until it's smooth and shiny; then remove from heat and set aside. In a bowl cream 3 sticks unsalted butter, $1/3$ cup powdered sugar, and the zest of 1 lemon. Stir in 8 oz melted bittersweet chocolate, 1 tsp kosher salt, and 2 tsp vanilla extract. Stir in the cocoa mixture; then while gently beating the mixture, slowly add $3\,2/3$ cups powdered sugar and 1 tbs of Pernod (or sambuca or ouzo). Once the cake sections have cooled completely, frost the top of one and lay the other on top of it. Then frost the top and sides of the cake. Garnish it with chocolate shards or shavings.

One Final Bit of Cooking Wisdom . . .

I asked chef Kerry Simon, of Simon Kitchen in Las Vegas's Hard Rock Hotel, what the most important thing is for kitchen novices to know about food, and he gave me this priceless piece of advice: "When in doubt, finish any dish with a few squeezes of lemon juice, a drizzle of good olive oil, some chopped fresh parsley, and maybe a little salt and pepper, and it's almost guaranteed to taste great."

Four Versatile Sweet Sauces

You can "create" a whole homemade dessert just by making a sauce and drizzling it over ice cream, store-bought pound cake, or one of the fruit desserts listed earlier. Commit these four sweet sauces to memory and you'll never be at a loss for elegant dessert options.

CARAMEL SAUCE: Heat 1 1/2 cups sugar and 1/4 cup water in a heavy medium-sized saucepan over low heat, and stir until sugar dissolves. Increase the heat to medium-high and let the mixture boil undisturbed until the syrup is a rich brown color (which should take about 7 minutes). Remove the pan from the heat and add 1 cup whipping cream (the mixture will bubble when you add the cream). Return the pan to the burner and set it to low heat, and stir mixture until any hardened bits of caramel dissolve. Add 2 tbs butter, and stir gently until smooth. This can be made one day ahead and chilled.

STRAWBERRY SAUCE: Hull a pint of strawberries and puree them with 3 tbs sugar in a blender or food processor. If the mixture is too thick, add a little water to thin it out. This makes about 4 servings, and can be made twenty-four hours ahead of serving.

Extra options: To make the sauce smoother, pour it through a sieve before serving.

Add 1/4 cup coarsely chopped mint leaves to the sauce.

If you can't find good fresh strawberries, use frozen.

This can alternately be made with a mix of strawberries and other berries.

CHOCOLATE SAUCE: Finely chop 14 oz quality sweetened chocolate (milk, bittersweet, or dark—it's up to you), and place it in a large glass bowl. Bring 2 cups of cream to a boil; then pour the hot cream over the chocolate, gently whisking it until it's smooth. Serve it warm or put it in the refrigerator for up to one week.

Extra options: Add 4 oz Kahlúa, Grand Marnier, or another liqueur right at the end.

(continued on the next page)

Making Food That Tastes Delicious

DULCE DE LECHE: This classic Latin American sauce is beyond delicious, and sugar-fiends go crazy for it. Since it's a bit more exotic than regular caramel, it can impress dinner guests, even though it's just as easy to make. Combine 1 cup whipping cream and 1 cup dark brown sugar in a medium-sized saucepan, and stir over medium heat until the sugar dissolves. Boil for about 5 minutes, stirring occasionally (it should reduce to about a cup of liquid). Then stir in $1/2$ cup sweetened condensed milk until well blended. The sauce can be made a day in advance, covered, and kept in the fridge.

Shopping Guide

These are the best sources for great kitchen gear, table settings, and gourmet ingredients.

Cooking and Tabletop Shops

A lot of the big furniture sources listed in the Shopping Guide at the end of chapter 1 sell items for the tabletop and cookware as well, but these are some sources that specialize in it:

ACE MART RESTAURANT SUPPLY, ACEMART.COM: This site is really geared toward restaurant owners, but you can access stuff for all your personal food-prep needs here too.

BOWERY KITCHEN SUPPLY, BOWERYKITCHENS.COM: A great source for your cooking and bartending needs—all the essential tools are here, at prices that are close to wholesale.

JOANNE HUDSON, JOANNEHUDSON.COM: Cute, country-style tableware and serving pieces, tea towels, and cooking utensils.

MICHAEL C. FINA, MICHAELCFINA.COM: Though this New York store may be best known for its wedding registry, single girls should get to know

Priceless Advice from the Previous Generations

"The best way to wash chicken is to use vinegar and lemon juice, and then rinse with cold water. It gets the chicken cleaner than water alone, and makes it tender and ready to absorb seasoning."—VIOLA, 78, DAVIE, FLORIDA

"My grandmother taught me that the most important meal to learn how to make is soup. It can last for a long time in the refrigerator, you can use scraps to make it, and it's filling and nutritious." —GALINA, 64, QUEENS, NEW YORK

"The dishes my family enjoyed the most, like homemade ravioli, required a lot of time and effort, so I would always cook in large batches and freeze portions for later use. Using this method makes complex dishes well worth the effort because you're creating numerous meals at one time."
—KATHERINE, 93, PLEASANT HILL, CALIFORNIA

"When you have a small amount of wine left over in a bottle, you can freeze it to use in cooking later." —NORMA, 62, ANN ARBOR, MICHIGAN

"Never use paper plates. No matter what you're serving—even if it's hot dogs. Don't be fooled by 'fancy' paper plates. They're still ugly and ruin whatever you're serving. They make a nice meal look cheap. And if you serve hot dogs on real dishes, you make the meal look better."
—ANNAMARIA, 69, BROOKLYN, NEW YORK

their site. There's no reason you should wait for a ring to start acquiring stylish tableware, and Michael C. Fina has an amazing selection of flatware, china, glassware, and table accessories (both formal and everyday), at prices that are always less than what department stores charge for the same brands and items.

SUR LA TABLE, SURLATABLE.COM: Tons of tableware, cooking equipment, bartending tools, and gourmet ingredients.

WILLIAMS-SONOMA, WILLIAMS-SONOMA.COM: Everybody knows this one—they've got pretty much everything you'd ever need to prepare or serve food with. However, many of the basic tools they sell can be found for less dough at restaurant-supply stores.

For Gourmet or Hard-to-Find Food

There's nothing more frustrating than picking a recipe and then getting to the store and realizing they don't stock a key ingredient. But now that a girl's got the Internet at her disposal, you can find the fixings for even the most exotic recipes— it just requires a little advance ordering. Here are some of the best sources for fancy or exotic ingredients.

AMAZON.COM: They've recently added a huge selection of food. It's a great place to locate exotic or ethnic ingredients like wasabi powder and walnut oil, usually at prices that are lower than those of gourmet sites.

THE CHEF'S RESOURCE, CHEFSRESOURCE.COM: This site is stocked with lots of gourmet condiments and snacks, in addition to kitchen supplies.

DEAN AND DELUCA, DEANANDDELUCA.COM: Indulgences including cheese, chocolates, high-quality coffee, and caviar can all be found here (though definitely not at any sort of discount), and they also sell practical items like oils and spices that can be hard to find elsewhere.

ZINGERMAN'S, ZINGERMANS.COM: This might be the best online source for foodies who are obsessed with quality. It's got an incredible selection of olive oils, vinegars, specialty dairy products, artisanal cheeses, and other key ingredients. Plus, it has tons of helpful editorial to help you decide what to buy.

Wine and Booze Basics

3

HOW TO PICK WINE WITH CONFIDENCE AND MIX COCKTAILS THAT HIT THE SPOT

When I moved into my first post-college apartment, my room-mates and I decided it was time to stop guzzling the cheap beer and bracingly stiff cocktails of our college days and graduate to wine. So we would buy big magnums of a Chilean red called Concha y Toro, to the tune of about $7 a bottle, and guzzle it greedily from water glasses, coffee mugs, or whatever drinking implement wasn't stacked in the sink. (We did buy four real wineglasses when we first moved into the apartment, but they were quickly shattered during Concha y Toro–fueled revelry.) Sitting around our cramped apartment throwing back cheap Chilean red wasn't a very sophisticated way to spend our first post-college year, but it still felt much more grown-up than it would have if we'd been drinking cans of Coors Light.

What you drink and how you drink it doesn't say anything about your inner self, but it does make a style statement, affecting how others see you and how you see yourself. So if you're aiming to see yourself as more of a grown-up, it's time to start drinking like one. Grown-ups, in theory anyway, drink to unwind, to connect with friends, and to really enjoy what they're drinking (not to get blind drunk). Now that you've left behind the frat-party, kamikaze-shot era of your life, you need to learn how to really savor a drink.

The secret to this lies in picking the right drink for the moment—whether having an early evening cocktail with a friend, or a late-night tipple with a new guy you

hope to still be with at breakfast—and, if you're eating as well, one that perfectly complements the food. When you're committed to kicking your cooking abilities up a few notches, it's wise to brush up your wine-selecting skills as well, since the right bottle can make your food taste even more delicious—and the wrong bottle can sabotage the fruits of your culinary labor. And when you're entertaining, you gotta know how to keep satisfying cold drinks in your guests' hands at all times.

Now, compared to other areas of domestic life, pouring wine and mixing drinks, whether for guests or just yourself, is probably the one you have the most experience with. You've been fixing drinks at home since your dorm-room days. But chances are you still don't know all that much about it, and now that you're going to be wining and dining and entertaining in your home, you need to get educated on the subject.

So here's a little tutorial on selecting and serving. I've devoted the most space to wine, because that's definitely the most mysterious and intimidating type of booze, but I also tracked down some top cocktail experts to share their wisdom on mixing up the hard stuff.

All You Really Need to Know About Wine

Being able to buy and serve wine with confidence is essential to feeling like the grown-up, awesome hostess you're now going to be. Even though most of us girls have drunk gallons and gallons of the stuff over the course of our legal drinking years, we tend to get totally freaked when faced with selecting it at a wine store. For years, I was overwhelmed by the options and insecure in my ability to decipher the labels, so I'd just seek out the California section and pick a bottle of one of the same brands I'd bought a hundred times before—not because I was in love with it, but just because it felt safe and I knew it wouldn't embarrass me.

But it shouldn't be like that. If you're a regular wine drinker, you should know enough about the wine grape to really appreciate it, know which wines you really like the most, and understand why you like them so much. It's not hard to get to this point. It just takes a little totally enjoyable homework—buying and drinking more wines, and really paying attention to what each one tastes like and how you feel about it. Kristin Moses, the thirty-one-year-old marketing and public relations director of Kluge Estate Winery and Vineyard, went from being totally clue-

less to being a total expert in a matter of a few months after she got her job in the industry. She swears it's not hard to master it, even if you're not lucky enough to be employed by a vineyard. "Once you start really paying attention," she says, "it's surprising how quickly the whole subject gets demystified and you understand what you like and start to form opinions on it."

And even if wine isn't your favorite tipple, selecting it and serving it with some degree of expertise is essential to being a good hostess. Finally, a damn good reason to educate yourself about wine is your wallet—drinking it at home is between 50 and 80 percent cheaper than drinking it in a restaurant or bar.

Before we get started, I need to point out that this is just a humble primer—there's lots, lots more to know about wine if you're really interested, and there are Bible-sized books devoted exclusively to the subject. But if your goal for now isn't to start a collection of vintage Bordeaux, but is to simply help yourself enjoy wine more and help dinner guests do the same—then the info I've compiled here is all you need to achieve that. And the most important thing you need to memorize about wine is this: A good wine is one you like to drink, period. There are no rights and wrongs, and absolutely no reason for wine selection to be scary. After learning the guidelines here, you'll know what you need to choose wine with confidence, and let your taste buds teach you the rest.

> "It used to be that choosing wine was a man's job, but now that women have careers and are staying single longer, it's a handicap if they don't know about wine. They need to develop taste in wine that matches their sophisticated tastes in other areas, so they can entertain with it and simply enjoy it themselves."
>
> —Cecile Roesch-Giannangeli, owner of Finewine.com

The Wine-Tasting Ritual

At any wine-tasting course they tell you to follow these five basic steps of your first sip: Examine the color, then swirl the wine in the glass, smell it, swish a sip around in your mouth, and then, finally, swallow it. While the color thing isn't really essential to your experience of it, the swirling, smelling, and swishing steps really are—at least for the first sip you take.

To swirl, keep the wineglass on the table and your hand on the base of it with

the stem in between two of your fingers. Then swiftly move the glass around in little circles while keeping the base flat against the table. The wine will swirl up and coat the sides of the glass, but because it's steady on the table, you won't risk it splashing out. I used to think this was a silly affectation—when I was fresh out of college and on a first date with an older guy, he made a big deal out of swirling around the wine before dramatically smelling and tasting it, and I immediately wrote him off as too ridiculous to merit a second date. But I later realized it's actually an important step in the process. Moving the wine around so that it sticks to the sides of the glass increases the amount of wine exposed to air, which really brings out its aroma.

So next you hold the glass up to your nose and inhale. Smelling a wine is also a key part of appreciating it. Scientists estimate that 70 percent of what we perceive as taste is actually smell. Your nose can pick up all sorts of nuances of its flavor, and amps up your anticipation of the drinking to come.

When you finally drink it, don't gulp it down. The first time you raise the glass to your lips, swish the wine around and let it coat the inside of your mouth. Since different parts of the tongue perceive different tastes, you need to make sure your tongue is well covered with the wine or you might miss out on some elements of it. Pay attention to the aftertaste—if it's a good wine, it will linger in your mouth after you swallow. The following are the different factors to evaluate when tasting wine:

Body: Essentially *body* means how rich or heavy a wine is. For example, a Chardonnay is more full-bodied than a Pinot Grigio, and typically Pinot Noirs are lighter-bodied compared to Cabernets.

Fruitiness: This is, obviously, the degree to which strong fruit flavors are present in a wine. When you're smelling one for the first time, try to pick out the different types of fruit present in its aroma.

Acidity: Acidity enhances the flavor of a wine, the same way a squeeze of lemon can play up the characteristics of whatever food you put it on. A balance of fruit and acid is considered a key characteristic of a good wine.

Tannin: This is the slightly bitter quality, mostly present in red wines, that makes your lips pucker a bit—they say you feel it in the center of your tongue. It comes from the skins of the grapes, which are what give red wines their color as well; so reds are generally more tannic than whites. Tannins aren't a bad thing, in fact expensive quality reds usually have more of them than cheap ones, but if there's too much tannin, it can overwhelm your palate and prevent you from tasting any fruitiness in the wine, making the wine taste a bit flavorless as a result.

Oak: *Oakiness* describes the quality wines get when they're fermented or aged in oak barrels. It's often described as making them taste creamy, toasty, or buttery. The presence of oak is much more noticeable in a white wine.

Wine 101: The Grapes

The first, most important way to get educated about wines is to gain an understanding of the wine grape. Different types of grapes are called "grape varietals." What's confusing is that many wines—most of those from the U.S. and Australia, for example—list the main grape used to make them prominently on the label, whereas other wines—like most of those from Europe—broadcast the region they're from but not the grapes that go into them. You're just supposed to know that a white wine labeled Pouilly-Fuissé is from the Burgundy region of France, and that all white wines from Burgundy are made of the Chardonnay grape.

But first let's ignore those issues and focus on understanding the characteristics of the different grapes. Here is a list of the key ones to know about—how they typically taste, where they're most often grown, and the reputation they have. Ulti-

mately, how they taste—and whether you like that taste—is what matters, but you may as well know what people usually think of them.

White Wine Grapes

The Big Three

Chardonnay: You already know Chardonnay wine well, or at least you think you do. Some of the words used to describe it are *buttery, nutty, creamy,* and *vanilla*. Of the three major white grapes, it makes the most full-bodied wine, which typically has a high alcohol content and low acidity. But there's a lot of variety among Chardonnays, depending on where the grapes are grown and the style of the winemaker. Some Chardonnays are aged for a long time in oak barrels, which gives them more of a heavy, buttery taste (which wine people refer to as "heavily oaked"). This style is common in California Chardonnays. Other winemakers age their Chardonnays in oak for less time, or not at all, so the resulting wines have a lighter, less robust taste. Chardonnay grapes are grown all over but are most often associated with California and the Burgundy region of France.

Riesling: Its wines are delicate, subtly fruity, and often, though not always, somewhat sweet. Riesling is associated with Germany, where most of the big-deal wines are made with it. The wine has a lower alcohol content than Sauvignon Blanc and Chardonnay.

Sauvignon Blanc: This grape makes a crisp, dry wine often referred to as "steely" or "flinty." It's usually fairly acidic and often has sort of a grassy taste. Some of the regions known for producing it are France's Loire Valley, New Zealand, and California (where it is sometimes called *Fumé Blanc*).

Other White Wine Grapes to Get to Know

Chenin Blanc: This grape is high in acid and tends to be on the sweet side. It's used a lot in wines of the Loire Valley and South Africa.

Gewürztraminer: This German varietal is full of flavor—its wines usually have a spicy quality and flavors of peach and apricot. In my experience people tend to love them or loathe them. I'm in the first category, but people who are freaked out by any sort of sweet wine can turn up their noses at Gewürztraminer. Even though they are generally quite dry, all that fruitiness makes them seem sweet.

Muscat: Wines made from the Muscat grape are said to be the one kind that actually smell like grapes. It is often used to make a dessert wine or a fortified wine.

Pinot Gris/Pinot Grigio: The wine from this grape is low in acid and has a range of tastes. You probably know it best as Pinot Grigio, which is what it's called when it comes from Italy. Italian Pinot Grigio has a reputation of being sort of bland, but that can make it a great mild choice for cocktail hour, when you don't want something too intensely flavorful.

Semillon: Full-bodied, low in acid, and aromatic, wines from this grape are most often blended with those of Sauvignon Blanc or other white grapes.

Viognier: A white grape whose wines are usually full-bodied, aromatic, and smooth. They've been increasing in popularity in the past few years, especially in California, in part because they are quite versatile with food.

Other white grapes to check out if you get the chance: Albarino, Grüner-Veltliner, Malvasia Bianca, Müller-Thurgau, Roussane, Sylvaner, and Vernaccia.

Red Wine Grapes

The Big Four

Cabernet Sauvignon: Its wines have lots of rich, jam-like flavor and high tannin levels. It's the main grape in red wines from the Bordeaux region, among which are some of the priciest wines out there. It's also very common in California, and is grown in Australia and most places where serious grape-growing takes place.

Merlot: The smooth wines from this grape were once just used to blend with those of Cabernet and other red grapes to make Bordeaux reds and other blends. But in the past fifteen years or so it's been increasingly used to make single-varietal (that is, just Merlot) wines, especially in California and Washington.

Pinot Noir: The wine from this grape is usually a lighter-bodied red than a Cabernet, often with subtle berry flavors. It's best known for being the grape in red Burgundies, but is grown all over and does especially well in Oregon.

Syrah/Shiraz: Called Syrah in Europe (or the "Old World") and Shiraz in Australia and elsewhere, this grape usually makes wines that are high in tannins, intense, full-bodied, and often have a peppery quality.

More Red Grapes to Get to Know

Gamay: This grape makes very light, low-tannin, fruity wines and is strongly associated with *Beaujolais*, because it is the varietal that makes that region's namesake wines.

Grenache: Wines made from Grenache grapes are high in alcohol, low in tannins, and slightly sweet. The grape is often blended with others to make complex reds, is most known for being used in the Rhone region of France, and it is also the main grape in many rosés. In Spain it is known as *Garnacha.*

Malbec: This grape produces soft, berry-flavored wines without a lot of bite. Like Merlot, it used to be grown mostly to mix with other grapes in wines from Bordeaux and those made to emulate them. But now it's coming into its own, especially in Argentina, where many Malbec-based wines are produced.

Nebbiolo: A grape associated primarily with Italy, it makes full-bodied, dark, high-tannin wines that are considered some of Italy's best. It isn't widely grown outside of Italy.

Sangiovese: This is the grape of Tuscany, and of the region's best-known wine, *Chianti.* It is medium-bodied and easy to drink. It isn't made much outside of Italy.

Tempranillo: Mostly grown in Spain, this grape makes full-bodied wines. Best known as the main grape in Spain's *Rioja* wines, it also makes up the majority of the wines from the country's Ribera del Duero region. It is also grown in South America.

Zinfandel: Thought to be one of the only wine-producing grapes originally from California, where it is widely grown, Zinfandel usually makes full-bodied, jammy wines that contain a bit less tannin than Cabernets. A very similar grape grown in Italy is called Primitivo.

Other red grapes to check out if you get the chance: Barbera, Cabernet Franc, Cinsault, Montepulciano, Mourvèdre, Petit Syrah, Petit Verdot, and Pinotage.

Understanding Different Wine-Growing Countries and Regions

In addition to getting familiar with grape varietals, you should know a little about the wine-growing regions. A whole lot more determines the taste of a wine than the types of grapes it contains. The part of the world it hails from, the style of the winemaker, and the climate conditions the year the grapes were grown are all factors that influence the flavor. Many wines are made with more than one type of grape, and different grapes taste different depending on where they're grown and

how they're treated in the wine-making process. So, understanding the characteristics typical of wines from different regions will make you savvier with your wine selecting.

The most important thing to know is which wine-producing regions label their wines according to the grape varietals they contain, and which just label them according to the region and expect you to understand what that says about the wine. Of the countries that have the confusing custom of labeling their wines according to region (or *appellation*—see the brief definition of this that follows), the only two whose categories you need to understand to get started are France and Italy.

AOC and DOC: What These Acronyms Mean and Why It Matters

In most of the European countries with big wine industries, there are strictly regulated standards for wine from different regions. The names of these regulated growing regions are called *appellations*, and for a wine to bear an appellation on its label, the winemaker must adhere to a legally regulated set of standards for how the grapes are grown and the wine is produced. In France, something called Appellation d'Origine Contrôlée (AOC) laws dictate things like what grapes can go into wine from a certain region, how many vines a winemaker can grow per acre, and what the minimum alcohol content must be.

So, for a wine from the Meursault region of Burgundy to be labeled a Meursault, it has to meet a specific set of rules. It's not that every single wine from the region must abide by them, but when they don't, they get a generic name like Bur-

gundy Table Wine, which doesn't cost as much or usually taste as good as a wine with an official AOC label.

Italy has similar laws, with the acronym DOC, for Denominazione di Origine Controllata, and some other countries do as well, but France's and Italy's are the only ones you really need a working knowledge of for now. It's useful to understand a little bit about these rules because once you've memorized some of the major appellations, you'll know what grapes go into them, even though it's not listed on their labels. Eventually, if you're really interested, you'll learn the differences between wines of different appellations within a region—so you'll know how a Chardonnay from the Meursault region of Burgundy will taste different from one from the Chablis region.

Getting Your Head Around French Wine

There's a whole lot to know about French wines that's beyond the scope of this book and many people's interest, but all you need for now is a little clue about decoding the labels. Since French wines generally list their region on the label instead of their grape or grapes, you need to learn which grapes dominate each region. Once you can decode that and have at least a vague idea of how the wines those regions produce differ from wines other countries make using the same grapes, you'll know a lot more than most girls. And you'll be able to start buying French wine with some confidence and then figure out the rest on your own.

Crib Sheet for French Wine

Bordeaux

To achieve any sort of in-depth knowledge of wine from the Bordeaux region, you'll need more information than I have room to provide here, and, of course, you'll need to drink a lot of it. But the basic lowdown is that Bordeaux is known for wines made of a careful blend of different grapes. So you can't just associate it with one grape and feel you have the region somewhat figured out—the way you can with, say, Chianti (more on that below). If you're going to spend any sort of serious money on wine from Bordeaux, you should consult with the buyer at a top local wine shop.

Red Bordeaux: Red Bordeaux wines are made from a blend of Cabernet Sauvignon grapes with Merlot, Cabernet Franc, Petit Verdot, and Malbec grapes (not all of these grapes are in every bottle, but some combination of them is present).

Some of the wine-producing regions within Bordeaux, whose names appear on the wine labels, are *Pomerol, St. Emilion, Médoc,* and *Graves.*

White Bordeaux: These don't get nearly as much hype as the reds from the region, but they're also considered quite good. They're usually a mix of the Sauvignon Blanc and Semillon grapes. *Graves* is one of the regions known for its white wines.

Sauternes: This region of Bordeaux is known for its totally delicious dessert wines. They're packed with flavor and usually quite expensive.

Burgundy

Wines from the region of Burgundy are thought of as some of the best in the world (and are often the priciest). White Burgundy is always made of Chardonnay grapes and red is almost always Pinot Noir grapes. Within the region of Burgundy there are different appellations.

Some of the big-name **white burgundies** to know: *Pouilly-Fuissé, Meursault, Puligny-Montrachet,* and *Chablis.* In general, a Chardonnay wine from Burgundy is dryer and less oakey than that from other places.

Some of the villages and appellations that appear on the labels of **red burgundies:** *Côte de Nuits-Villages, Côte de Beaune-Villages, Beaune, Pommard, Aloxe-Corton,* and *Nuits-St.-Georges.*

Beaujolais is technically part of the region of Burgundy, but unlike the rest of Burgundy, its red wines are made of the fruity, light Gamay grape. There are three levels of Beaujolais: basic *Beaujolais,* one that's a step up called *Beaujolais-Villages,* and the most prestigious, which are called *cru* and named after the specific villages where they come from. Some of the well-known cru include *Brouilly, Moulin-a-Vent,* and *Fleurie.*

Beaujolais is best known in the U.S. for *Beaujolais Nouveau,* the very young, fruity Beaujolais that is released at the same time each November and meant to be drunk right away.

Insider Tip: The conventional way to serve Beaujolais is slightly chilled, a colder temp is supposed to bring out its taste better.

Never, Ever: Buy anything called a Chablis that doesn't come from the French region of Chablis. You can tell which ones do because their label will be in French and say either "Burgundy" or "Bourgogne," the French word for Burgundy, somewhere on it.

Loire Valley Wines

This region is renowned for its white wines, and the two main grapes used in them are Sauvignon Blanc and Chenin Blanc.

The big names to know: *Sancerre*, which is made of **100** percent Sauvignon Blanc grapes and is known for being very crisp and herbaceous; *Pouilly-Fumé*, which is also made of Sauvignon Blanc but is more full-bodied than Sancerre; and *Vouvray*, which is made of **100** percent Chenin Blanc and varies between dry and quite sweet, depending on the vintage. Finally, there's *Muscadet*, a Loire white made of a grape called *Melon* that isn't really used anywhere else. It creates a light, dry wine.

Rhône Wines

When people think of the Rhône area, they think of strong, full-bodied red wines. Reds from the northern Rhône are made of the Syrah grape, and reds from the southern Rhône area are made of Syrah, Grenache, Mourvèdre, and a number of other red grapes. The big appellation to know from the northern region is called *Crozes-Hermitage*. The most widely known appellation from the southern Rhône is *Châteauneuf-du-Pape*, an area known for spicy, fruity reds made from Grenache grapes. One basic, affordable appellation for Rhône wines is *Côtes du Rhône*, and *Côtes du Rhône-Villages* is a more prestigious version of that standard appellation.

Italian Wine Briefly Explained

The name of Italy's most famous wine is of course Chianti, which is also the name of the region in Tuscany that makes these wines that are the standard in Italian restaurants everywhere. But there's a lot more to know about Italian wine, and it takes a little bit of study to figure out. As with wines from France, the *vino* of Italia is generally named for production areas where the standards are strictly controlled (these production areas are referred to as DOC).

Italian Wine Decoded

Chianti and Other Tuscan Reds

The most widely known Italian wines are those from the Chianti region. All Chianti is made of the Sangiovese grape (though other grapes may be mixed in, by law

Chianti has to be at least 75 percent Sangiovese), which is medium-bodied, fruity, and slightly astringent. Wines from Chianti are further broken down according to quality. One labeled simply *Chianti* will be less expensive and, probably, less tasty than one labeled *Chianti Classico*, and the most prestigious wines from the region are labeled *Chianti Classico Riserva*—this last category of wines must be aged for over two years.

More Tuscan reds: Like Chianti, the other reds from Tuscany are usually made of the Sangiovese grape, although different DOC regions are associated with different styles. The other biggies to know about are *Vino Nobile di Montepulciano* and *Brunello di Montalcino*, which is made of 100 percent Sangiovese grape but is generally richer and more tannic than Chianti.

Barolo and Barbaresco

These are also among the most high-profile Italian wines. They're DOC appellations from the Piedmont region. Both of them are made of the Nebbiolo grape and are big, full-bodied, and have a reputation as being two of the most prestigious wines of Italy (and so of course tend to have prices to match that rep). Barolo is a little more intense and full-bodied, and Barbaresco is thought of as more refined (though that's a distinction a novice wine shopper needn't concern herself with really).

Insider Tip: One way to get a sense of how a wine will taste is to look at the alcohol content listed on the label. They typically range from 9 to 14 percent, and the higher the percentage of alcohol, the more full-bodied the wine will be.

Wine from Home-Grown Grapes

It's good to get to know European wines, since they're the granddaddies of our own, but looking to the vineyards across the pond is never absolutely necessary, since America produces some of the best wines in the world—and the labels are ten times easier to understand. Since our country's wines almost always list their main grape varietal directly on the label, you can pretty easily pick out an American wine based just on your knowledge of the grape. In addition, some of the back labels go into detailed descriptions of what the wines taste like and even what foods to pair them with.

The major wine-growing states in the U.S. are California, Washington, and Oregon, followed by New York and Virginia.

California

Cali is of course the biggest wine-producing state in the country. In the nineteenth century European immigrants realized that the climate in the areas around San Francisco, like Napa and Sonoma counties, was pretty similar to that of the big grape-growing regions in France, so they brought some of their grapes over and got started. The top wine-growing regions in California are Napa and Sonoma counties, though there is great wine made in Santa Barbara County and along the central coast of the state as well.

Chardonnay and Cabernet are the two grapes grown the most in California, but all the other major grapes are grown there too. California Chardonnays are known for their complexity and oakiness (because they're usually aged in oak barrels for relatively long periods). California Cabs are usually quite dry but come in a variety of styles and have the rep of being really fruity and bold (as compared to the more subtle Cabernet-based Bordeaux wines, for example).

Although the name of the grape is prominently displayed on the label of most California wines—which means that, by law, at least 75 percent of the wine must come from that varietal—wines made of the same grape can vary a lot in taste, depending on the style of the winemaker. The best way to discover which wines you like the most is to simply try a lot of them.

Washington and Oregon

Even though they aren't as high-profile as California, these two states produce lots of delicious wine too. Oregon is especially known for its Pinot Noir and Chardonnay, and the wineries of Washington State make just about every style of wine California does, but are especially known for their Merlots and Rieslings.

Quality Vino from Other Corners of the World

Spain

Spain is primarily known, in this country anyway, for its reds from the regions of *Rioja* and *Ribera del Duero*. Wines from Rioja are usually made from a blend of the grapes Tempranillo and Grenache (which is called Garnacha in Spain). There are

Deciding How Much to Spend on Wine

There's no reason you should spend more than fifteen dollars on a bottle of wine, unless it's a special occasion or you just feel like indulging. There are hundreds of great, widely available wines for under fifteen dollars and even under ten dollars. The best way to find the best bargains is to talk to the owner of your local wine shop or read reviews in food-and-wine magazines or online.

And no matter how bored you are by talk of trade deficits and exchange rates, it pays to pay a little attention to them when it comes to wine. The U.S. dollar has been really weak relative to the euro for the past few years (2002–2005), which means European wines are among the priciest on the shelves. But Argentina suffered a currency crisis a few years ago, and their economy has been struggling ever since—bad news for them, but great news for international appreciation of their wines. You can find really top-quality Argentinean wines for next to nothing. So right now a ten-dollar Argentinean wine could easily be of a higher quality than a twenty-dollar French one (though, of course, that could change with their economies).

But to get you started, here is a very short selection of the many wineries that make delicious, widely available wines costing less than $15:

Beaulieau (California)
Bodegas Arrocal (Spain)
Bonny Doon (California)
Bulletin Place (Australia)
Castle Rock (California)
Chateau Ste. Michelle (Washington State)
Cypress (California)
Gallo of Sonoma (California)
Hogue (Washington State)
Jackaroo (Australia)

(continued on the next page)

J. Lohr (California)
King Estate (Oregon)
Matua Valley (New Zealand)
Rancho Zabaco (California)
Ricardo Santos (Argentina)
Sebastiani (California)
Spy Valley (New Zealand)
Veramonte (Chile)
Vinansar (Spain)
Windmill Estates (California)
Wishing Tree (Australia)
Yalumba (Australia)

three quality (and price) levels of Rioja, depending on how long they've been aged: *Crianza* (the cheapest), *Reserva*, and *Gran Reserva* (the priciest). Ribera del Duero wines are made mostly of a grape called Tinto Fino, which is similar to Tempranillo, mixed with other red grapes like Cabernet and Malbec.

Australia and New Zealand

Wines from the down-under countries have been growing in prestige and popularity over the last decade. Australia has a huge wine industry and is known more for its reds, especially its Shiraz (called Syrah elsewhere), than for its whites, though it makes great whites too. New Zealand is known for its delicious Sauvignon Blancs, mostly from the Marlborough region, which have lots of grassy, fruity flavor.

Even More Wine-Growing Countries and Regions

Germany churns out a lot of wine, but buying German wines is pretty confusing, and they're usually not sold as widely in the U.S. as wines from the previously mentioned countries are. If you're interested in exploring wines from Germany, your best bet is to ask your wine merchant to educate you about the German wines he or she has to offer.

Argentina and Chile are considered to be the next big thing in wine-making. Argentina is especially known for wine made with the Malbec grape, and both countries grow a lot of the other red grapes associated with Bordeaux.

South Africa makes a wide range of wines, with an emphasis on reds, such as Cabernet, Shiraz (Syrah), and Merlot. It also has a grape varietal of its own, called Pinotage, which is a bit like a Pinot Noir.

The Scoop on Champagne and Sparkling Wine

The term *Champagne* technically applies only to sparkling wine grown in the French region of Champagne according to a strictly regulated, labor-intensive process called *méthode champenoise*. Because of the exclusivity and expense of the process, and the resulting price tags on the bottles, the word *Champagne* connotes luxury and fabulousness.

But unless it's a really special occasion, there's no need to spring for authentic Champagne. Many of the sparkling wines from California, for example, are nearly if not just as delicious as some Champagnes. Although many wine lovers do consider Champagne to be unmatched anywhere in the world, it's a big mistake to think bubbly that's not "real" Champagne is necessarily inferior.

The cheapest options are usually the Italian sparkling wine called Prosecco and the Spanish sparkling wine called Cava. Some of these are quite delicious, others are rather icky. But if you open a bottle that turns out to taste just as cheap

How to . . . Open a Bottle of Champagne

For years I was scared of taking the cork out of a bottle of bubbly and would always ask a guy or a brave girlfriend to do it. I now know that was the stupidest thing, because it's dead-easy to do.

First, always point the cork away from you, your drinking companions, and any precious antiques or other valued possessions. After removing any foil from the top of the bottle, place a napkin or towel loosely over the cork and remove the wire. Then cover the cork with the cloth and hold it with one hand while holding the bottom half of the bottle with the other. Slowly turn the bottle with your bottom hand while holding the cork steady with your top hand. After a few turns, the cork and bottle will gently pop apart.

as it costs, just add some Crème de Cassis and turn it into a Kir royale or some fruit juice and turn it into a Bellini.

Decoding Bubbly Labels

Many of these terms are French, since proper Champagne comes from France, but many sparkling wines from California and elsewhere are labeled this way as well.

Blanc de Blancs: This means the bubbly was made entirely of white grapes (Chardonnay) and is lighter than that made of red grapes.

Blanc de Noirs: This means it was made of red Pinot Noir grapes. The bubbly is still white, but the red grapes give it a fuller flavor than that of Blanc de Blancs.

Brut: There are four levels of dryness for sparkling wine, and Brut is the driest, and considered the highest quality.

Extra Sec: Extra dry; contrary to what would seem obvious, this designates a wine that's sweeter than a brut.

Sec: Sweeter than either of the above.

Demi-Sec: The sweetest of all. Sec and Demi-Sec sparkling wines are usually considered dessert wines.

Insider Tip: You can tell a really fabulous Champagne from a cheaper sparkling wine by the size and number of the bubbles—the good stuff has tons of tiny ones.

Essential Info

A bottle of sparkling wine holds six flutes' worth of bubbly.

$$-Saving Strategy: Instead of spending $35 on a bottle of real Champagne, spend $25 on a bottle of sparkling wine from California. Denis Toner, of the Nantucket Wine Festival, suggests Roederer Estate Anderson Valley Brut and Pacific Echo Brut, both of which have price tags in the $20 range.

Essential Info: Though it's unlikely you often open a bottle without finishing it, if you for some reason do, you can store the Champagne for about a day if you insert a Champagne stopper, which are those metal-and-rubber gadgets you can find at any wine or kitchen store. If you don't have one, cover the mouth of the bottle with plastic wrap and secure it tightly with a rubber band. Also, somebody told me that dropping a raisin in the bottle before you put the stopper in will help preserve the bubbles in bubbly. Though I can't tell for sure if it helps, it doesn't seem to hurt. And Kristin Moses, of Kluge Estate Winery and Vineyard, swears that placing an upside-down spoon in the mouth of the bottle will keep it fresh and fizzy.

Dessert Wines and Other Grape-Derived Drinks

Dessert Wine

These wines have a higher sugar content than regular wine and are meant to accompany dessert or serve as dessert in and of themselves. Dessert wines from the United States are often labeled "Late Harvest," and ones from Germany are often labeled "Ice Wine."

Sherry

Sherry is a fortified wine, which means brandy has been added to the wine to increase its alcohol content (which is usually about 18 percent for sherry, versus regular wine's 10–14 percent). Sherry is made in southern Spain. There are five

different types, ranging from very dry to quite sweet, but the only ones you proba-bly want to bother with are Manzanilla and Fino. Both make wonderful aperitifs, especially, unsurprisingly, with Spanish-style tapas.

Port

Like Sherry, Port is a fortified wine, with an alcohol content of around 20 percent. It is made in northern Portugal and is usually sweeter than regular wine, which makes it a great after-dinner drink. There are three levels of quality with Port: Ruby Port, the cheapest; Tawny Port, which is aged longer than Ruby and has a more refined taste; and Vintage Port, which is often meant to be aged and con-sumed fifteen or more years after it's bottled. It's as expensive as it sounds.

Brandy and Eau-de-Vie

These are highly alcoholic drinks, such as Poire Williams, a French eau-de-vie made from pears; Kirsch, which is made from cherries and comes from Switzer-land; and Grappa, which is Italian and made from grape skins. If you're feeling stuffed and lethargic post-dinner and crave a little jolt to the system, these can be the perfect choice.

Smart-Girl Secret: Serving dessert wine or another after-dinner drink at the end of your dinner party is elegant and a real unexpected treat for your guests. You don't need to buy a lot of it, because most people will want only a glass at most (since these drinks are either rather sweet and heavy, as with dessert wine and port, or, in the case of brandy, startlingly stiff). So if you're trying to end things on a sort of civilized note, and ensure your guests don't linger till two and move on from the dinner wine to whatever's in your liquor cabinet, serving a proper diges-tif (which is what these are) is the way to go. (On the flip side, if you want the party to keep going into the wee hours, dessert wine could slow it down; so in that case serve sparkling wine or cocktails instead.)

Guidelines for Serving Wine

The conventional wisdom is that white wine should be cold and red wine should be room temperature, but, according to Cecile Roesch-Giannangeli, we Americans

tend to overchill whites and underchill reds. If a white is too icy, it deadens the taste—which, of course, can be good if you're sipping something super-cheap and sort of crappy, but generally is a bad thing. The "room temperature" red wines should be served at is 60–65 degrees, so if you're in a room that's warmer than that, you may want to chill your red for five minutes. The lighter-bodied the red, the more it can benefit from a little cooling down, and Beaujolais is one red that's meant to be served slightly chilled.

Pour the glasses no more than halfway full. Denis Toner says they should be just one-third full, to allow the right amount of swirling and aeration for the wine, but if you're serving a number of people, serving so little at a time may just necessitate constant repouring of wine. As you finish a pour, prevent drips by turning the neck of the bottle to the side a bit as you lift it up.

$$-Saving Strategy: Buy your favorite wine by the case. It's cheaper that way to begin with, and almost every wine merchant will give you another 15 to 20 percent off if you ask. "If you don't get a discount, go to another wine shop," says Denis Toner.

Rules for Storing Wine

To store wine without ruining it, you need to keep it in a coolish, dark place. Heat and light prematurely age it, and the ideal temperature to store it at is 55 degrees.

Try storing it under your bed or on the floor of a closet, where it's dark and the temperature doesn't fluctuate too much. Keeping your vino on top of the fridge may seem convenient, but it's actually a terrible place for it, since it gets too hot up there. If you must store wine there, be sure you drink it up quickly before it can get wrecked, within a month or so.

The ideal solution is to buy one of those special little wine refrigerators, which keep the wine at a perfectly constant temperature and humidity. Yes, they seem pretentious, and, no, most of us do not have room for one, but all the experts seem to own them, so if you're serious about storing wine, they're the thing to have.

Finally, you should always store wine on its side, or else the cork can dry out and let oxygen seep in, which damages the taste of the wine.

Four Confusing Wine Questions Answered

DO WINES REALLY NEED TO BREATHE?

The idea that some wines need to "breathe," or be exposed to air to reduce their tannins and open up their bouquet, seems to be controversial. "In my opinion very young red wines and big, full-bodied reds can benefit from some aeration," says Cecile Roesch-Giannangeli. "But just opening the bottle won't do much, since so little of the wine will have contact with oxygen that way." If at first sip a wine tastes very tannic and you think it could benefit from some breathing, leave it in your glass for five minutes or so before trying it again.

DOES THE YEAR OF A WINE MATTER?

The year a wine's grapes were harvested, its *vintage*, reflects the weather conditions those grapes experienced. If the weather that year was favorable to grape-growing, the wine will taste slightly better than if it was not. However, unless you're shopping for the finest Burgundies and Bordeaux, you probably don't need to concern yourself with a wine's vintage. Wine-making technology today can compensate for most vagaries of the weather.

DOES WINE HAVE TO BE A CERTAIN AGE BEFORE YOU DRINK IT?

The idea that wine will improve with age and shouldn't be consumed too "young" is sort of an outdated one—generally, once a wine has reached the shelves, it's done all the aging it needs to. "Now wine is ready to drink earlier than it used to be," says Denis Toner. "Unless it's something special like a great Bordeaux or Burgundy, it's probably not going to benefit from aging." If you are going to spend a lot on a special bottle or case of wine, ask your wine merchant if you should hold on to it a while before drinking it. The wines that are good candidates for this are reds with equal amounts of fruit, tannin, and acid. However, if you're still in the stage of your life when you're moving from place to place every few years, long-term wine storage is not a good idea, since,

in addition to the annoyance of having to move all those bottles, there's a good chance you'll ruin the wine because it will be hard to keep the conditions it's stored in constant.

DOES IT MATTER WHAT KIND OF GLASSES YOU DRINK WINE OUT OF?

If you've hit Williams-Sonoma or any purveyor of fancy crystal in the past few years, you may have noticed there are really expensive wineglasses ($60 each for some, and they're not cut-crystal goblets) created for very specific wines. The Cabernet glass has one shape; the Pinot Noir glass has another. But does it really matter what kind of glass you serve your wine in?

The general consensus is that it does matter a little, but not that much. In general, you want to drink wine out of a glass with a nice round bowl that slopes inward at the top. The wide bowl creates lots of surface area, to aerate the wine and bring out its flavors and aromas, and the curved-in sides help capture those aromas. You particularly need this if you're drinking a great wine with complex flavor and scent. The traditional white-wine glass is smaller and rounder, whereas the red-wine glass has a bigger, more vertical bowl; though it's up for debate whether each color wine really needs its own shape.

On the other hand, you can drink inexpensive, everyday wine out of any sort of glass at all. A friend who lived in Madrid sent me a set of glasses that are about the size and shape of a measuring cup and which I love. They're especially great for entertaining when you want to keep the mood very fun and casual, and they're a good choice if you're drinking wine with pizza or some other humble food, as they fit the mood of the meal better than stemware would.

And all the wine experts I've talked to agree that there's no need for a girl to get glasses with different shapes for different grapes. One set of quality glasses will work with any wine you uncork.

How to . . . Tell If a Wine Is "Corked"

The term *corked* means that somehow a fungus has got into the cork and is affecting the taste of the wine. This is very hard for the wineries to prevent entirely, and it can sometimes be hard to tell whether a wine is corked or not. "Drinking a corked wine isn't physically bad for you at all, and you probably have had glasses of it unknowingly many times, and totally enjoyed them," says Cecile Roesch-Giannangeli.

The sign that a wine is corked is that it has a funky smell or taste. It may smell a bit moldy or not smell as good as it would otherwise (if a wine you've enjoyed a lot in the past doesn't live up to your memories, there's a strong chance it's because the cork is tainted). All that said, there's no reason to stress about whether a wine is corked or not. "If it tastes nasty, throw it out; but if it just seems a tiny bit off but still tastes good, go ahead and drink it," says Cecile.

Smart-Girl Secret: Instead of just buying wine at the supermarket or a big liquor store, find a small wine shop to patronize and get to know the owner or manager. Tell him or her what you like and what type of meal you're buying the wine for, and ask which bottles are a great deal and what's new and interesting that you should try. But set strict price parameters and don't let him try to push you into spending more. If his shop is well stocked, he should be able to recommend something great in every price range.

Pairing Wine with Food

Wine is such a key part of a meal—this is true for ordinary, every-night sorts of meals, but is especially true for those special gourmet ones. If what you're eating is really mouthwatering, you need the wine to make it taste even better. And the reverse is true too: the food should enhance the yummy flavors of the wine.

The basic principle of pairing wine with food is to make sure neither overpowers the other. So you wouldn't pair a delicately flavored red snapper fillet with a

bold, fruity Syrah, because the wine would overwhelm your taste buds and the fish would taste bland. On the flip side, pairing a Pinot Grigio with a steak au poivre could make the wine taste like water. So it could still be refreshing as a beverage, but you wouldn't be able to taste the nuance in the wine nor really savor it as a result. "To understand why picking the right wine for your food matters, think of how you use spices and herbs with food," says Cecile Roesch-Giannangeli. "You wouldn't put curry in pasta with a fresh tomato sauce; for the same reasons, you wouldn't drink a big Cabernet with a fillet of sole."

So while the cliché of "white wine with fish, red with meat," has some validity, it oversimplifies things. A lot of wine pairing depends less on the meal's main ingredient than on the spices you cooked it with or the sauce you're serving with it. A chicken breast cooked simply with some herbs might taste best with a grassy Sauvignon Blanc, whereas one covered in a savory Parmesan crust would work better with a Sangiovese. Rather than relying on rules, you should develop your personal tastes, and to help you hone your skills for it, check out these experts' opinions on the subject. They might clue you in to some wonderful combinations you haven't thought of before.

> "Wine is like fashion, the more time you spend cultivating your individual tastes, the more confident you get about knowing what's your style and what's not."
>
> —*Kristin Moses, marketing and PR director for Kluge Estate Winery and Vineyard*

Appetizers

The most ideal wine for cocktail hour is probably sparkling wine or Champagne. "Champagne loves a little salt," says Denis Toner, of the Nantucket Wine Festival, and most hors d'oeuvres are nice and salty.

Salads

Some people say wine and salad are a tricky pairing because the acid of the vinegar or citrus juice in the salad dressing leaves your tongue unable to properly take in the taste of the wine. Perhaps that's true to some extent, but it would be no fun at all to have a wine-free salad course, and I think high-acid white like Sauvignon Blanc tastes great with salad.

Shellfish

Crisp Sauvignon Blanc and sparkling wine are two good matches for the delicate taste of shellfish. Crab and scallops both benefit from a touch more sweetness in the form of a light Chardonnay or a Viognier.

Fish

It depends upon the type of fish you're having, as well as the sauce or marinade you've prepared it with. But in general, dry, light whites, like Pinot Gris and Sauvignon Blanc, that aren't too fruity are a good match for fish, especially light white fish, or any fish that's been cooked with lemon.

More full-flavored fish like tuna and salmon matches well with light reds such as Pinot Noir or Beaujolais (and other wines made of the Gamay grape).

Pasta

With tomato sauce: Light fruity reds like, of course, Sangiovese.

With cream sauce: Full-bodied whites that aren't too fruity, like Pinot Blanc and Chardonnay.

With pesto: A light crisp white like a Pinot Grigio.

Poultry

Again, it depends a bit on how it's prepared, but full-bodied whites like Chardonnay and light- or medium-bodied reds like Pinot Noir and Merlot are considered right for it.

Meat

Beef tends to go best with medium- or full-bodied reds like Cabernet, Zinfandel, and Syrah, among many others. Pork is really flexible, and pairs well with just about anything from medium-bodied whites to medium-bodied reds.

Grilled Food

A spicy Syrah/Shiraz could stand up to the intense charred flavors of food that's cooked over a flame.

Spicy food

Crisp and fruity whites are the best bet for balancing out spicy food like Indian or Thai. Try an aromatic Sauvignon Blanc or a dry Gewürztraminer. Intense spiciness numbs your palette, so don't waste a pricey, complex wine on these meals. Reds aren't an ideal match for spices, but rosés can work because they're fruity but still light and refreshing.

Sushi

I've heard a lot that beer is the best match for sushi, and that sparkling wine is too. But if you want wine with your raw fish and rice, go for a dry Riesling or an un-oaky Chardonnay.

Dessert

Of course a dessert wine is the obvious choice to serve with dessert, but the pairing can be overwhelmingly sweet for many people. If you've got a delicious dessert wine to serve, you might want to keep the dessert simple—roasted or poached fruit, biscotti, or other simple cookies—to keep the focus on the wine.

They say chocolate and most wines destroy the taste of each other, but since they're two of my favorite things on earth, I refuse to accept that. Other than a dessert wine, your best bet to pair with a chocolate dessert is a rich, ripe, not-too-tannic red like a Merlot.

And of course, I think sparkling wine works wonderfully with dessert, especially a slightly sweet one.

Cheese

Cheese and wine just naturally go together—both are meant to be savored. A bottle of wine, a couple types of cheese, some crusty bread, and a few other accompaniments can make a great dinner for you and a girlfriend, and it's one of my favorite choices when I want a meal that feels indulgent but don't want to lift a finger to cook. Don't think of it as having cocktail hour instead of dinner; think of it as a picnic in your kitchen.

But what wines go best with cheese? That's tricky to answer, because different wines match best with different cheeses, but you're usually drinking only one wine with a variety of cheeses. "I like young tannic red wines, like young Bordeaux, with cheese," says Denis Toner. "The fat in cheese tames the tannins in the wine."

How to . . . Create a Cheese Plate

When you're putting together a cheese plate, whether for two people or twenty, there are a few guidelines you should pay attention to so you can get an interesting interplay of cheeses. Here are the general pointers, courtesy of Mark Allen, of Le Soir Bistro in Newton Highlands, Massachusetts, where they do a delish cheese plate.

Mix animals: Try to serve one cow's milk, one goat's milk, and one sheep's milk cheese.

Mix textures: You want one really gooey one, such as a room-temperature Brie or a triple cream like Explorateur; one hard one, like an aged cheddar or a Gruyère; and one crumbly one, like a blue cheese or a young goat cheese.

Mix flavors: Balance out the mildness of a Camembert and the herbaceous flavor of an aged goat cheese with the sweetness of a Gorgonzola Dolce.

Mix ages: You want at least one fresh young cheese and one older one with more pronounced flavors.

Add some yummy accompaniments: Round out your cheese plate with such dried fruit as figs, apricots, and sundried tomatoes, and nuts like walnuts and hazelnuts.

Select great bread: A plain white baguette and simple water crackers are often the best base for cheese, because they don't add extra salt or competing flavors. That said, a slightly sweet dark raisin bread is a delish pairing with many cheeses, especially blue.

Mark Allen, owner of Le Soir Bistro in Newton Highlands, Massachusetts, prefers a dessert wine like Sauternes or a glass of Port to go with his cheese eating.

Essential Info

As discussed in chapter 2, there's a huge taste gap between raw-milk cheese and the kind that's been pasteurized. "Pasteurization is done to kill any bacteria in the cheese, but since cheese gets its flavor from bacteria, the process robs cheese of lots of its character," says Mark Allen. In the United States it's illegal to sell raw-

milk cheese unless it's been aged at least sixty days, after which it's thought the worst of any bad bacteria will have died off (though in Europe they eat young raw-milk cheese all the time with no ill effects). Raw-milk cheese is more expensive but worth ponying up for. It's rarely available in your average supermarket, so seek it out at cheese shops or gourmet stores that take cheese seriously.

Cocktails: Your Drink-Mixing Master Class

Sure, anyone can throw some booze and a mixer together in a glass and get the job done, but there's a gaping gulf between your average mixed drink and a cocktail that tastes truly divine—like the kind they serve at the Carlyle in New York City or

the Ritz in Paris or any fancy hotel with a bartender that approaches his craft as if it were an art form. Just think how cool it would be to be able to serve icy potions that make people swoon at the first sip. Mixing up one of those truly transporting cocktails is a matter of doing a few little things that make a big difference. I've collected the essential wisdom top bar chefs know that the rest of us should commit to memory.

The Key Ingredients of a Great Cocktail

Quality Booze

When you're aiming to make delicious cocktails, quality booze is key. Good liquor both tastes better and results in less morning-after suffering than its low-quality cousins, because it has fewer additives and was more carefully crafted. That said, the expensive, heavily marketed brands of booze aren't necessarily the best. Look on the bottle label to see how many times the liquor was distilled. The more times alcohol is distilled, the smoother it is. If it's distilled just once or twice, it's going to taste like rubbing alcohol. Look for sauce that's been distilled three, four, or five times.

The Mixers

The fresher the juices, fruits, and herbs you use in your cocktail, the more delicious it will taste. Fresh-squeezed juice is ideal, and when it comes to lime and lemon juice, you should never settle for anything else. And in cases where fresh juice is not an option, as with cranberry juice and the like, try to get the best quality juice you can find—stuff that's not from concentrate and doesn't have a lot of sugar added to it.

Ice

This is the ingredient that turns alcohol into a cocktail, both by chilling it and by adding some water to the booze. Water is a key ingredient to any cocktail because it helps "open up" the flavors of the alcohol. In a straight-up drink without added water, like a martini, water still plays a key role because the ice you shake it with releases some water into the gin or vodka. This is one of the reasons shaking plays such an essential role in cocktail making.

How to . . . Make Simple Syrup

Simple syrup is what top bar chefs use to sweeten drinks. It's made simply by dissolving sugar in water. You can add it to drinks without having to wait for the sugar granules to dissolve, and since it's combined with water, it helps "open up" the flavors of the spirit, says Kim Haasarud, owner of the Los Angeles-based beverage design company Liquid Architecture.

To make: Put 1 cup of water and 2 cups of sugar in a small saucepan; then bring it to a boil and stir until the sugar dissolves. You can store the syrup in a sealed container in the refrigerator indefinitely. If you want syrup that's less sweet, just lower the ratio of sugar to water.

The Sugar

When a drink calls for sugar, use either simple syrup (details above) or superfine (aka, fast-dissolving) sugar.

Drink-Mixing Ingredients to Always Have on Hand

Superfine sugar
Lemons and limes
Club soda
Ginger ale
Cola
Tonic (in the summer months)

Essential Info

Before any gathering at your pad, polish your rarely used glasses with a soft cloth, since they probably won't look their best after sitting in your cupboard for a while.

Do It on Pennies

A shaker and strainer

A one-ounce shot glass (Use this to measure out alcohol for drinks if you don't have a jigger.)

A wooden spoon (You can use this instead of a muddler.)

Do It Posh

A shaker and strainer

A double-ended jigger (This bartender tool has two cone-shaped metal cups, one that holds one ounce, and one that holds two ounces.)

A wooden muddler (This tool looks sort of like a tiny baseball bat, except you hold the thicker end and let the smaller end do the work.)

Drink-Mixing Moves to Master

While quality ingredients are key, truly amazing cocktails require some technique. There are two essential moves for making any type of mixed drink. First, *measure the alcohol.* Although it's tempting to just pour it in there haphazardly, it's so easy to measure it out in a shot glass or jigger first. And since drinking too much of it can ruin your party guests' entire next day, it's irresponsible to go overboard. If they want to get hammered, they can go ahead and have more drinks, but don't let a single drink knock them out.

The second essential move is to *make sure the cocktail is cold enough.* If possible, chill glasses in the fridge for a half hour or in the freezer for ten minutes before you use them. Always use plenty of ice. And when you're shaking a cocktail, be sure to do it long enough, almost thirty seconds, so everything gets properly mixed.

Do It on Pennies Plain vodka, bourbon or Tennessee whiskey, tequila, and medium-colored rum.

Do It Posh All of the above, plus a quality Scotch, a good gin, a top-quality sipping rum, a premium tequila, and a couple interesting flavors of vodka.

Essential Info

There's no one right answer to whether a martini should be shaken or stirred. Members of the stirred school say that shaking adds too many air bubbles to the drink and that it should have a silky texture, not the frothy one the bubbles can create. But members of the other school say that the alcohol doesn't properly mix with the ice if it's not shaken, and the ice is necessary both to chill the drink and bring out some of the flavors of the booze. If you're going to stir a martini, place the alcohol in the cocktail shaker with ice and stir it with a long wooden spoon for an entire minute before straining it into the glass.

Pitfall to Avoid

If you store your booze in the freezer, that doesn't mean you can skip the step of shaking it with ice when making a cosmo or other straight-up drink. Even though the liquor is already cold, it's essential you shake it with ice to open up the flavors of the alcohol. The same thing goes for when you make pitchers of drinks in advance—you still should shake them with ice before you serve 'em.

Eight Cocktail Recipes to Commit to Memory

Except for the basic, two-ingredient mixed drinks (gin and tonic, vodka soda, whiskey and Coke), these are the most popular party cocktails. So they're the ones you should be

"When you've got a delicious spirit, you aim to enhance the flavor; whereas with a low-quality spirit, you have to try to hide it."

—*Kim Haasarud, owner of the Los Angeles–based beverage firm Liquid Architecture*

Do It on Pennies

Medium-sized wineglasses (In addition to using them for wine, you can use these for cocktails you'd ordinarily serve in a rocks glass, like mojitos, or in a martini glass.)

Highballs (These are the medium-tall glasses that hold ten to twelve ounces.)

Champagne flutes (No, these aren't absolutely necessary, since you can drink your bubbly out of wineglasses, but I'm a believer in every girl having a set of at least four proper Champagne flutes. *Note:* Flutes, the tall skinny ones, are superior to the saucer variety, because they trap the Champagne's bubbles and concentrate its aroma.)

Do It Posh

All of the above, plus:

Rocks glasses ("On-the-rocks" glasses. Also called "old-fashioned" glasses, these are the short, squat ones that usually hold six ounces.)

Martini glasses (When you're not having straight-up drinks, you can use them to serve ice cream and other desserts in.)

Beer mugs (Serving guests beer in a frosty mug—chill them in the freezer if you know beer-drinkers are stopping by—is way more grown up than just handing them bottles.)

Shot glasses (Even after your spring-break days are over, you want to have a few of these on hand for parties.)

Red-wine glasses (If you've got the storage space, buy bigger glasses for red wine. They're not totally necessary, but a table set with wineglasses in two sizes looks so fancy.)

How to . . . Muddle

To muddle is to mash up fruit or other ingredients before you add alcohol to them, to bring out their oils and juices—do this with a wooden spoon or a thick wooden stick called a muddler. For some drinks the ingredients are muddled in the shaker and shaken with the drink but then strained out so they don't wind up in the glass, but in other recipes you muddle right in the glass and put the drink on top of the muddled fruit.

able to do without having to stop and think about it or look up a recipe. Once you've mastered them, you can add and subtract different ingredients to create new drink recipes of your own.

Martini

1 DASH OF DRY VERMOUTH

3 OZ GIN *OR* VODKA

Shake ingredients or stir with ice, strain into a glass, and garnish with an olive or a twist of lemon.

Extra options: To make a dirty martini, add ¼ oz olive brine (the liquid from a jar of olives) before shaking. To make a French martini, use just 2 oz vodka and add ½ oz Chambord and 1½ oz pineapple juice before shaking.

Cosmopolitan

There are a lot of slightly different recipes for a cosmo, but this is my favorite.

2 OZ CITRON *OR* ORANGE VODKA

1 OZ ORANGE LIQUEUR, LIKE COINTREAU OR GRAND MARNIER

1 OZ CRANBERRY JUICE

1/4 OZ LIME JUICE

Shake ingredients with ice, strain into a glass, and serve with orange zest.

Extra option: To make them without the orange liqueur, replace it with a $1/2$ oz simple syrup and another $1/2$ oz cranberry juice.

Margarita

1 1/2 OZ TEQUILA

1 OZ ORANGE LIQUEUR, LIKE COINTREAU OR GRAND MARNIER

1 OZ FRESH LIME JUICE

Shake ingredients in a shaker, and strain into a glass, either straight up or on the rocks. First rim the glass with salt if you'd like, and garnish with a slice of lime.

Extra options: Add 1 ounce of any tropical or summery juice.

Mojito

6 SPRIGS FRESH MINT

1 OZ SIMPLE SYRUP

3/4 OZ FRESH LIME JUICE

1 1/4 OZ RUM

CLUB SODA

How to . . . Slice Lemons and Limes

Use fresh, firm fruit, and wash and dry it well before slicing.

To make half-moon slices to garnish the side of a glass: Slice off both ends, cut the fruit in half lengthwise, and place the two halves on a cutting board juicy side down. Working from end to end, slice each half into quarter-inch slices.

To make quarters to muddle with and put in drinks like caipirinhas: Slice off both ends, and cut the fruit in half widthwise. Then place each half on the cutting board juicy side down and cut it into four quarters (each lemon or lime makes a total of eight "quarters").

To make twists, cut off both pointy parts of the fruit so the ends are flat. Place the fruit standing up on one end. Hold it firmly against the cutting board by placing one hand on the top end, and then, holding a sharp paring knife in your other hand, slice off very thin, inch-long pieces of peel. You want to try to get as little pith (the white stuff underneath the peel) as possible.

Muddle 3 mint sprigs with the simple syrup and the lime juice in the bottom of a shaker. Then add the rum and lime juice and shake with ice. Strain the drink over ice into a highball glass, top with soda, and garnish with the remaining sprigs of mint.

Extra option: "We add some cucumber and muddle it with the mint," says Adam Jannese, bar manager at the Lobby Bar at London's One Aldwych hotel. "It adds another flavor and makes it taste very fresh and summery."

Caipirinha

1/2 LIME, CUT INTO QUARTERS

3/4 OZ SIMPLE SYRUP

2 OZ CACHACA (A BRAZILIAN SUGARCANE-BASED LIQUOR)

Chill a rocks glass with ice. Add limes and syrup to a shaker and muddle to get all the juice out of the limes. Add the cachaca, put the ice from the rocks glass in the cocktail shaker, and shake well. Pour the entire contents back into the rocks glass and serve.

Extra options: You can add any seasonal fresh fruit at the muddling stage, and if you don't want to buy cachaca, you can make what's called a caipiroska instead, by using vodka in place of the cachaca.

Pitfall to Avoid
Making cocktails too strong or too weak. Of course you can customize the intensity of a drink a bit to suit your mood (or that of your guest's), but in general a drink that's too strong or too weak just won't taste great. You need the alcohol to be in perfect balance with the sweet and tart and refreshing elements in a cocktail. So it's essential you use a jigger or shot glass to measure out the right amount of alcohol, even if you're just making a basic vodka tonic.

Gimlet
1 1/2 OZ GIN
1 OZ FRESH LIME JUICE
1 TSP SUGAR

Either shake ingredients with ice and strain into a martini glass or just pour ingredients into an ice-filled rocks glass.

Extra option: If you're not into gin, make it with vodka instead.

Manhattan
2 1/2 OZ BOURBON
3/4 OZ SWEET VERMOUTH
1 DASH ANGOSTURA BITTERS (AVAILABLE IN MOST SUPERMARKETS)

Shake with ice and strain into a martini glass or an ice-filled rocks glass. Add a maraschino cherry and an orange twist.

Bloody Mary

2 OZ VODKA

4 OZ TOMATO JUICE OR V8 JUICE

1 OZ WORCESTERSHIRE SAUCE

2—3 DASHES TABASCO SAUCE

SQUEEZE OF LIME JUICE

PINCH OF SALT AND PEPPER

Either shake ingredients, and strain into an ice-filled highball glass, or just pour ingredients into an ice-filled glass and stir well. Garnish with a lime.

Pitfall to Avoid

Skip cocktail mixes—like margarita mix, mojito mix, artificial lime juice, and all their overly sweet, artificially flavored cousins. You can occasionally use these shortcuts if you're preparing drinks in a blender at a massive pool party or something, but if you're going for quality libations, you need authentic ingredients.

"A lot of what passes for cocktails today are merely punch-type drinks with some vodka thrown in to make them alcoholic. A true cocktail must do a fantastic job of complementing, and not just covering up, the alcohol that is its base."

—*Adam Jannese, bar manager at London's One Aldwych hotel*

Four Designer Drinks from Top Watering Holes

Today the people designing the beverage menus at the hippest restaurants and lounges bear no resemblance to bartenders of the "Tom Cruise in *Cocktail*" variety. They're called "bar chefs" or "mixologists," and they mix ingredients with all the care with which a four-star food chef creates entrées. With these recipes you can sip their cocktails in the comfort of your own home.

The Buddhadrop served at the Slanted Door in San Francisco.

This delicious Thai-and-Vietnamese-fusion restaurant is one of San Francisco's best, and this is one of their signature drinks.

1 1/2 OZ HANGAR ONE "BUDDHA'S HAND CITRON" VODKA

3/4 OZ LIMONCELLO (ITALIAN LEMON LIQUEUR)

1 1/2 OZ FRESH LEMON JUICE

1/2 TSP SUPERFINE SUGAR

Place ingredients in a cocktail shaker with ice, shake vigorously, and strain into a glass with a sugared rim.

Mango Martini served at the Kittichai restaurant in New York City.

This drink was created by renowned bar chef Albert Trummer for this hip restaurant in SoHo's 60 Thompson hotel.

2 FRESH MANGOES, PEELED AND PUREED

2 OZ GRAND MARNIER

2 OZ FRESH LIME JUICE

6 OZ DARK RUM

Pour all the ingredients into a cocktail shaker with large cubes. Shake vigorously, strain into martini glasses, and garnish with a slice of mango. (Makes four.)

Aldwych Thai Martini served at the Lobby Bar of London's One Aldwych hotel.

It may be a bit of work to find these ingredients (look in an Asian market), but the flavors are totally divine and really unexpected in a cocktail. Of all the drinks he serves, One Aldwych bar manager Adam Jannese says, "This is easily one of my favorites."

1 WHOLE BLADE OF FRESH LEMONGRASS, CUT INTO 1/2-INCH-LONG PIECES

6 LEAVES OF FRESH CILANTRO

1 OZ GINGER SYRUP

1/2 OZ OF SIMPLE SYRUP

2 1/2 OZ VODKA

1 TSP FRESH GRATED GINGER

1 KAFFIR LIME LEAF, SHREDDED INTO SMALL PIECES

In a shaker muddle all of the ingredients *except* the vodka and Kaffir lime leaf; then add the vodka and ice and the shredded Kaffir lime leaf. Shake and strain into a chilled martini glass.

The Almond Reserve served at the Lobby Bar of London's One Aldwych hotel.

Since so many of the yummy drinks, like mojitos and margaritas, seem more summer-appropriate, it's sometimes hard to think of the perfect winter cocktail. This one is a fab option for a chilly night.

2 1/2 OZ QUALITY BOURBON (15-YEAR-OLD PAPPY VAN WINKLE'S FAMILY
RESERVE IS ADAM JANNESE'S FAVORITE)
1 OZ QUALITY APPLE JUICE
1 TSP ORGEAT SYRUP*
4 DROPS ANGOSTURA BITTERS

Place in an ice-filled shaker and stir well, then strain into a chilled martini glass.

Perfectionist Tip: Make Flavored Ice Cubes

Freezing little bits of fruit or herbs right into your ice cubes is a great way to give your drinks an extra flavor, and they look great too. Or, keep a drink's flavor from getting diluted by adding some of the mixer to the ice cubes. For example, you can serve screwdrivers with orange-juice ice cubes, and Bloody Marys with cubes of frozen V8 juice. For a really simple drink, Kim Haasarud suggests you just pour vodka on top of any of these special cubes, or vodka and club soda.

Here are four fancy ice cubes Kim recommends. They're especially great for spicing up simple, low-calorie, club-soda-based drinks. They make a basic drink more interesting without adding calories.

Mojito Cubes: Combine 1 part fresh lime juice and 1 part simple syrup, and pour the mixture into ice cube trays. Chop up mint leaves and add a pinch of chopped mint to each cube.

Berry Cubes: Dice a mixture of blueberries, strawberries, and raspberries. Fill an ice cube tray with orange juice, and add diced berries to each cube.

Grape-Lime Cubes: Combine 1 part water with 1 part fresh lime juice, and pour it into ice cube trays. Dice a mixture of green and red grapes, and place a bit of each into each cube; then freeze.

Mandarin Cubes: Chop up mandarin oranges, and place a chunk in each section of an ice cube tray; then fill the tray with orange juice.

Wine and Booze Basics

*This is an almond-flavored syrup you should be able to find at fine gourmet stores or online, but if you can't, you can substitute another almond-flavored syrup.

Creative Cocktail Garnishes

Don't limit yourself to lemons and limes, try some of these cool alternatives:

Cranberries strung on a toothpick in a cosmo or another cranberry-based drink.

Melon balls—one green, one orange—in a melon cocktail.

Berries floating at the bottom of, or stuck on a toothpick in, a drink with berry flavors.

A Hershey's Kiss at the bottom of a martini glass, for either a chocolate martini or just a vanilla vodka martini (for a new twist, try one of those mixed white-and-dark-chocolate-striped ones).

An edible flower floating on top of any cocktail.

A striped candy stick or a rock-sugar candy stick, used as a drink stirrer.

Perfectionist Tip: Make Homemade Vodka Infusions

Flavored liquor, especially vodka, has taken the booze world by storm in the past few years. But instead of buying the preflavored kind, why not create your own uniquely flavored liquor at home? The taste of spirits that have been infused with real fruit is often far superior to the artificially flavored stuff.

Find an empty glass jar, fill it about three-quarters full with sliced fruit of your choice, and then pour in plain vodka. Let it marinate for at least four hours. You can use any fruit that appeals to you, but two of Kim Haasarud's favorite infusions are "kiwi melon" (create melon balls out of honeydew and cantelope and add peeled, sliced kiwi) and "berry berry" (any combination of strawberries, blueberries, raspberries, and blackberries).

If you don't have time to let the fruit marinate in the vodka—because your party is starting in just a couple hours—create what Kim calls a "fast-fusion": Soak the kiwi and melon balls in melon-flavored vodka, and soak the berries in berry-flavored vodka. The vodka will still absorb some of the fruit's flavor, but because it's preflavored, it won't need to sit as long.

A Final Word on Wine and Cocktails . . .

While alcohol can fuel a lot of really fun times, it's key to remember how mercilessly it will make you suffer when you drink too much of it. One of the points of educating yourself on wine and liquor is that once you have a grown-up appreciation of (and not a college-kid fixation on) them, you'll be able to savor them with restraint, and minimize painful mornings-after.

Shopping Guide

Online Resources for Wine and Wine Accessories

There are still some states that don't allow wine to be purchased through the mail, but these sites ship to the states that do. Make your wining and dining life much easier by ordering wine by the case—having your vino land on your doorstep is so much easier than having to lug the stuff home from the store!

FINEWINE.COM: Cecile Roesch-Giannangeli's site lets you search for bottles according to varietal, region, price, or all three, and provides lots of guidance to help you find wine you'll be into.

PERSONAL CELLAR, PERSONALCELLAR.COM: Personal Cellar specializes in boutique wines that are hard to find elsewhere. They promise that a tasting panel has sampled and given the thumbs-up to every bottle they sell. In addition to online shopping, the site offers info on the winemakers and on wine education.

SELECT WINES, SELECTWINESLLC.COM: This site claims to have the "best wine values on the Web," and they certainly have a fun selection of bottles at great prices. They break them down into categories like "Light-Bodied Reds" to help the novice wine buyer.

WINE.COM: This is probably the best-organized wine source on the Web. They've got customer reviews à la Amazon.com, so you can see what other wine-drinkers think of a bottle before you buy.

Perfect-Hostess Pointers 4

ADVICE ON THROWING GATHERINGS YOUR
GUESTS WISH WOULD NEVER END

Because you picked up this book, we've already established
that you've grown a little tired of doing your socializing in restaurants and bars. If
you've started to feel that shouting to be heard by your dinner companions over
the din of the people at the next table, and the background music you didn't
choose, is more exhausting than it is fun, or are tired of having to employ flirta-
tious eye contact to get the bartender's attention, or are simply feeling like a
sucker for paying $10 for drinks and $40 for bottles of wine you could get for $12
at your local wine shop, you know what I'm talking about. But don't ever let a little
nightlife fatigue lead you to hang up your party shoes and get overly familiar with
the programming on obscure cable channels! The solution is to supplement your
social life with gatherings at your own place.

You definitely shouldn't deny yourself all the gossiping, flirting, schmoozing,
boozing, and communal eating those nights out at restaurants, bars, and clubs en-
tail, but you can partake in those activities surrounded by the comforts of home.
You'll find that dinner parties and drinks gatherings under your own roof are often
much more enjoyable than the socializing you do in public: you get to have every-
thing just the way you like it, and in addition to your own fun, you get the satisfac-
tion of creating fun for others.

But hosting people can be downright frightening if you haven't done much of

it before. The important fact to keep in mind is that it's not perfect food or some nightclub-style sound system that makes a great party. I learned this well a number of years ago when I went to two very different parties in the same weekend. Friday night's bash, a birthday party for a girl with very generous parents, had platters and platters of professionally catered food and a big-name DJ. Letterpress invitations had been sent out a month in advance, and everyone I knew who was invited had been looking forward to it ever since. We were all dressed to the nines when the night arrived. But the party never really took off. It wasn't a total dud, but it was one of those events where you check each other's outfits out and nibble at the passed hors d'oeuvres, but never really get down to the business of letting loose and living it up. Before the event's official ending time everybody had already plotted out which bar to hit afterward and started to head out the door.

The next night I attended another friend's birthday party. This one was held on her apartment building's roof, which wasn't a fancy wood-floored deck, just the concrete roof at the top of the stairwell. She'd borrowed beach chairs from friends and scattered them around, and had a keg and a simple self-service bar of vodka and mixers in the corner. In place of a DJ, she had set up a boom box playing mix CDs, and the only décor was flickering votive candles placed in glass jars around the perimeter of the space. For food, she took a group order for pizza midway through the party.

This humble roof party was about a hundred times more fun than the previous night's fancy one. Dancing broke out in the middle of the roof, and everyone stayed until something like three-thirty. I can't say exactly why the first party paled in comparison, but it had to have been due to the attitude of the hostess. The Friday-night hostess passionately wanted her event to be a smash, and that perfectionist, slightly obsessive attitude must have permeated the atmosphere of the party and thrown things off. But hostess number two didn't overthink it: she just mixed together a few key ingredients—good music, ample alcohol, and some mood lighting—adopted a happy party attitude, and let the rest take care of itself.

So that's the first, most important rule of party planning: Have a fun attitude and don't obsess over the details. However, there are a few more lessons you should learn before you launch your new life as a hostess. Here I've spelled out the essential elements a get-together needs to be a true success, whether it's a tiny dinner party or a one-hundred-person blowout, as well as some basic principles of hospitality you should stick to whenever you invite someone into your home.

To host gatherings people never forget, make your pad the place everyone

wants to party, and leave friends with a warm fuzzy feeling at the end of the night, just read on.

The Four Requirements for a Perfect Party

These are the elements that every party has to possess in order to be truly impressive: the right crowd, a festive atmosphere, plenty of great food and drink, and the little details that make guests feel you really care. Whether you're throwing an intimate dinner party or a blowout drinks bash, these are the key things you need to think about.

Sure, we've all been to insanely fun parties that lacked some of these qualities—super-informal gatherings over cheap beer in a brightly lit room that turned out to be unforgettable, because all the right people were there in just the right mood. But at the same time, no party that has all these elements has ever truly been a disaster. And that bare-bones, poorly planned party would have been even more fun with these attributes on its side.

Party Essential #1: The Right Crowd

Picking the Perfect Guest List

The first step in planning a bash is of course deciding whom you want to be there. As a general rule, invite more people than you think your place can handle. It's better for a fete to be too crowded than not crowded enough. Think about it, at a crowded party you're never sure who's across the room, you have to lean in close to people, and you bump rumps with other guests a bit, all of which gives the event a fizzy, flirty energy. At an undercrowded party, on the other hand, you're obligated to make the rounds to talk to everybody in the room, however boring (since you can't just stare at each other across the expanse of empty floor and not engage), and once you're talking to someone, you have a terribly awkward time breaking away. (A side note to this bit of advice from pro party-planner Sam Sabine, owner of New York's Great American Catering: Don't limit the guest list because of a lack of seating—if lots of people have to stand, it keeps everyone up off of their butts and keeps things energetic.)

That said, you obviously don't want a crush of bodies that'll make people feel at risk of death by trampling. When deciding how many people to invite, you should

count on a **20** percent no-show rate, taking the nature of the occasion into account in your estimates—more people will show up at a birthday party, because they feel especially obligated to attend; fewer people will show up on a holiday, since they'll have other invitations and obligations, and that type of thing. And Pauline Parry, owner of the Los Angeles events company Good Gracious! Events, advises that you consider how many people will be there at any given time. So if you've got sixty people you want to invite, and estimate that ten of them won't be able to make it, keep in mind that not all of the remaining fifty will be there at once, except perhaps at the party's peak, since people will come and go at different times.

As far as deciding whom to invite, always try to bring a few new people into the mix. Most of us have one or two set groups of friends, and while parties provide a great opportunity for the members of those crowds to catch up, always socializing with the exact same people can get boring. If you only invite a standard crowd to your gatherings, people will come to expect the same old thing. So take a chance and invite some people you don't know all that well or just never spend Saturday nights with—friends of friends, the girl you always chat with before your Pilates class, the coworker you have Tuesday lunches with but have never seen after dark. Mixing new faces in with the expected ones will add new energy to your gathering.

A corollary to that: You're not obligated to invite every friend you have every single time. Those pals whose presence will require babysitting—the socially anxious single girl who stays in a corner looking standoffish, the rowdy drunk who manages to offend half the partygoers before the night's halfway through—can spoil a lot of your fun and eat up the time you have to spend with your other guests. If these people are truly close friends, you have to invite them over occasionally, but give yourself a hall-pass from them sometimes. As long as they aren't really close with your other friends (and these high-maintenance friends usually aren't, or they wouldn't be such burdens), they're not going to know that they're not getting the nod to your every fete.

Sending Invites That Lure Them

The method you use to summon people to your place sets the tone for the night weeks before it occurs. While the e-vite is an easy, indispensable way to notify a bunch of people about a last-minute gathering at a bar or to summon them to a really casual affair, when you want your party to feel special, an old-school

mailman-delivered invitation is the way to go. Proper paper invitations build excitement—receiving a piece of personal mail is such a treat in the e-era—and signal that you're making the effort to ensure your party's a good one. And, they're a good idea strategically, because they tend to increase turnout. When you've singled someone out by sending a personal invite to his home, that person is way more likely to RSVP and follow through than if you just included him in a group e-mail that took little effort on your part beyond hitting the *send* button.

Of course you can buy invitations with specific spots for the date, time, and so on, or get invitations printed, but if you want to save some dough, just create them at home. Buy simple note cards and write or print all the pertinent information on them. Here is the essential info any invitation needs to include.

What type of party to expect: In the first line give a clue as to what the tone of the party will be and why you're throwing it—something like "Drinks and Snacks to Celebrate Amy's 27th Birthday!" accomplishes this. You should give your invitees an idea of what to expect in terms of food and drink. "Cocktails" or "Drinks" means you'll have a variety of drinks to offer and at least a few appetizers. If you're going to limit your selection to wine and cheese, vodka and caviar, champagne and dessert, or margaritas and guacamole, let them know that. People will feel more comfortable attending, and get more amped up about it, if they know a little bit about what awaits them.

The details: Of course after the first line you need to list all the wheres and whens, but here are a few things the pros suggest that you might not think of otherwise. First, always include the day of the week in addition to the date (for example, "Saturday September 25," not just "September 25"), because it lessens the chance anyone will get confused about the day of the week and double-book on the night of your bash. Second, it's best to give an end time for your affair. This helps you control the evening. If you write "6 to 9 o'clock," you signal to people that it's not okay to show up at 8:15, which they might do if you didn't designate the end time. Also it should keep people from staying till all hours, since they know you want things to wind down by a certain time.

Now, if you're just having a few people over for dinner, there's no need to send paper invites (unless you're planning a really over-the-top meal for a truly special occasion). Just call or send an e-mail and then follow up a few days before the event—if you e-mailed the initial invitation, call your guests to touch base, and if you called or talked about it in person initially, send an e-mail to follow up.

Five Great Reasons to Throw a Party
(not that you need a reason)

IN SOMEONE'S HONOR: You can and should go beyond birthdays as a reason to host a party for somebody else. If a friend just moved to town, is moving out of town, or has done something impressive (won an award of some sort, run a charity marathon and raised unheard of amounts of money for the cause, completed some kind of artistic endeavor like directing a play or performing in a concert or having a show at an art gallery), it's a good reason for a party. Parties in someone's honor usually guarantee a good turnout and a festive atmosphere—what better excuse is there for staying out too late and drinking too much than to honor a friend?

FOR CHARITY: You don't have to attempt a blowout benefit to throw a party for a cause. Try having a "girls' tea" one Saturday afternoon and state on the invite that everyone should bring some gently-worn work clothes to donate to a program for women on welfare who are looking for jobs. Or ask people to bring a small toy to your holiday bash, and then donate the loot to one of those Toys for Tots programs. People will appreciate the opportunity to do good without having to do any of the research.

TO CELEBRATE THE SUNDAY NIGHT OF A LONG WEEKEND: Of course, many people go out of town for long weekends, but if you're in town for one, why not have some fun with the other people who stayed close to home?

B-LIST HOLIDAYS: Throwing a party on big national party days like July 4th, Halloween, or New Year's Eve can be a bit stressful—since lots of other people are throwing parties that day, you may have to compete for your guests and will feel extra pressure to make your party fabulous, because your guests are choosing to spend their big holiday with you and not somewhere else they may have been invited. If you want to throw a party on a festive occasion without the added pressure, do it on a special day that people like to celebrate but don't get as worked up about. Ones

> like Mardi Gras, St. Patrick's Day, Kentucky Derby Day, Cinco de Mayo, and Bastille Day are all great excuses for a bash.
>
> **A "FALL FORWARD" PARTY (ON THAT SATURDAY NIGHT IN THE FALL WHEN YOU GAIN AN HOUR):** I've never actually done this, because I never seem to know this night is approaching until it's upon us. But it's always a super-fun night to go out on and would be an excellent one for a party—knowing they can stay out till two AM and it will then magically become one AM really inspires people to let loose.

Party Essential #2: A Sexy Atmosphere

All the pros agree that the two elements essential to making a gathering truly feel like a party are lighting and music. But before getting into those topics, I should add a sort of obvious but so-essential reminder—make sure your place is pretty clean and uncluttered. For people to truly get in a party spirit, they need to feel like they've escaped the mundane, which will be impossible if you've got piles of papers in the corners, bags of recycling in the foyer, and the like. So clear out all the crap by whatever means necessary. (That said, dimmed lights hide a lot, so if you haven't polished your place from floor to ceiling, don't get stressed out about it.)

Getting the Lighting Right

It's a well-known but often overlooked fact: Everyone's happier in flattering lighting, and the right lighting creates a cozy, intimate atmosphere that'll encourage your guests to mingle. So dim the lights to the level at which you can just barely read a magazine. Party planners always recommend you screw in pink- or amber-hued bulbs for the night to ratchet up the warmth and complexion-enhancing factor.

Plus, it's essential that you fill the room with candles. Stick to unscented white votives in glass containers, and place them in spots where people are unlikely to lean and accidentally light hair or clothing on fire. As an alternative to candles, interior designer Heather Wells suggests you switch all your lightbulbs for the evening to the lowest wattage you can find. For a recent party she switched all her bulbs to 10-watt ones (which can be found in most hardware stores), and it made the room look completely candlelit, without the hassle of candles.

When your lights are low, you don't need to stress so much about how your

place looks. It doesn't matter if some of your furniture has seen better days, because your home will be filled with friends and the sound of cool music and in the soft light it will all look glam and gorgeous. (Candles have become omnipresent in the past few years—just about every store out there has a line of scented ones—but there are still parties where the lights are on full force, so I know at least a few people haven't caught on to the powers of candlelight.)

Be a Great DJ

You can't overestimate how important music is in determining the mood of your gathering—the right sounds will make it feel elegant, sexy, hip, raucous, goofy, or whatever you're after. But the wrong music can really kill a party's buzz, or just keep things from feeling as festive as they could. The ideal drinks-party music is different from great dinner-party music. You want your drinks-party music to be more energetic, so people move around a little and get fired up about each new song and even, if you want it to be that sort of party, push the furniture aside and turn your living room into a dance floor. But killer party music takes some strategizing. The perfectionist way to go is to burn a set of mix CDs or create an iPod playlist specifically for the night, so you can control the mood every minute.

"Party music should start out on a somewhat mellow note and build heat over the course of the evening," points out Sam Sabine. Begin with something instrumental, or, if the music has lyrics, then make it songs everyone doesn't know by heart. If it's too-too recognizable, your guests could find the music distracting, because they'll already either love it or hate it or have the annoying urge to sing along. My friend Hedy, who knows more about music than any other girl I know, says that Brazilian music is best for a cocktail party because you can find really festive stuff that people won't be familiar with but will like right away.

But once your party has gone on for longer than two or three hours and everyone has had more than two or three drinks, you can crank it up a bit and put on some danceable tunes. No matter what else you've done, if people wind up dancing in your home, your party will go down in the record books as an epically fun evening. If you want to get 'em boogying, play party classics that you know will appeal to your particular crowd, whether it's seventies disco or early nineties grunge. "People dance to what they know, so music for a party in your home shouldn't be cutting-edge," says Boston and Miami–based events-planner Bryan Rafanelli. "I

love modern DJ remixes of old classics, so the songs feel hip but people recognize them." Also, when getting a crowd dancing is your goal, gear the soundtrack a bit more to what you know the women in the crowd will dance to. Here's a little piece of wisdom a guy once pointed out to me: "If the cute girls start dancing, a guy will too, even if he's not that into the music, but no straight guy is going to start dancing—no matter how much he loves the music—if the girls aren't."

For a dinner party, the background music should be just that—in the background and not too noticeable—but it's still essential it's good. Steer clear of anything too energetic or rock 'n' roll because it will make it hard for people to relax and enjoy the food. But don't play all classical stuff, either, unless you're willing to risk a stuffy atmosphere. The goal is to create a mellow-but-sexy mood, so think rhythmic soul or trip-hop or ambient tunes or soft jazz or mellow world music. The Buddha Bar, Café del Mar, and Om Lounge compilations are all safe bets, as are the mellow mixes a lot of hip hotels now make, such as those from the W chain and Paris's Hotel Costes.

Never, Ever: crank up the music so it's too-too loud (unless it's really late and nobody left at the party is able to talk coherently anyway). You can't jumpstart a party into wild-and-crazy mode by blasting the music, and it will just be wildly annoying. New York photographer Patrick McMullan, who literally goes to parties for a living and has been doing it for decades, recently declared, "These days, loud is the new smoke. It used to be that you'd be driven out of parties because they'd be

way too smoky. Now people don't smoke as much, but parties get so loud that you have to leave," says Patrick. "I've been at absolutely great parties that just died because they were too loud. You'll be at a party filled with the most interesting people—someone like Henry Kissinger will be at your table—and you won't even be able to hear what they're saying." Now, you probably don't have a megawatt sound system that's going to deafen people, and (hopefully!) won't have former Nixon cabinet members at your next bash, but it's important to remember that a too-loud party will send people looking for a place where they can hear each other, and that place may be home or a mellow bar down the street.

Smart-Girl Secret: Have a cohost. Photographer Patrick McMullan gives this as one of his key pieces of advice for girls eager to master the art of the cocktail party. Unless you have a dependable significant other to share hosting duties with, enlist a girlfriend to help you out. If the party is your idea, she shouldn't have to fork over any money or do serious prep work, but she can be your go-to girl on the night of the event. When you're occupied talking to someone or popping a tray of appetizers into the oven, she can welcome newcomers, mingle, and introduce people who don't know each other, and do little details-y tasks like disposing of discarded cocktail napkins and keeping an eye on the ice supply. Of course, at the end of the night your cohost deserves a big fat thank-you—in the form of a gift or at least a share in any hostess gifts you've received that night.

Party Essential #3: Plenty of Great Food and Drink

Dinner parties and cocktail parties require very different things of you, since the one is smaller and food-focused, and the other is bigger and booze-focused. Throwing a drinks-oriented party may seem less scary than hosting a dinner, because you've been having people over to drink in some fashion since college. But now that you've got domestic goddess inclinations, you want to do way better than slapping a few bottles of liquor down next to a basket of pretzels and asking your guests to bring beer. You want to host people for a special night that will make them feel indulged and stir up good conversation and possibly some intrigue in your living room. Even though sloppy, thrown-together booze sessions can still be fun at any age, an elegant cocktail party done right will inspire your guests to be at their wittiest, flirtiest, and most fun.

Delish Do-Ahead Drinks

All of these drinks can be made two hours in advance of the start of your party.

WHITE COSMOPOLITAN: This trendy tipple is a great solution for at-home hosts because it tastes every bit as scrumptious as the drink made famous by Carrie Bradshaw, but it won't stain anything cranberry red in the event of spills. This recipe makes a batch that will dole out 4 to 6 drinks, depending on the size of the glasses you're pouring it into. Just double, triple, or quadruple this recipe to fit a big pitcher or pot.

The recipe: Mix 20 oz white cranberry juice with 8 oz citrus vodka, two oz fresh lime juice, and 1 oz Cointreau, Grand Marnier, *or* another orange-flavored liqueur (but you can substitute 2 tsp superfine sugar if you don't feel like buying liqueur). Stir it together, and when you're ready to serve it, pour some into a cocktail shaker with ice, shake, and strain it into a glass. Garnish with a twist or slice of lime. *Note:* There are lots of slightly different recipes for cosmos out there. This one isn't super-strong, but just increase the proportion of vodka to cranberry juice if you want stiffer drinks.

PAULINE'S WHISKEY-TINI: Events planner Pauline Parry serves these at some of LA's biggest shindigs. Using brown liquor instead of vodka makes them a little more interesting than your standard martini-style drink. Makes 4 drinks.

The recipe: Combine 10 oz whiskey, 2 oz simple syrup, 1 dash Angostura bitters, 2 oz fresh lime juice, 1 oz Pastis, and stir. When you're ready to serve it, pour some into a cocktail shaker with ice, shake, and strain into glasses.

THE PASSION BULL: Master bar chef Albert Trummer created this for SoHo hotspot Kittichai, a bar and restaurant located in the 60 Thompson hotel. The Red Bull Energy Drink gives it a little extra kick, and the sparkling Prosecco adds a touch of fizziness. Although the recipe calls for passion fruit puree or juice, you can substitute other fruits, such as

(continued on the next page)

mango, peach, or whatever is available and appeals to you. If you want to give the drinks more of a sparkling quality, you can up the amount of Prosecco, or if you want them to be slightly weaker and less sweet, add a little club soda. This recipe is enough for 4 to 6 drinks.

The recipe: Combine 10 oz fresh passion fruit puree (if you can't find passion fruit, substitute passion fruit juice) with 4 oz vodka, 2 oz Cointreau, and 1 oz Red Bull Energy Drink. Stir the ingredients together; then top off with a few splashes of sparkling Prosecco. When you're ready to serve it, pour it into ice-filled glasses.

A Strategy for Quenching Everyone's Thirst

The number one requirement for a good party is that the guests have a chilly drink of their choice in hand pretty much at all times, and achieving that is probably the novice host's biggest challenge. You need to put some advance planning into making sure (a) that your guests will have enough drinks to get them as buzzed as they wanna be, and (b) that they're able to get those bevvies (along with plenty of ice and served in something better than a plastic cup) without delay.

The best way to save money and hassle is to limit the types of drinks you offer. Most top party-planners advise you to serve just one or two festive signature cocktails, along with beer and wine. You can make up big batches of these cocktails in advance, leave them in pitchers in the fridge, then as guests arrive serve individual glasses on trays, and walk around refilling their glasses from a chilled pitcher throughout the evening. For this to work, the drink in question needs to be a little bit special (not just a vodka tonic or the like) and truly taste amazing.

Smart-Girl Secret: "When you're mixing up big batches of cocktails, make them slightly weaker toward the end of the night," says Pauline Parry, owner of Los Angeles's Good Gracious! Events. "Your guests won't notice at that point, and they won't remember your party with warm feelings if they spend the whole next day with an awful hangover."

However, if you feel a bit cheap not offering your guests a wide variety of booze, or if you know the crowd you've invited takes the sauce rather seriously and won't be

happy without some selection, you'll want to put together a fuller bar. Take into account the inclinations of your crowd, but a safe bet is to go heavy on supplies of vodka (just about everybody drinks it), medium on bourbon and rum (the favorites of many boys), and light on the scotch, gin, and tequila (there's usually at least one scotch or gin fan in the crowd, and people may want to do shots with the tequila), but these last three aren't totally necessary. Nobody ever *needs* tequila, really.

Set up the bar in an easily accessible corner in the main room of the party, not in the kitchen if you can help it. If you put the bar in the kitchen, half the guests will wind up squeezed in there at any given time and your fete won't flow properly. If you can afford to hire a bartender, that will make everything much easier and more elegant, and doing so doesn't have to be that expensive. Call a local bartending school, or even ask around to see if anyone knows a college kid willing to do it for ten or fifteen dollars an hour. The only potential problem with bargain bartenders is that they can be overly slow with the drink mixing, and the last thing you want is a long line of thirsty people at the bar, wishing they could just take over and mix their own drinks.

But regardless of what sort of bar you set up, place a pitcher of water and a stack of paper cups on a tray across the room, separate from the drinks (add some sliced lemons or cucumbers to the water for a tasty touch). This way people can easily get their share of H_2O without having to ask you or root around your kitchen cabinets looking for a glass.

Smart-Girl Secret:
Even though nothing looks more grown-up and glam than a roomful of people sipping out of martini glasses, it's terribly easy for guests to spill a bit over the sides of them, often without even realizing it, and especially when they're on their third drink. There are a couple ways to reduce the percentage of these "straight up" drinks that will dribble straight down onto your sofa or rug. First, if you do use martini glasses, don't fill them all the way. Or, just use small wineglasses instead—they're much easier for tipsy people to manage.

Perfectionist Tip:
To give your party an injection of goofy energy when it's been going on for a few hours, bring out a surprise tray of Jell-O shots. To make them, just follow the recipe on the box but substitute vodka for the cold water called for. Don't try to use more vodka than that or the Jell-O won't gel right.

How to . . . Stock Your Bar

The party-planner rule on cocktail consumption: Assume one drink per person for every hour the party lasts. So for a three-hour party for twenty people you'd need to plan to serve sixty drinks. This generally works out well—because even if some boozehound guests throw back a drink every half hour, other guests will be going light because they're driving or recovering or just health conscious. Still, you want to stock a bit more booze than this to be on the safe side.

Memorize these figures: A standard 750 ml bottle of alcohol yields 12 to 15 drinks—so for the three-hour party for twenty people, you'd need at least four bottles of liquor to make the sixty drinks needed. A bottle of wine holds 5 glasses.

The right mix of mixers: While it depends on your crowd, the bar basics are club soda, tonic, cola, diet cola, ginger ale, and orange juice. I've been to tons of parties where someone has to run out to get more club soda mid-evening, so I'd say buy three times as much of that as you think you'll need. Take into account the length of your affair and the liquor tastes (and lush factor) of your invitees, and purchase accordingly.

Appetizers They'll Gobble Up

A quick way to thrill your guests and ensure that they leave your home happy is to serve delicious snacks other than the expected crudités, cheese-and-crackers setup. The thing that's so exciting about professionally catered parties is all those perfect-looking delicious little bites being carried around by waiters, and while you won't have (or want) waiters at your house party, it's really not much extra work to give your cocktail food a bit of a professionally-catered feel. There are a bunch of delish apps that can be almost totally done ahead. And you don't need to serve a zillion different things. Try for one or two hot appetizers, plus at least one with meat in it and one that's vegetarian-friendly. Supplement your appetizers with a few simple munchies like bowls of olives and nuts. The standard caterer rule is to plan for every guest to eat $4\frac{1}{2}$ appetizers per hour, so for a three-hour

Do It on Pennies

Pigs in blankets: Every caterer I've asked says these are one of the most popular options out there, even among the most well-heeled crowds. Don't bother trying to make them, since everyone likes the frozen kind so much. Get over the idea that they are tacky—but do dress them up by putting them on a fancy tray along with a little bowl of Dijon mustard for dipping.

Pita-and-hummus bites: This is a dressier, easily edible way to serve the classic pita-hummus pairing. Just slice a mini pita in half from the side (into two thin circles); then slice each half into eight triangles. Brush each with olive oil; then sprinkle them with chunky sea salt, like Maldon. Pop a tray of them into the broiler for five minutes. Top with a dab of hummus and a parsley leaf.

Caprese toothpicks: Slide half of a cherry or grape tomato, half of a bocconcini (those little mozzarella balls), and a leaf of basil onto a toothpick. Once you've done a plate of them, drizzle them with olive oil, add a few splashes of balsamic vinegar, and sprinkle them with chunky sea salt and freshly ground pepper.

Endive with herbed cream cheese: Endive spears are great vehicles for just about any type of spread or mousse you want to put in them. One of the easiest fillings is herbed cream cheese. To make the cream cheese filling: Mix together an 8-oz package of room-temperature cream cheese with 2 finely chopped green onions, 4 tbs finely chopped fresh dill, 2 tsp of chopped fresh chives, and 1 tsp lemon zest. Process the mixture in a food processor if you have one, but otherwise just mix it together really well. This makes enough for about 30 endive spears, which you can get from 4 or 5 heads of endive. Just spoon a dollop of the herbed cream cheese onto the round tip of each endive spear and garnish it with a sprig of parsley or a few chopped chives. For a fancier version of this app, place chopped smoked salmon on top.

Do It Posh

Mini crab cakes: In addition to pigs in blankets, this is the other hors d'oeuvre every events planner says is a favorite. There are hundreds of different recipes for crab cakes, but this is a basic one I perfected with a little help from the guy behind the fish counter at

Perfect-Hostess Pointers

the Gourmet Garage in the West Village. You can add all sorts of herbs and seasonings to the crab mixture, but I like to keep the recipe pretty simple so you can taste the crab. The key thing is to do it far enough in advance that the crab mixture can chill in the refrigerator for a while both before and after you form it into cakes; that's what keeps the crab cakes from falling apart. My recipe: Mix together 1/3 cup mayonnaise, 1/2 tbs stone-ground mustard, 1/2 cup diced green onions, 1 tsp Worcestershire sauce, 1 tbs lemon juice, 1 tsp paprika, 1/8 tsp cayenne pepper, and 1/2 cup bread crumbs. Next, add 1 egg and mix it in well; then add 1 lb crabmeat, gently mix it in, add a bit of salt and pepper, and refrigerate the mixture for about 1 hour. Meanwhile, heat the oven to 350 degrees, spread 2 cups of bread crumbs on a baking sheet and toast them for 10 minutes or until they're golden. Once the crumbs have cooled and the crab mixture has chilled, form the crab mixture into little cakes that are 1 inch or less across and roll them in the toasted bread crumbs until they're thoroughly covered. Remember, you want to keep them bite-size. Place the crab cakes on a cookie sheet or in a baking dish, cover them, and put them in the refrigerator for at least 1 more hour (but up to 5 or so). When you're ready to serve them, preheat the oven to 450 degrees, brush a bit of olive oil on top of each crab cake, and bake them for 15 minutes. Serve them hot, with a bowl of cocktail sauce and/or mayo-based dipping sauce on the side.

Proscuitto-and-goat-cheese bites: This appetizer is a delicious mix of salty and sweet, and creamy and crisp. Just take a toast point, toasted baguette slice, or any flat cracker (whether store-bought or homemade), smear it with goat cheese, put a tiny piece of arugula on top of that, a piece of proscuitto on top of the arugula, and then top the whole thing with a dab of fig jam or raspberry jam. This is one people might be a little hesitant to pick up at first, but once they do, they'll go back for more.

Bagel chips with smoked salmon: This is a really fun, laid-back way to serve smoked salmon. Take plain store-bought bagel chips, smear them with cream cheese, and top with a strip of smoked salmon or lox. Garnish with a sprig or two of dill. (Use thick, sturdy chips or they could get soggy after sitting on the appetizer table.)

Stuffed baby potatoes with caviar: Take 16 small red-skinned potatoes and slice them in half lengthwise. Put them in a bowl, drizzle them with a little olive oil, and mix together so they're covered with a thin layer of oil. Bake them at 400 degrees for 25–30 minutes; then let them cool. Use a small spoon or a mellon baller to scoop out some of the center of each potato; then set them on a tray, cut side up. If they don't stand upright, cut

a small sliver off their undersides to form a flat base. Fill each with crème fraîche and put a dollop of caviar on top. *Note:* To make this more affordable, look for American sturgeon or paddlefish caviar, which are both much less expensive than foreign fish eggs, or use salmon roe.

. .

cocktail party you'd want to have at least 12 apps per guest. I've also heard that the larger a party is, the less people will eat, and vice versa.

Stepping up the elegance factor of your party food doesn't have to involve a boatload of work—you don't need to do super-complicated or pricey stuff, and preparing the appetizers definitely shouldn't take as long as a Thanksgiving dinner. You just need to go a few steps beyond the chips-and-salsa, crudités-and-onion-dip thing. If you're going to the bother of having your friends over for fun, you may as well put a little extra effort into the food, right? It's one of the main distinctions between a low-key gathering and a proper grown-up party.

See the two sample menus of easy appetizers for two budgets, starting on page 179. The first is pretty inexpensive but still elegant; the second one is a little swanker.

Smart-Girl Secret: "To keep a party vibrant, you need to keep people moving. So place your food area across the room from the bar to promote mingling, and have seating for no more than a quarter or a third of your guests," says Sam Sabine.

A Caterer's Appetizer Axioms

I quizzed the pros on which appetizers are the ones party guests always gobble up the minute the waiter steps into the room, and which trays tend to come back to the kitchen still half full, rejected like last year's handbag. Here's what Bryan Raffanelli said event planners know about what people want to eat.

- All hors d'oeuvres should be bite-size. If you're going to do stuffed mushrooms, find the smallest mushrooms in the city.
- People don't want to pick up anything wet or messy-looking—like stuff with a lot of sauce already on it or an oily puff pastry.
- People are hesitant to eat things on sticks, like chicken on skewers. They worry they'll make a mess, and not know how to dispose of the stick.

- The exception to the messy rule may be shrimp—everyone likes them so much that they're willing to take the risk at least some of the time.

Never, Ever: Serve hot appetizers that have to be made on the stovetop. Hot appetizers should always come from the oven: that way you can pop them in when the first guest rings the doorbell, leave them baking while you greet everybody, and then just bring them out however many minutes later, without your having spent any time tending to them. Any app that requires stove attention is out, as evidenced by this anecdote from my friend Melissa: "Once I made potato pancakes with caviar as an appetizer, and it was a disaster," she says. "I was totally sweating over the frying pan with my guests unattended in the living room, and exhausted myself before dinner even started. Of course three people called me the next day to ask for the recipe, but ultimately it wasn't worth it."

If your party's not just predinner cocktails but is more of an all-night affair, clear away the apps about a half hour before it's slated to end. Then bring out a few desserts, both to satisfy sweet tooths and (if you're getting ready to call it a night) to signal that things should be winding down. Don't bother making gourmet desserts for a boozy bash because nobody will appreciate them. After a few drinks people either want no sweets at all or want something yummy and uncomplicated. The biggest crowd-pleasers are the simplest sweets—chunky chocolate chip cookies, brownies, and that sort of thing. If you want to keep up the elegant vibe you've had going, bring out trays of classic desserts with bitsy dimensions—just cut up stuff like brownies and Rice Krispies treats (whether homemade or store-bought) into little one- or two-inch cubes. Desserts are generally better when bite-size, I think. You can always have more than one bite, but you don't feel as gluttonous as when you dig into a big fat baked good—or worse, gradually, guiltily pick at one until it's a pile of crumbs (which is something I'm very prone to do). People, women in particular, will be more likely to indulge if the dessert is served in tiny portions. Some other elegant sweets to serve are gourmet chocolates, little madeleines or macaroons, or chocolate-dipped strawberries. Chocolate-dipped strawberries look really impressive and seem like such a treat, but are easy to do. You just buy quality strawberries (ideally the kind with stems, if you can find them), and then melt good baking chocolate (Pauline Parry recommends a brand called Callebaut) for a minute or so in the microwave. Be care-

Cooler Crudités

Nothing's less exciting than a plate of cut-up veggies and dip, but partygoers always want some crispy fresh veggies, especially if other appetizers you're serving are scrumptious and heavy. So to liven them up, make these standard party snacks look more appealing. Instead of dumping a bunch of veggies on a tray together, set out two or three types of raw veggies separately, each with its own dip. For example, celery sticks could get a spicy Thai peanut dip, while cherry tomatoes are next to a cheese-based dip, and carrot sticks are across the room with a classic green goddess dip.

ful not to heat the chocolate for too long—microwave it bit by bit until it's just liquidy enough. Then dip the berries in the chocolate, set them on wax paper, and refrigerate them.

Smart-Girl Secret: "Never, ever use peanut oil in party food," says Pauline Parry. "Nut allergies are one of the most common and can be deadly."

Pointers for a Terrific Dinner Party

Now, dinner parties are a different type of beast, and although the key ingredients of any gathering, whether a cocktail party or a dinner party, are the same (the right crowd, atmosphere, food and drink), mastering a dinner party requires some extra know-how. The payoff of hosting one is big: you get to experience that great feeling of generosity that comes from treating friends to good food and a fun evening; you hone your cooking skills with a hungry, appreciative crowd to feed; and you have an entertaining night in the company of people you handpicked. But when I first attempted to host dinners, I quickly learned (and you will know if you've ever tried to serve more than two people a hot meal) that it can be a totally stressful endeavor. Even if you choose an ultrasimple, pasta-with-red-sauce sort of menu, serving up food that looks good and tastes great—while at the same time making sure your guests have some sort of beverage in their glasses and your

Insiders' Tips on Making Your Apps Look Professionally Catered

Sure, it's important that the food tastes good, but presentation counts for a lot. I really believe things taste better when they look good. Here are some ways to make the nibbles look nice.

- When plotting your serving strategy, gather all your bowls, trays, and serving plates in advance and think about what will look best in what. For example, hummus won't look great in a glass bowl, but multi-colored olives will.
- Decorate platters of hors d'oeuvres with flowers, fresh herbs, and mini votive candles.
- Line plates with beautiful (nonpoisonous!) leaves before putting appetizers on them.
- Sam Sabine sometimes serves hors d'oeuvres on a bed of dried beans, "as long as the food isn't sticky—you don't want the beans to stick to the food!"

cute little outfit doesn't catch on fire—is usually a lot harder than you expect. And, if you want to do something a little more gourmet, the anxiety factor goes up exponentially.

So, to help all of us pull off terrific, relatively stress-free dinner parties with total confidence, I compiled every bit of know-how I've picked up over the years and asked a bunch of pros for their input. Just remember, while you want it to be elegant and show that you really made an effort—the whole point of having people over is to make them feel a little bit pampered—at the same time you need to keep it as easy for yourself as possible, or you'll be a stressed-out mess and it won't be fun for anyone. For a dinner party to really be a success you need to enjoy it every bit as much as your guests do.

The first thing you need to consider is the menu. When you're feeding more

How to . . . Cope with Smokers

Decide in advance whether you're going to allow smoking at your party and how you're going to handle it. It's a bit tricky because as a hostess it's your job to make everyone comfortable, so you want to let the smokers smoke, but you also want to prevent the people who hate secondhand smoke from being subjected to it. One solution is to create a smokers' corner, by placing an ashtray next to an open window and subtly (or not-so-subtly) directing people to only do their lighting-up there. I never think kicking smokers outside is such a great idea, because then a portion of the party is taking place outside and things feel sort of disjointed.

than two people, you have to pay attention to some additional factors when deciding on the dishes you'll serve. You need to strike a tricky balance: make food that's tasty and special enough that the event is worth your effort, but isn't so labor intensive or risky that you can't enjoy the evening. So to help you choose a menu that makes both you and your guests happy, keep in mind the following three criteria when planning.

Three Requirements a Dinner Party Menu Should Meet
- It can be 75 percent prepared before your guests arrive. So you spend most of the night carousing with them, not slaving over a stove.

- It accounts for the diverse tastes of a crowd. If your entrée is rich and meaty, the starter should be something crisp with vegetables, to keep the health nuts from feeling too guilty about the indulgence to follow, and if the entrée is a low-fat fish dish, the starter and dessert should be a bit richer, so the chowhounds in the group don't leave disappointed.

- It leaves everyone satiated but not stuffed. Control portions and limit the number of super-heavy dishes. People will feel obligated to clean

their plates, and they won't have good memories of the night if you send them home with stomachaches. At the same time, you need to make sure everyone gets enough—the worst thing that could happen would be if one of your guests has to grab a slice of pizza on the way home.

The Simplest Strategy: Serving It Buffet-Style

Having a dinner party where all the food is laid out on a table and people serve themselves is the least intimidating way to get the hang of the dinner-hostess thing, because for you it will feel less like a grand performance—with a bunch of hungry people sitting there and watching as you draw the curtains back on your meal. Yes, buffets don't feel quite as special as a sit-down dinner party, where each course is served individually, and, personally, I think there's something about serving myself bits of this and that that's not as satisfying as having it presented neatly on a plate. But there's no doubt that a dinner party done this way has a more laid-back vibe than a sit-down one, and is much, much easier to pull off when you're hosting on your own and don't have someone else to help you get the plates to the table. It's also a good call when you're afraid that a sit-down dinner would strike a stuffier note than you'd like. And when you're trying to feed more people than your table will fit, it's your only real option. This way, people can pick up their food from the table, but then sit all around the room on the sofa, chairs, and pillows alongside low tables.

The Basics of Pulling Off a Great Buffet

- Make a bit more of everything than you would otherwise. Since some people may serve themselves heaping portions, you need to be sure there's enough left over for those that come behind them—and a buffet should never look skimpy.

- The visual aspect of a buffet is important, since you want the food to call out to people and get them excited to dive in. When you're planning the menu, think about how all the food will look together when it's on the table. If most of the dishes are brown, it won't get people as pumped as a variety of colors would. So if you're serving steak and roast potatoes with a simple salad, add some bright peppers to the salad and a sprinkling of parsley to the potatoes, and serve the steak with a red or green sauce on the side.

- Arrange the food on the table in a logical sequence that reflects how it will be eaten (the salad before the protein, for example), and place cold items before hot ones.

- Put the plates at the "start" end of the table, where the salad is, and the silverware wrapped in napkins at the end of the table. That way people don't have to juggle both their plate and their silverware as they serve themselves.

- Caterers often create different levels on a buffet, to make the food look more appealing. The easiest way to do this is with pedestal cake plates. Place a couple of your dishes on them, so they're a level above the other dishes on the table. This can also provide you with extra room on the surface of the table if you're having trouble finding room for all of your feast.

Formula for an Impressive Sit-Down Dinner

But when you want to host a somewhat formal, multiple-course dinner party, you need to do some strategizing first. It will feel relaxed and fun for your guests, only if you actually put quite a bit of energy into making things go smoothly. Here's a step-by-step breakdown of how to pull off an elegant, really fun evening.

When the Doorbell Rings: How to Get Things Started Right

Once your guests arrive, greet them warmly and say how excited you are to see them. Don't tell them how stressed you are about the meal, or how behind schedule you are or any of that. Just get them a drink and sit them down someplace where they can chill out. It's a common mistake of novice hostesses to rush people to the table and feed them right away. So don't get so nervous or excited about the meal you're making that you forget that the point of the evening is the gathering of people, not your command performance as a chef. Remember, you want to start with a "cocktail hour" of at least a half hour (but no longer than an hour, or people can get really famished and overly cocktailed).

Offer one special drink to everyone as soon as they arrive—maybe something seasonal or something that goes with the meal that's to follow, like a margarita if you're serving Mexican food or a Sazerac if you're serving gumbo. It creates a festive mood and saves you the trouble of having to serve a gin and tonic to one person, a bourbon to another, and a Diet Coke to yet a third.

Setting the Table with Style

Unless you're married and have reaped the benefits of that uber-consumerist ritual called registering, there's a strong chance you don't have a perfectly matched set of dinnerware. But don't let that be a hindrance to inviting as many people as your place can comfortably hold. Just mix up what you've got and borrow what you don't have from a friend. Dishes in a variety of colors and patterns all mixed together can make the table look gorgeous. But if you're going to use, say, four place settings of your grandmother's china and four Bed, Bath and Beyond sets with funky patterns on them, don't place all the antique pieces at one end of the table and the modern-mall ones at the other. Alternate them around the table to give your mix a bit of visual coherence.

A note on napkins: Cloth napkins are an important touch if you want your dinner party to feel elegant. Of course the problem with them is that they tend to get stained with red wine or red sauce every time you use them. Sam Sabine told me that she solves this problem by using napkins that are either richly colored, so stains don't show very much, or stark white, so she can bleach the hell out of 'em to get stains out. What are not ideal are ivory or pale pastel napkins, which you can't bleach but which show every stain.

To get wrinkled, newly washed napkins crisp again, iron them using a bit of spray starch. (To keep the amount of ironing needed to a minimum, try to take them out of the dryer right after it stops, and store them flat until you need them.) Then just slip them into napkin rings or fold them into simple rectangles (no need to attempt anything complicated—those origami-esque napkin folds bring to mind hotel ballrooms and conference centers). Don't have napkin rings? Take thick pieces of ribbon and tie a bow around each napkin. Use ribbon that coordinates with your dishes or tablecloth or flowers to add extra color to your table. If you want to make it feel more formal, use silver or gold ribbon, and to add a playful, partyish feel, use ribbon with a colorful pattern like polka dots or plaid.

You should definitely have some nibbles out when everyone arrives, placed wherever you want people to sit before dinner. Maybe that's in the kitchen with you so you can do dinner prep while you chat with them, or maybe you want them in the living room around the coffee table so they don't start poking their noses into what you're doing. People love finger foods because they feel so elegant and like little treats, and besides, one or two people might arrive starving and you don't want them passing out during the predinner conversation. Any of the bite-size apps listed earlier would also make a great predinner snack. But if trays of hors d'oeuvres are too much work or feel too formal for you, simple store-bought snacks work too, and you can be sneaky and make that straight-from-the-deli-aisle purchase appear to be made from scratch. By doctoring it up a bit you'll make it taste better too—for how-to's, see the box above.

Never, Ever: Stuff your guests with predinner snacks. The goal here is to whet their appetites without filling them up too much. "Don't put out tons of hors d'oeuvres, and be especially careful with cheese," says Melanie de Coppet, of Red Table Catering in New York City. "It's really easy for hungry guests to overindulge and then feel stuffed after two bites of dinner." So either skip cheese as an appetizer

One easy and ultra-impressive (but deceptively inexpensive) potion to proffer when your dinner companions arrive is a fizzy cocktail made with sparkling Prosecco, Cava, or some other cheap sparkling wine. You don't need fancy Champagne when you're mixing it with juice anyway, so pick up a couple $10 bottles of bargain bubbly and add some exotic juice (just not orange, which will seem too breakfast-y). Fill each glass one-third or halfway with juice, and then fill to the rim with bubbly.

Do It for Pennies: Use juice in a can from the supermarket brand Kern's. They make hard-to-find flavors like apricot, mango, guava, and peach for about a buck a can.

Do It Posh: Puree fresh strawberries with a tiny bit of sugar or sugar syrup. Bar chef Albert Trummer made a champagne-and-strawberry-puree cocktail (called the Rossini) at Manhattan's Town restaurant when he worked there. It is so damn good, words can't do it justice. To make strawberry puree, just puree 2 ½ cups of clean fresh strawberries (or one 10-oz thawed package of frozen ones) in the blender or food processor with 2 tbs of sugar.

altogether or put out just one or two modest-size portions of an interesting, intensely flavored cheese.

Perfectionist Tip: Use Place Cards

Place cards may sound ridiculously formal if you've never used them before, particularly if the table you're thinking of putting them on is "vintage" (circa 1994) Ikea. But they can make the evening a little more organized, especially when you've invited friends who don't all know each other very well. If you do decide to use place cards, have fun with it: seat single guys and girls next to each other, and separate people from their best friends so they'll be more likely to bond with the whole group.

You can get creative with what you use as place cards. Write each name on one end of a strip of thick ribbon and tie the ribbons around the napkins so that the name shows on one end of the bow. This is both easy and more informal than proper place cards. Or, make the meal feel more like a celebration by using some little kids' cardboard party hats and writing the names on those. You'll delight

Do It for Pennies: Score some small flowers from the supermarket, corner deli, or your own backyard and place them around the table in water-filled shot glasses. A tiny number of little blooms will upgrade the look of the table a lot.

Do It Posh: Putting mini bouquets in individual bud vases at every guest's place setting will make them feel pampered, four-star-hotel style.

everyone if you make the place card a party favor. When my friend Lindsay was hosting a big group of us for a week at her parents' beach house, she dressed up the dinner table on the first night by using brand-new brightly hued rubber flip-flops as place cards. Each pair had a place card tied around the straps with a color-coordinated gingham ribbon, and was roughly the right shoe size of the person to be seated there. While it sounds extravagant to use footwear as a place setting, the flip-flops (from Old Navy) only cost about two bucks each, and everyone was so excited to get them—people love an unexpected gift.

One great idea I heard from a hostess with decades of dinner-party-throwing under her belt: If you're hosting a largish group of people who don't know each other very well, write the names on both sides of each place card, so people sitting across the table from each other will be able to see each other's names in case they've forgotten them.

Sitting Down to Dinner: What to Serve as a Starter
The first course should definitely be done almost entirely ahead of time, so choose either something cold or room-temperature, or a soup that can be all ready and then quickly reheated. If you're serving a salad, have it ready to go and then just quickly add the dressing and plate it while your guests are finishing up their cocktails. While serving

"For a dinner party, votives are a better choice than traditional tall candles, which can block your line of vision and can be knocked over so easily. But if you do want to use tapers, put them in the freezer for a few hours first—this turns any candle into a nondrip candle. You can also buy nondrip candles, but they cost more."

—Sam Sabine, owner of New York City's Great American Catering

the entrée family-style is often your best bet (particularly if you have more than six people over), you should plate the first course individually. It's easy to do and creates an elegant first impression. Again, to make sure your guests don't get too full and spoil their appetite for the entrée that's to come, don't serve huge portions of the first course.

The Main Event: The Entrée

Your entrée is the first thing you should choose when planning a menu, since it dictates the rest of the meal. The classic rule is that a main course should involve a protein, a vegetable, and a starch of some kind—though if your starter was very veggie or starch-heavy, you can probably skip that corresponding element in your entrée. When planning a dinner party menu, it's absolutely key that you take into account how each element is going to be prepared. If your protein will roast in the oven, you need to choose a vegetable that can either roast in there with it or be sautéed or steamed on the stove. Also, think about timing. If one element needs a lot of last-minute attention—say, a risotto you have to stir until it's served—the other dishes have to be low-maintenance, stuff you can either pull from the oven or make earlier and reheat, or which can be served at room temperature.

The easiest way to go may be a one-dish entrée. Things like orzo with veggies, paella, lasagna, pad thai, chicken pot pie—they don't necessarily require added veggies or starch on the side, so it's much easier to deal with preparing and serving them. This approach just requires you to know your guests' food tastes pretty well. Since everything is in one big pot, you need to take into account whether any of your guests are vegetarians or have food allergies or keep kosher or are attempting Atkins—any of which might limit what you put in the dish. You should consider everyone's food issues anyway, but if you're serving a protein with a couple sides, it's a little less essential, since a guest who turns out to be allergic to shellfish can skip your scallops and load up on the baby brussels sprouts and roast potatoes, and another guest who hates brussels sprouts can have extra scallops instead.

"When I entertain at home, I usually make something casual, a one-pot meal, with a simple salad to start and some crusty bread on the side, and I find that people are so refreshed by that. They don't need a rack of lamb or a steak to be happy; often people prefer simple food."

—Pauline Parry, owner of the Los Angeles events company Good Gracious! Events

Smart-Girl Secret: Place a big pitcher of water on the dining table or on a side table next to it. That way people can refill their water glasses themselves, you don't have to worry about it, and they won't wander into the kitchen in search of *agua* just as you're trying to maneuver an unwieldy roasting pan out of the oven. Don't have a pitcher? Clean out a couple clear-glass wine bottles, scrape off the labels, and serve water in those, the way many bistros do.

Smart-Girl Secret: "Just in case disaster strikes and your entrée turns out totally inedible, always have a few boxes of preseasoned couscous on hand," says Melanie de Coppet of New York City's Red Table Catering. "It takes absolutely no time to make, and it's filling and always tastes great. You can dress it up with things like nuts, dried fruit, chopped herbs, or whatever you have on hand."

A Sweet Send-off: Dessert

No proper dinner party is complete without a delicious dessert as a finale, so don't try to skimp on this step—unless you're hosting just a couple close girlfriends whom you know are watching calories. You should make dessert easy on yourself, but that doesn't mean it can't be impressive. Sure, you could throw a plate of chocolate-chip cookies on the table, but if you've gone to the trouble to do everything else so well, why get lazy on the last lap? You can find how-tos for a number of dinner-party-perfect desserts in chapter 2.

But if you simply don't have the time to make a dessert yourself, an elegant alternative is to put out a tray or two of petits fours, chocolates, and little sweets such as pieces of nougat and peanut brittle. Make sure there's some variety and that the sweets are about bite-size, so people can grab them without feeling greedy or needing a fork. The New York restaurant Jean Georges always brings trays of beautiful little sweets to your table at the end of a meal, which I find so thrilling. Even people on diets won't be able to resist one or two. Also, if you've got a lot of hungry-man types in your group, you might want to bring out a cheese plate at the same time you bring out the sweets. As a girl, it's easy to forget that some men, big

"With a dinner party, it's much better to keep the menu simple and make an effort to make simple things right than to try to overachieve. The failure rate with a complicated meal is higher, first of all; plus you won't enjoy it as much, and people will pick up on that."

—*Bryan Rafanelli, of Boston and Miami–based Rafanelli Events*

Impress-'em Presentation Tips

A little know-how can make your dishes look as if they came from the kitchen of a four-star restaurant.

• After you toss a salad and distribute it onto individual plates, sprinkle the top of each with an extra dollop of a few of the key ingredients. So, if you've mixed salad greens with goat cheese, dried cherries, and walnuts, place a bit of the cheese, a few cherries, and a few nuts front and center on top of each pile of greens. It looks more polished and lets people know what's in the salad before they dive in.

• When you're serving soup, place a toasted, olive-oil-brushed slice of baguette in the center. It'll taste delish once it's soaked up some of the liquid, but looks better than a hunk of bread served on the side would.

• Decorate dishes with dribbles of an herb oil. To make the oil, heat parsley, basil, and chives in a bit of olive oil just until they wilt; then puree the mixture in a blender or food processor. Drizzle it along the sides of plates you're serving food on.

• To dress up a dessert, sift confectioner's sugar on top of it, or decorate the rim of the plate with swirls of a berry coulis. To make the coulis, just puree a few cups of fresh or thawed frozen berries in the blender with a few tablespoons of sugar.

guys in particular, need to eat a whole lot more than we do, and a lot of them aren't into sugary stuff. If you serve some cheese and slices of baguette at the end of the meal, any guests who, for whatever reason, didn't get quite enough to eat with the entrée will be able to fill up. The best cheeses for a dessert course are soft and rich or intensely flavored, like triple creams and blue cheeses.

Your Hot Hostess Outfit

You won't enjoy your evening if you look like a maid or a harried hausfrau. But you also don't want to wear something super-fancy—you won't be able to comfortably juggle pots and pans, and if you splatter your designer oufit in the kitchen, it'll put you in a foul mood. Melanie de Coppet is known for dressing fantastically when she cooks—a typical outfit consists of Prada and Manolos—and she's never worn an apron. She advises all aspiring hottie hostesses to wear a sleeveless dress or a simple cami and skirt. Being sleeveless and bare-legged will keep you from overheating, and the ideal color palette is either darks or busy prints, so any drips or spills won't be noticeable. The right shoes are a pair that lets you move around with ease but that you still feel cute in— think ballet flats or kitten-heel sandals. Also, as a hostess you should never be too dressed up or too dressed down, because you don't want guests to feel over- or underdressed in comparison.

Never, Ever: Try to serve ice cream to more than four people. It seems like an easy dinner-party dessert, but serving it to a crowd is difficult, because by the time you get to scooping out the final bowl of it, the first ones will have started to melt.

Perfectionist Tip: If you're feeding a group that's pretty evenly divided between girls and guys and are willing to put in some extra effort, Bryan Rafanelli suggests you give the boys one type of dessert and the girls another. It will feel sort of sweetly old-fashioned, and of course everyone will want a taste of the dessert that they didn't get, so they'll share or swap, which ensures a cozy vibe at the end of the meal.

Smart-Girl Secret: Wear your hair up—either in a ponytail or a casual updo— when both preparing and serving the food. Even though your guests are hopefully people who adore you, the more uptight among them will nonetheless be grossed out if strands of your hair wind up in their suppers.

Party Essential #4: The Little Details That Count for a Lot

Art-Direct It a Little Bit

Put some thought into how you can make your party look great. Not that you should get all obsessive and theme-y; just choose one or two colors that fit the mood you're trying to create and find ways to work them into the party space. Not via cheesy streamers or balloons necessarily, but via the stuff you need at the party anyway. "Buy bright-colored paper cocktail napkins in, say, pink and green, and serve two signature cocktails—green apple martinis and spiked pink lemonade, for example—in those same colors," says Bryan Rafanelli. "It will make the room look amazing without any extra expense on decoration. It will just *look* like a party."

Perfectionist Tip : *Create custom serving trays for your party.* Pauline Parry suggests you just go to a hardware store that sells glass and ask to have 12×12-inch squares of roughly $3/8$-inch-thick glass cut, and have the edges polished. Then slip something interesting between the two of them—a copy of the invitation, a photo of the guest of honor, pressed flowers—Pauline does this for parties she plans. You can also do this with Lucite if you find a plastic vendor who will custom cut it for you.

Add a Few Fresh Flowers

Adding flowers will make any table look elegant and your meal feel more special. Magazines and style-oriented TV shows always seem to encourage you to think of "creative" centerpieces and decorations, like bowls of limes or vases of marbles, but I'm kind of a traditionalist in this area. Flowers do the job so well, so why mess with the formula? You don't need a big, pricey arrangement either. Just get a bouquet from the supermarket or corner deli and give it a makeover by tossing away any baby's breath, cutting the bottom half of the stems off, and breaking it into two or more smaller bouquets.

"If you're having a biggish drinks bash and are on a budget, flowers aren't something you should spend a ton of money on," says Bryan Rafanelli. Nobody will notice them, really, once the room fills up, what with the lights being dim

"Cool-looking appetizer trays are a hostess essential, and Target, Ikea, and Crate and Barrel are all great places to find inexpensive ones."

—Pauline Parry, owner of the Los Angeles events company Good Gracious! Events

and everyone being focused on their cocktails and conversation. But if you're having an intimate gathering or one that you're really trying to make nice for a special occasion (someone's thirtieth birthday or engagement or that sort of thing), having two or three vases of fresh flowers is really essential. It instantly makes everything seem fancier and tells your guests that you care about them enough to make things beautiful in their behalf.

Control the Temperature

"Temperature is really important at a party—it can't be too hot or too cold, or it ruins it," says New York City photographer and man-about-town Patrick McMullan. So pay attention to the temp, and use the heater or air conditioner to get it where you want it. In general, if your party's going to be a crowded one, you want to keep things on the cool side, since all those bodies in close proximity will heat things up.

Perfectionist Tip: *Decorate the front door.* This is totally unnecessary, but a great touch if you want to be full-throttle festive. My friend Amy often does it when she has people over, and I always get a little thrill when I arrive at her place and see something fun and silly on her door. It signals to your guests that you're so excited to be having them over and really intend for it to be great time. For a friend's bachelorette party, she used a photo of a naked man (privates semidiscreetly covered by a sticker) she'd cut out of a gay skin magazine. Silly stuff like that makes people giggle (at least immature girls like me, anyway), and you want them to enter the party with a smile on their faces. If it's a birthday party, blow up a photo (whether a cute childhood one or a silly recent one) of the guest of honor and tape a cutout party hat on its head. There are all sorts of possibilities you can tailor to any occasion.

Prep the Bathroom

Why go to the trouble of making everything else at your party look great only to ignore the space where every guest will inevitably spend a bit of quiet time? Make sure it's squeaky clean, and follow these pointers:

- Put out a brand-new little hand soap and some nice guest towels.
- Light a scented candle or two to keep it smelling sweet.
- Put out a fresh roll of toilet paper, and place an extra roll on the back of the toilet or in a basket next to it.

- If you want to really be cute, place cups filled with spearmint candies and chewing gum next to the sink so your guests can freshen their breath. They'll be so grateful.
- You know that cliché about people snooping in the host's medicine cabinet? I wouldn't know for sure, but I bet it's a cliché for a reason, so do a pre-party medicine cabinet check and remove any prescriptions or other stuff you don't want exposed.

Remember These Perfect-Hostess Pointers

There are three rules about being a good hostess that are, pretty much, more important than anything else in this chapter: (1) it's all about the guests having fun, (2) they won't be able to truly have fun if you don't seem like you're having fun, and (3) just because you should have fun at your own party doesn't give you permission to slack off on making sure your guests have fun. As Pauline Parry says, "If you're not going to give your all to make sure everyone's comfortable, don't bother." Which means you have to mingle like it's your job. "If there are people coming who I don't know incredibly well, I'll do research on them in advance, find out from mutual friends what they're up to at work and what their interests are," she says. "That way I can greet them with real interest and introduce them to other guests I know they'll get along with." It's dorky and Emily Post–y but it's true: In your home everyone should feel important and welcome. "I'm vigilant about making sure everyone has someone to talk to and nobody feels left out," she says. So, if you're suddenly tempted to hunker down with your best friend in a corner and gossip, you've got to stop yourself. You can do that the next time you're at someone else's party, but at your own you must be up and taking care of the group.

Also, first and final impressions are key, so greet enthusiastically and get drinks the second guests enter the door. If you're for some reason not ready and totally stressed that the doorbell has started to ring, never reveal that: you don't want guests to feel unwelcome or that they have to soothe your frayed nerves. Somebody gave me this next bit of advice years ago, and I can't remember who, but it's saved me on many occasions: Even if you're running totally behind and feel crazed, take a time-out about twenty minutes before your guests are due to arrive. Dim the lights, light the candles, turn on the music, put a bowl of cocktail nuts on the table, put on your lipstick, and pour yourself a drink. That way everything will

Dinner Party Wisdom: Pulling It Off with Grace and a Good Attitude

I asked some seasoned dinner-party throwers what they consider the most important thing for girls just launching their hostess careers to keep in mind, and here's what they said.

"One mistake beginner hostesses make is that they get nervous and rush the pace of the evening. So if, as you're eating your salad, you feel the urge to jump up and start preparing the entrée, stop and take a deep breath and a few sips of wine. Your guests will be in absolutely no hurry to eat the entrée; they're having fun talking and drinking and digesting the delicious things you've already fed them, so force yourself to chill out. If you're tense and rushed, it will create bad vibes." —MELANIE DE COPPET

"Chances are, one of your dishes won't taste quite as perfect as you'd planned, and even though it takes a lot of discipline, don't say anything about it. *It's no fun at all for people to feel pressure to praise and reassure the hostess. So remember that ultimately it's not about you and your recipes; it's about your friends having a great evening together. Also, they're probably enjoying the food just fine, and you dissing it will make them notice its shortcomings."*

—MY FRIEND MELISSA BRECHER

"Set it up so that you can spend as much time as possible out of the kitchen and talking to your guests. Put the water and the wine close to the table so people can help themselves, and do almost everything in advance."

—SAM SABINE

Finally, the thing that I think is most essential to remember to do when hosting a dinner party is to honestly assess what your guests will enjoy most, in terms of food, drink, music, and mood, and let that dictate what you do. As a hostess it's so tempting to get caught up in what you feel like

(continued on the next page)

serving, or the music you feel like listening to, and forget that the whole point is to make your guests happy. Just because you were given a Malaysian cookbook you're all excited about doesn't mean the six friends you invited are going to be psyched for a Malaysian meal. Or maybe they will be; it depends on the crowd. The lesson is that you need to think about the tastes of the crowd at all times, and if you suspect most of them would be more excited about classic roast chicken and mashed potatoes, pass on the exotic international fare and aim to make the meanest chicken and mashed potatoes that's ever touched their tongues. Of course you can't please everybody all the time, since people can be damn finicky, but if you aim to delight the majority of your guests the majority of the time, you can't really go wrong, since delighting people is the whole point.

look great, and you'll appear pulled-together when people show up, and they'll never suspect you've already had three kitchen crises.

And at the end of the night as people leave, give each guest a big hug and say that the party would not have been the same without them.

Perfectionist Tip: *Give everyone a party favor as they leave.* A little bag containing biscotti and some fancy tea bags for the next morning is an adorable idea. Or, you can give something silly and tacky like pornographic lighters. Or pass out temporary tattoos at the end of the night. Guests will get caught up in it and quickly put them on, and when they wake up in the morning and see lightning bolts on their arms or snakes on their ankles, it'll serve as a startling but funny reminder of the fun they had the night before at your place.

Overnight Guests

Having a friend spend the night at your home is an opportunity to truly spread some good vibes. As you get further away from your college years, you find that people sleep over at each other's places less and less. So, even if your houseguest is coming

at an inconvenient time—because he or she just happens to be in town for some other reason and needs a place to crash, or decided to come visit you because he or she found some great deal on a flight, without asking if you have a million other things to do on the nights in question—try to remind yourself that the cozy feeling of having a friend bunking under the same roof is rather a rare treat in grown-up life.

Here's a bunch of ways you can make sleeping-over friends feel spoiled and happy in your home.

- Have your guest's bed all set up when she arrives. If you have a spare bedroom, make sure the bed has got clean sheets on it, and if your spare bed is your living-room sofa, get it as close to ready as possible. Have the blankets and pillows waiting there neatly so you can make the bed up easily once you're ready. If you wait till the last minute to prepare her bed and, right before you're both turning in, are scrambling to find pillowcases and throwing blankets at her, she won't feel very welcome.

- Put these essentials on the nightstand or a table next to where your guest is sleeping: A pitcher of water and a glass, a travel alarm

clock, and some reading material. In addition to a basic magazine like *Newsweek*, get something fun like *Hello!* or *Heat* or one of the other European gossip magazines (if your guest is a girl), or if it's a guy, buy him *Sports Illustrated* or *Esquire* or *Playboy*.

- Make sure there's at least a little bit of food in the kitchen—a bowl of fruit, cheese in the fridge, crackers in the pantry, Popsicles in the freezer—so you can offer a variety of snacks.

- Before you go to bed, set out mugs with tea- and coffee-making implements in the kitchen, so your guest can access some morning caffeine if she wakes up before you do.

- Make sure you've got some clean fluffy towels set out for her, and a bathrobe if you've got an extra. Another nice touch: Have a new toothbrush to offer her in case she forgets hers.

One way to simultaneously make your guest feel at home and dispel the pressure to wait on her hand and foot is to emphasize straightaway that *mi casa es tu casa* and she should treat it as such. "My dad had a great rule for our country house," says Sam Sabine. "When someone would come for the weekend, he would tell them straightaway on Friday, 'These are the house rules: You get offered your first drink, but now I'll show you where the bar is and where the kitchen is, and from now on you can help yourself.'"

How to Always Be Prepared to Entertain

If you're really going to perfect your hostess skills, you should be able to confidently invite people over at a moment's notice. The restaurant lost your reservation for four? You just left an afternoon movie and everyone's famished but no place is open for dinner yet? The din at your local bar is deafening, and your friends want to escape to a place where they can hear each other? In situations like these you should be able to invite everyone up to your place for a drink and a snack.

The last-minute-entertaining staples to stock at all times: Food you can leave in your cupboard for a few months without it going stale, like sealed crackers and

Priceless Advice from the Previous Generations

"A hostess should take care to dress the table appropriately. Every item on the table, from butter to mint jelly, deserves its own proper serving dish. A packaged item has no place on the dining table." —VIOLA, 78, DAVIE, FLORIDA

"Always buy extra greens for decorating plates. Line the bottoms with lettuce leaves or place a bunch in a corner of a serving dish. It's an easy but elegant touch." —ANNAMARIA, 69, BROOKLYN, NEW YORK

"Let dinner guests and houseguests help out, whether by making their beds, cooking a course, preparing a salad, or making an exotic drink. It involves them more intimately and makes their lives easier when they ask you to be a guest. You'll set a precedent that works for everyone."

—JOAN, 74, MONTAUK, NEW YORK

"There's nothing like a deadline to force you to get busy. Invite people to a dinner party and you will then have to really clean up the house."

—SUE, 63, BETHESDA, MARYLAND

flatbreads, plus things in jars, like olive tapenade, artichoke pesto, and sundried tomatoes in oil. With those basics you can always put together a simple but tasty little spread. Have a few boxes of preseasoned couscous in the pantry, and keep some salted mixed nuts in there as well. Try to always have some cheese in the fridge and some frozen appetizers, like mini quiches and pigs in blankets, in the freezer. As for drinks, keep red wine on hand at all times (ideal for impromptu gatherings because it doesn't need to be chilled) and basic cocktail fixings, like vodka, club soda, and lemons. Always have a stack of cocktail napkins. And change the ice cubes in your freezer every week or so; then they won't be stale when you're all of a sudden serving drinks.

Ultimately, the formula for being a success at any sort of hostessing is equal parts enthusiasm and preparation. One won't matter without the other. You've got

to have a welcoming, generous attitude, but that won't get you anywhere unless you've got the food and drink and fresh ice to back it up.

Shopping Guide

Party Supplies and Entertaining Accessories

Party planning is much less stressful when you do the bulk of the prep work without leaving your work desk (on your "lunch break" of course).

CHELSEA PAPER, CHELSEAPAPER.COM: This site makes purchasing custom-printed invitations really easy, and they have an impressive selection of cute designs and fonts, so you can give your party a really personal touch.

DISCOUNT CANDLE SHOP, DISCOUNTCANDLESHOP.COM: The name of this site is all you need to know—all sorts of candles at unbeatable prices.

KATE'S PAPERIE, KATESPAPERIE.COM: A great source for invitations and place cards (and all your other stationery needs as well).

MOUNTAIN COW, MOUNTAINCOW.COM: The $40 or so you'll spend on their stationery software will pay for itself after just one set of party invitations, but you can keep using it indefinitely. It's beyond worth it if you've got a color printer and like to send out cool printed invites (and why wouldn't you?). You can choose from all sorts of clip art, fonts, and designs.

PLUM PARTY, PLUMPARTY.COM: This is an awesome site selling just about anything you could need for a party, from the silly to the serious. Tiki-style shot glasses, piñatas, temporary tattoos to pass out as party favors, and coconut cups for tropical drinks are just a very small sampling of the stuff they've got for sale. In addition to the kitschy, the site sells elegant touches like julep glasses you can use as flower vases and pretty invitations.

Taking Care of Domestic Business 5

THE KEY PRINCIPLES OF KEEPING YOUR HOME
CLEAN, TIDY, AND TOTALLY LIVABLE

The idea of being enthusiastic about housework has loads of
negative associations: prefeminist housewives being chained to their mops, not
allowed by society to have any ambitions beyond making the kitchen floor glisten
and getting their families' whites really white. But that has nothing to do with
your current reality, so you need to change your mind-set and stop looking at
cleaning as a chore. It is, after all, something we all have to do to some extent, and
always will.

People have amazingly different standards on this issue. My friend Michelle
cleans and organizes compulsively and could never go to bed if a single dirty glass
remained in the sink, but my friend Kathleen can blithely carry on in a super-
cluttered apartment she cleans at most every few months (and once admitted to
shoving dirty dishes into the oven to get them out of the way when a guy was com-
ing over, and then forgetting for two weeks that they were in there). Then there are
people who keep everything looking very tidy but don't actually clean more than
occasionally, and people who are quite anal about fighting germs and dirt but will
allow two weeks' worth of mail to pile up on a table or half their closet to wind up
on the bedroom floor, unbothered by organizational chaos as long as they know no
bacteria is lingering on the kitchen sink.

There's no one right standard you should adhere to—if you can live contentedly with a little bit of dust on the furniture and soap scum in the shower, don't feel compelled to change your ways. I've never seen evidence that living in a slightly dirty space is really bad for you, and there's growing speculation that an overly sanitized environment can actually be detrimental to our health.

That said, I think everyone would prefer to live in a clean and pulled-together space if given the choice. You're able to feel more serene when everything around you is orderly and in its place. But a big obstacle for many of us is that we feel we don't know how to clean, and believe we're never doing it quite right. The rituals of dusting and scrubbing and tidying seem somewhat mysterious, which gives us an excuse not to do them all that often.

Of course, simple laziness gets in the way too. I'm not a natural neatnik, and used to put off domestic chores until things were in such a state of chaos that it was unavoidable. I wasn't a total slob, but I would definitely turn a blind eye to dust gathering in corners, and reasoned that if the bathroom sink and toilet bowl were newly cleaned, nobody would notice that the tiles were no such thing.

There's a mental trick you can use to motivate yourself: start thinking of caring for your home the same way you think of caring for your body—as a totally essential and even enjoyable routine. I mean, we shower and wash our faces and shampoo and condition our hair every day without dreading it. And without thinking twice we shave our legs, do our nails, moisturize our bods, and apply makeup before any sort of night out, and we actually take some pleasure in these rituals (well, maybe not in shaving our legs). The point is, if you start looking at your home as if it were an extension of your body, as something that really represents you, and not just the square footage where your stuff is stored, it becomes much easier to get off your butt and take care of it.

Here's a more practical motivating factor: Since you're starting to decorate and fill your home with more special things you've carefully selected, you need to take care of them. Dirt and disarray make things age and fall apart faster. So whenever you have trouble getting pumped to do your chores, remind yourself that you deserve to live in a beautiful place you're crazy about and that the occasional work it takes to keep it in top form is well worth it. The more you keep things clean the more you'll love your place and the things in it, and the more you love them the more you'll want to take care of them and keep them looking nice.

Here I'm going to lay out the best tips and bits of wisdom I've learned about

how to keep your home a clean, pretty, and happy place to live in—and accomplish it with as little fuss as possible.

Sparkling Clean vs. Simply Sanitary: Setting Your Standards and Creating a Routine

Of course given the choice, anyone would prefer to live in a perfectly clean place at all times, but ultimately the more meticulous you keep your pad the less time you'll have to do other things you love, like cuddle on the couch with your honey or hit the town with your girlfriends. Because while a clean, orderly home is a pleasure to live in, keeping it that way falls pretty short as a passion, so you need to figure out the best way to keep your place reasonably clean without getting all OCD and having it hurt your quality of life.

The only way to ensure that you stay on top of it without stressing about it too much is to make a cleaning schedule and stick to it. Plus, cleaning seems like much less work if you don't have to think about it too much, and a schedule definitely helps with that.

Your Cleaning and Tidying Time Line

A lot of your individual routine is going to be unique to your situation. You need to take into account how you live in your home when making a schedule for cleaning it. If you cook every night, you're going to need to wipe down the kitchen every day, and if you've got a pet that sheds a lot, you might want to vacuum some areas every day too. Also, how often you do these tasks depends on the cleanliness standards you've set for yourself. But here is a good basic cleaning schedule to start with. Just adjust it to meet your lifestyle.

At the beginning of each month, look at your calendar, Filofax, PDA, or whatever you use to keep track of your life, and schedule in each of these semi-weekly, weekly, and monthly tasks. Of course, if Tuesday the 18th is when dusting and shower-cleaning are supposed to happen, but you get invited to a fabulous party that night, obviously the party takes precedence. You can just

Where Nasty Germs Lurk

You've no doubt heard horror stories about how zillions of nasty bacteria and viruses and other microbes are festering even in places that look clean. And it's true—but there's really no reason to be alarmed. If all those little bugs were really so dangerous, you'd be sick a lot more than you are, and in general, unless you have a weakened immune system, washing your hands regularly and adhering to a basic cleaning program should keep you safe.

That said, it pays to know which areas of your place are prone to be bacteria breeding grounds. Unsurprisingly, toilets and sinks are generally the dirtiest places in a home, both because organic matter passes through them and because they're wet. So they're the places you have to be most scrupulous about keeping clean. But because bacteria thrive in moisture, two seemingly innocent household objects may actually be the most dangerous: sponges and towels. Ironically, when you hand-wash dishes with a sponge and then dry them with an already damp dish towel, you may be spreading bacteria all over them. So keep a big stack of clean dish towels around at all times and throw each one in the laundry the second it gets damp. And disinfect sponges often, either by tossing them into the dishwasher or, even better, into a bleach solution. To do the latter, mix 1 teaspoon of household bleach in a bowl with 1 quart (4 cups) of water and soak the sponge for five minutes.

reschedule the cleaning for the next day, but this way you know everything is getting done.

For the serious, once- or twice-a-month jobs, it's really least painful if you do them all in one big two- or three-hour block of time. Yes it's tedious, but the work has to be done and you'll feel so much better when it is—and it's especially satisfying to have it all done at once. Look at it as you would a hair-color appointment or a session with a personal trainer, as something that's rather boring but is a necessary part of taking care of and feeling good about yourself.

Your Daily Routine

In the morning:

Make the bed.

Put away any clean dishes that are still in the dishwasher or on the drying rack from the night before.

Scan the apartment for things that need to be straightened up—fluff pillows, tackle clutter, and deal with any of yesterday's clothes that didn't make it back to where they belong before bedtime.

Remember how much nicer it will be to return home at the end of the day if things aren't a disaster, and deal now with anything that needs to be tidied.

In the evening:

Wipe down the kitchen counters to clean up after any food prep you did that day.

If you cooked dinner at home, do the dishes and wipe down the dining table and the stove.

Touch up the floors. You don't need to mop your kitchen from corner to corner all that often if you clean up obvious messes as you go. Keep a broom and dustpan close at hand to sweep up crumbs, and if you drip any liquids on the floor, wipe them up ASAP.

Your Twice-a-Week Routine

Sweep the kitchen floors.

Give the bathroom a quick cleaning—touch up the floors, mirror, toilet, and sink.

Scan your rooms for any obvious dust on furniture and dust it off.

Your Weekly or Twice-Monthly Routine

Vacuum all the floors and upholstered furniture.

Mop the kitchen floor and any wood floors.

Thoroughly clean the kitchen sink.

Change your sheets and bedding.

Dust the furniture and electronics.

Using an all-purpose cleaner, wipe down doorknobs, switch plates, and any handles or drawer pulls you touch frequently.

Thoroughly clean the bathroom from top to bottom.

Thoroughly clean the kitchen, including the walls behind the stovetop and sink, appliances, the outside of the refrigerator (don't forget the top), and the cupboards.

Things to Do Every One to Three Months

Clean the refrigerator.

Clean out the insides of your kitchen drawers.

Wash the windows.

Move big pieces of furniture and vacuum underneath them.

Carefully look for stains and broken things and fix them.

Five Ways to Make Cleaning Less Tedious

- While you're watching television, dust, polish silver, clean blinds if you have them, or do other tasks in your living room.

- Have a long phone chat with your mom or a friend while you sweep, dust, or dry dishes.

- Wear headphones and listen to some favorite tunes—especially helpful when you're vacuuming, doing dishes, or working on any loud task.

- Crank up some music on the stereo and boogie around while you dust—you'll get a little workout at the same time.

- For major jobs, always put your hair up, wear comfortable old clothes you don't care about, and wear gloves to protect your hands. You'll mind cleaning less when you're not worried about getting dirty in the process. Take a nice hot shower or relaxing bath when you're done, so you'll be as squeaky clean as your pad is.

The Keep-It-Simple School of Cleaning

Supermarket shelves are packed with an ever-increasing array of cleaning products, all promising to make your chores easier than ever. There's a premoistened disposable towelette out there for just about every job on your list. Now I'm not denying how convenient those ready-to-use wipes can be for quickly dealing with spills and keeping things sanitary when you're feeling just too lazy to do more than a one-step cleanup. But a lot of these tools are like the takeout Chinese food of cleaning—they seem convenient, but over time they're an expensive, sometimes unhealthy, habit.

Women have been cleaning quite well for centuries, or certainly decades (since I'm not sure how clean everything was centuries ago), with-

out the help of this stuff. So, while you should go ahead and use them if you prefer to and you're willing to pay for them, you should also get educated in the old-school way of doing it. Using super-basic cleaning methods saves you a *lot* of money. Also, a lot of the chemicals in big-name-brand commercial stuff just aren't great for you or the environment. Now, I'm not saying you have to play *Little House on the Prairie* and deny yourself all modern conveniences in pursuit of some ultrapure ideal—but it's smart to have this knowledge at your disposal. Knowing how to use the most ultrabasic cleaning tools and techniques is a skill every babe should have under her belt.

The Seven Products You Need

These are the essential products you should keep under the sink or in the closet at all times. In other parts of this chapter I refer to additional products that it can be helpful to have, but these are the only absolute must-haves. For each I've provided the most down-home, dirt-cheap option as an example, but of course you can find lots of alternatives at the supermarket or any home-supply store.

An all-purpose cleaner: A spray bottle of soapy liquid you can use to clean just about any surface. Dr. Bronner's or any simple, natural soap is probably your best option (see "The Case for Hippie-Style Cleaning," on page 217). Mix a few teaspoons of it with 12 oz water in a spray bottle. It can tackle basic tasks ranging from cleaning the shower to wiping down the refrigerator and getting simple dirt stains out of rugs or upholstery to removing marks from the walls.

Dishwashing liquid: In addition to being used to hand-wash dishes, this can double as an all-purpose cleaner and handle any of the tasks listed in the previous paragraph. Just dilute it with a little water and use it in just about any corner of the house that needs a cleaning.

A glass-and-window cleaner: For an old-school alternative to the bright-blue commercial kind, just use a teaspoon of ammonia in a spray bottle full of water.

A scrub: You need something abrasive to clean anyplace where grime is caked on, such as the stovetop or tough soap scum in the bathtub. The most basic scrubbing product out there is baking soda, which forms a paste when you mix it with water or vinegar—it's all you need for most tasks. Bon Ami and Bar Keepers Friend are two other classic scrubs.

Laundry detergent: If you're interested in being eco-friendly, keep two on hand, one phosphate-free detergent like the one by Seventh Generation to use on

regular loads and one tougher mainstream brand for when you're doing a seriously dirty load.

A spot cleaner for rugs and upholstery: An all-purpose cleaner (or, again, dishwashing liquid) can do a lot to treat simple spots, but for more serious stains, try a tougher stain-remover such as Mystical Nontoxic Carpet Shampoo, Carbona Carpet Wizard, or Folex Instant Carpet Spot Remover.

Household bleach: Bleach is a really powerful chemical and too hard on surfaces to use all the time, but it's also one of the most powerful disinfectants out there, so keep some on hand. And an occasional dose of it gets your white laundry crisp and clean like nothing else.

Smart-Girl Secret: Never get rid of old cotton T-shirts. Slice them up and use them as rags. Just make sure they're 100 percent cotton before you clean with them—Lycras and blends aren't as absorbent.

The Classic Cleaning Tools You Can't Live Without

There are hundreds of things you can buy, and many may make your housekeeping easier, but these are all that are truly necessary. If you're short on storage space, you can easily limit your tools to these.

The Cheater's Guide to Cleaning

Although it's good to know how to clean the traditional way, there is one modern invention no girl should go without: Swiffer or Grab-it cloths. These disposable cloths attract dirt, lint, and hair like crazy and keep them stuck there until you throw them out. You can attach them to a Swiffer or Grab-it duster (which is a sort of like a sponge mop, but there's just a flat, rectangular surface where the sponge would be) and clean the floor with them, or just use them like rags and run them over any surface at all. They're perfect to use on hard-to-clean items like oil paintings and lampshades, because they suck up the dust without applying any pressure.

And if you want to keep your place pretty clean without actually cleaning it very often, these cloths are your secret weapon. Every day or two just run one over all your furniture and then turn it over and use the other side on the main footpath areas of your floors. You can buy them at most supermarkets and chain drugstores, but they're also available online.

Lots of cotton rags
A good broom and dustpan
A vacuum cleaner
A sponge mop
A scrub brush
A bucket big enough to dip your sponge mop in

Know-How for Specific Tasks

Conquering Dust

The aforementioned Swiffer and Grab-it cloths make dusting easier than ever, but they're a somewhat expensive habit (about $7 for 32 cloths). If you want to save the dough, soft cotton rags are still an ideal dusting tool. They just take a little more effort on your part.

The Case for Hippie-Style Cleaning

Even if you're a bit of a high-maintenance girl who loves leather accessories, is never seen without lip gloss, and prefers any fresh-squeezed juice you drink to be mixed with Champagne, that doesn't mean you can't have crunchy-granola habits in your home. A lot of the chemicals that go into your standard mass-market cleaning products are downright frightening. Ingredients like chlorine are highly toxic, and you can wind up inhaling their fumes or absorbing them through your skin when you're using them. Phosphates, which are found in many detergents, go from our drains into rivers and lakes and lead to algae growth that kills fish and other marine life.

Barbara Fierman, the owner of New York City's Little Elves cleaning service, says her staff of cleaners sticks primarily to "green" products, because when they consistently use the commercial kind, they develop breathing problems and skin reactions, and because the chemicals in these products can damage surfaces of furniture. We still don't know exactly what the impact of these things is on our bodies or our planet, but common sense says it's not all good.

At the end of this chapter there's a list of Web sites where you can buy nontoxic cleaning products, but some great brands that are widely available at health food stores and even some supermarkets (such as Whole Foods) are Seventh Generation, Ecover, and Earth Friendly Products. The green cleaner Barbara can't live without is Dr. Bonner's Pure Castille Soap. This brand has been around since the 1940s, and their liquid soap may be the best multitasking cleaner on the planet. "You can use it to clean any surface, do dishes with, do the laundry with, anything," says Barbara Fierman. But it's still so gentle you can use it as a body wash.

The downside of green products is that they often don't work as swiftly and require more elbow grease than the toxic stuff. But if you do stick to big-brand commercial cleaners, dilute them. "Most cleaning products are made much too strong," says Barbara Fierman. "They destroy surfaces and make your things wear out more quickly." So cut big-brand cleaners in half with water before using.

Another invention that makes dusting (and other tasks) easier is microfiber cloths. The surface of these cloths is covered with zillions of minuscule threads that trap dust and dirt like crazy. You can use them both dry and dampened with a little water or cleaning solution, and just throw them in the wash when you're done. Keep one in a drawer in every room of your home, so you can easily grab one every time you see dust that needs to be dealt with. (You can buy one for about $10 at casabella.com.)

Always work from the top to the bottom of furniture, so any dust that escapes your rag and lands on a lower part of the object will be caught by you later.

To make sure you don't miss any spots in a room, start dusting the area to the left of the entrance and go clockwise around the room.

Televisions, stereos, and other electronics are usually the biggest dust-collectors. Clean them with a Dustbuster (or another small vacuum) if you've got one, or wipe them with a towel dipped in a little rubbing alcohol or a bit of glass cleaner.

Vacuum *after* you dust (never the reverse order), because that way any particles that got dusted off the furniture and onto the floor will be sucked up by the vacuum.

Unless you have really fine antique wood furniture, there's no need to polish it or use any special cleaners on it—dusting is all you need to do, says Barbara Fierman. And if you do have special antique stuff, have a professional clean and polish it annually.

Kitchen-Cleaning Tips

To prevent oven mess, lay a piece of aluminum foil on the bottom of the oven when you're cooking something that might spill over. Once it's too late for that, force yourself to clean up any spills as soon as the oven has cooled. If you leave them and use the oven again, they'll get totally baked on and be even harder to remove. Don't use anything abrasive on the oven, or you could damage its heat-retentive surface. Soap and water, a scrubber sponge, and a lot of elbow grease are the way to go.

Make it a habit to clean countertops at least once a day, after every time you've placed food on them. This is easier to do if you buy a countertop

Pets can bring so much joy to your life, but they can also bring a lot of messiness to your home. To keep your dog's or cat's hair and unique aroma from dominating your space, you need to be extra-diligent about cleaning. Stay on top of the hair situation by keeping sticky lint-collector rolls in every room and wiping them over furniture whenever you notice animal hair gathering. Swiffer and Grab-it sheets are also great at grabbing animal hair. To battle scent, Barbara Fierman recommends you use Febreze Fabric Refresher. It doesn't cover up odor; it just miraculously zaps it. And always shake baking soda over your carpet or rug about ten minutes before you vacuum to battle odors.

cleaning spray with a scent you really love. The Good Home Co., Caldrea, and Crabtree & Evelyn all make them in delicious scents. But a basic soap-and-water solution works too—just be sure to dry the counters thoroughly after washing them.

Cutting boards you cut raw meat, poultry, and fish on require special care, since bacteria can flourish on these surfaces. Wash them right after you use them with lots of soap and really hot water. If you can't get hot enough water from your faucet, boil it on the stove and then rinse the cutting board with it. Or, after washing with soap and water, wash the cutting board with a solution of 1 teaspoon bleach and 1 quart (4 cups) of water.

To thoroughly clean your kitchen sink, fill it with scalding hot water and dishwashing liquid and let it soak for an hour; then drain and scrub with a gentle scrub like baking soda or Bon Ami. To make it sparkle, rinse it well and dry it thoroughly using an absorbent cloth.

The Best Way to Deal with Dishes

The most important rule: Do them as you cook! This is 101 advice, but easy to forget. You're always waiting for something to heat up or boil or bake, and that's when you

> "Two of the most essential ingredients for doing dishes are hot water and elbow grease."
>
> —*Barbara Fierman, owner of New York City's Little Elves cleaning service*

should be washing the knives and cutting boards and bowls you've used in the prep work.

Soak dishes covered in sticky food as soon as you can, so it doesn't get too stuck on. "Soaking dishes in a thin layer of warm water and soap for thirty minutes will lift most foods right up," says Christine Dimmick, owner of The Good Home Co. line of cleaning products. If it's a stovetop pan, fill it with water and place it on the stove; then bring the water to a boil and let it simmer for five minutes. The stuck-on food will either come off in the water or be easy to remove in the sink.

For really tough, cooked-on grease and grime, you need a scrubbing product like baking soda or Bon Ami, and a scouring pad.

When hand-washing glasses, the secret to getting them spot-free is to make sure the water you wash them in is superhot, and then let them air-dry on a rack. Towel-drying might help you put dishes away faster, but it won't get them spotless and shiny the way air-drying can.

If the water you used was hot enough, your dishes should dry pretty quickly on the rack, so don't waste energy tackling them with a towel when they're still wet. Wait twenty minutes or so; then return to them and quickly wipe away whatever remaining moisture there is before putting them away.

When cleaning nonstick pans, just use soap and warm water, but *don't* use steel wool or any abrasive product, as it will ruin the nonstick surface. Never put them in the dishwasher.

Caring for Rugs and Floors

Most dirt on your floors gets there from your shoes, so it's worth it to have a doormat and to rub your feet well on it whenever you enter. Ones with a lot of texture, like the natural fiber variety, tend to get more grime off. But your doormat will do more harm than good if you don't remember to clean it, so vacuum it at least once a week.

When you're sweeping or mopping a floor, begin in the corner farthest from the exit and work across the room while backing toward that door, so you never have to step on the area you've just cleaned.

To keep dust bunnies from flying out of your dustpan as you take it to the garbage, dampen the pan with a bit of water before you use it.

Before you start vacuuming, scan the floors for any objects like buttons or pins or spare change, which could get sucked into the vacuum and damage it.

To really get the job done, move the vacuum slowly and make two passes over each area.

Give extra vacuum action to the footpaths and areas where you and others sit, since that's where the most dirt will be.

To freshen and deodorize rugs and carpets, sprinkle baking soda on them before vacuuming.

Always change the bag before it is entirely filled, to reduce the dust that will enter the air. A full bag reduces a vacuum's suction power.

When you're faced with carpet stains, "treat stains right away with a gentle soap and warm water," says Christine Dimmick, owner of The Good Home Co. "I've found that most foam cleansers don't do as good a job as this, and they don't get rid of the smell—they just add to it. Use a scrub brush and just enough water so you don't saturate the rug. Let it dry completely, then vacuum." If that doesn't work, try one of the products listed earlier (page 215), or just suck it up and call in a professional carpet cleaner.

> "As a general rule, vacuum bags should be emptied more often than you think, and always empty the vacuum bag after sweeping up something damp, pet hair, or any food or flower petals. If you don't, they will decompose in the bag and emit a terrible smell."
>
> —*Christine Dimmick, owner of The Good Home Co. line of cleaning products*

Most people clean wood floors the wrong way. "Ninety-nine percent of wood floors have a polyurethane finish on them, so the floors aren't truly wood and shouldn't be cleaned with an oily wood cleaner," says Barbara Fierman. Instead, clean them with a product called Polycare that's made for floors with a polyurethane finish. Oil soaps designed for unfinished wood will just sit on top of them and make them sticky.

For a bleached-out spot on a colored carpet, the only thing to do is find a felt-tip pen that matches the original shade and color that area of the rug. I've had to do this, and while it doesn't blend in perfectly, it's much less noticeable than the bleach spot, and is invisible at night, when you do most of your entertaining.

For serious carpet-cleaning, pay professionals to do it once a year.

Bathroom-Cleaning Tips

Since the bathroom gets dirty so easily, and since it's a room that quickly feels gross if it's not squeaky clean, you need to tend to it as you go. One of the best ways to make sure this happens is to keep a couple basic cleaning supplies under the bathroom sink. If you keep them with your other supplies elsewhere—even if they're

right in the next room—you'll be much less likely to use them on a regular basis. Stock a glass cleaner for the mirror and a cleaning scrub for the toilet and shower.

Start at the top and work your way down, so you're never at risk of redirtying an area you just cleaned.

The best way to deal with soap scum and mildew is to prevent it, by taking a squeegee to the walls and glass shower door (if you have one) at the end of each shower. It takes less than a minute, and by removing the water you're getting rid of the water minerals and bits of soap that mix to create soap scum. By getting it as dry as possible in there, you're also reducing the possibility of mildew growing. You can buy sprays that you use at the end of every shower to prevent soap scum, but the squeegee takes the same amount of time, costs less, and, I think, is the more effective option. Don't ever use a shower spray on marble surfaces—they'll slowly destroy it.

When you spot mildew developing in your bathroom, act quickly before it gets the upper hand. It will get way more difficult to deal with if you wait. Use mildew remover or a simple bleach-and-water solution.

Keep a toilet brush in the bathroom so you can quickly clean the bowl whenever it occurs to you.

Beautiful-Bedroom Rules

To ensure your bedroom feels like a sanctuary at the end of the day, you need to put a little work into it in the morning. Although on many days you think you're way too crazed to spend time cleaning up before you head out the door, the reality is that straightening up your bedroom takes just seconds, and you can squeeze it in while you're looking for earrings and brushing your hair and things like that.

Always make your bed, though how meticulously you do so is up to you. But it should look perfectly made from the outside, even if the sheets aren't tucked in perfectly. The lazy-girl bedding setup is to have just a duvet and no top sheet—I lived this way for years. You can "make" the bed in the morning simply by pulling up that one piece and smoothing it out a bit.

It's one of my firm beliefs that cheap hangers are the enemy of organization. I'm much more likely to put all my clothes back into the closet where they belong if I have nice hangers to hang them on. So give the wire ones from the dry cleaner straight back to him every time you drop off a new batch of clothes (try to find a dry-cleaner who recycles them), or just throw them away and hang your threads on wooden, or at the very least quality plastic, hangers.

Flip your mattress every so often, ideally once a month, side to side one month and end to end the next, so no one part of it gets worn down more than any other. And vacuum your mattress every once in a while when your sheets are off the bed. This will get rid of dust mites or other icky minuscule microbes that might be living on it.

Insider Tip

Invest in a HEPA-filter air cleaner—these silent, electronic machines filter dust, dirt, and allergens out of the air (*HEPA* stands for "high-efficiency particulate air"). Even though it's not a fun thing to spend $400 on, Barbara Fierman swears you'll notice that you feel much better after you get one (because you're breathing cleaner air), plus they'll do a lot of your cleaning for you. "This is especially important in cities," she says. "You'll feel radically different."

Laundry Basics

A remedial but crucial rule: Always, always separate whites and darks. If you don't, the lights will get dingier and the darks will come out covered with light-colored lint.

If you have a top-loading machine, always put the detergent in the washer first, and wait until the water has diluted the detergent somewhat before putting in the clothes. Clothes that touch the undiluted detergent directly can, in some cases, be stained.

Before throwing clothes in the wash, be sure pockets are empty and zippers are zipped. If you accidentally wash and dry an item with a tissue in the pocket and white fuzzies wind up all over that load of laundry, pop the fuzzy-coated clothes in the dryer with a fabric-softener sheet—this will unstick the fuzzies.

Don't overload the washer, because if you do, clothes won't get as clean and may get more wrinkled.

Use bleach only occasionally. It's really hard on fabric, and even "color-safe" bleach does fade colors over time. So use it at most every five washes. Use the washing machine's bleach dispenser, which dribbles it in gradually rather than dumping it in all at once. And after your bleach load is done, let the washer go through a cycle empty (using cold water and the shortest time possible). There could be some bleach lingering from the previous load, and you want to make sure it's totally gone before you add colored clothes to the machine.

The first time you wash a new item always use cold water, to prevent shrinkage.

The first time you wash a colored item, wash it in cold water by itself. Otherwise the color might bleed and stain your other clothes. Reds and pinks seem to be the

most prone to bleeding, but wash every colored item by itself at first, just to be safe.

Clean the lint trap on the dryer before you use it, every single time. Even a thin layer of lint will slow down the efficiency of the dryer and make it take longer to get your laundry dry.

Whether you do or don't use fabric softener is a matter of taste. Fabric softener, which comes both in dryer sheets and in a liquid form that's dispensed in the wash, puts a coating on your clothes to make them softer. Throwing a fabric-softener sheet in the dryer can keep items from sticking together, which is especially useful when drying synthetic fabrics like polyester, which are prone to stick. The sheets also prevent wrinkles and get odors out.

The dryer is the easiest means of getting wrinkles out of clothes, so if at all possible take clothes out of the dryer as soon as the cycle is finished. If you can't be there when the cycle ends and the clothes get all wrinkled from lying in there in a heap, put them through a five-minute "Fluff" cycle to get some of the wrinkles out.

Stain Solutions

There are so many seriously powerful stain removers available now that spilling things is no longer automatically an upholstery and clothing death sentence. I use one called Mary Ellen's Stain Remover (there's a whole line of them, even a special one that gets old blood stains out of undies—see the shopping guide at the end of the chapter).

With all stains, it's essential that you treat them absolutely as soon as you can. The longer a spill has to mesh with a fabric, the less of a chance you have of ever getting it out. When clothing, bedding, or table linens get stained, put them in the washing machine the second you can. If you send your laundry out or go to a Laundromat, keep one of those stain sticks handy and treat stains with it right away. You can use them to pretreat stains for up to a week before washing. Then treat the stain again with a spray stain remover right before you launder the item.

Remember that you need to *blot* stains, not rub them, because rubbing breaks the fabric fibers and can grind the stain in more. Also, you should wash stained fabrics in the hottest water the fabric can take, but don't put them in the dryer until you're certain the stain came out in the wash—because if it didn't, the dryer will just set it for good. Instead, treat it again and put it through another wash cycle. Here are the rules for treating some of the most common, notoriously tricky stains.

Red wine: There are tons of different ideas about this one, and no perfect solution (I've tried them all, because red wine stains are something that've occurred a lot in my life). If the spill is on something you can deal with over the sink (and not on a chair, for example), I've found the best thing is to boil a kettle full of water, then place the soiled cloth in the sink over the mouth of a bowl and pour the boiling water on the spot, holding the kettle at least a foot above the fabric as you pour. For a stain on a piece of furniture or rug, pour club soda on it and dab at it with a rag. The bubbles help lift the stain out. After that, dab a solution of water and dishwashing liquid on any color that remains.

> "In the end, being a good cleaner isn't about any one product. It's about having a lot of rags and doing a lot of hard work."
>
> —*Barbara Fierman, owner of New York City's Little Elves cleaning service*

Blood: Pour hydrogen peroxide (the 3 percent kind) directly onto the stain, let it bubble for a bit, then rinse it away. Keep repeating until the stain is gone.

Ink: Dampen a cotton towel with rubbing alcohol and blot the stain repeatedly, working carefully from the outside in, so you don't spread the stain over a wider area. Then turn the item of clothing over and dab at the back of the stain with more alcohol. Finally wash it in hot water.

Berry stains: Place the stain over the mouth of an empty bowl in a sink and boil water in a teakettle. Pour the boiling water over the stain from a distance of a foot above it. The stain should disappear completely.

Smart-Girl Secret: Premoistened baby wipes work on many types of brand-new food stains, so keep a set in your kitchen so you can quickly deal with food spills on table linens or people's clothing.

Finally, if you're really clueless about cleaning, nothing beats an in-person tutorial. Hire a cleaning person just for a half day (this will set you back about $40–$60 in most cities). Find a legit cleaning service and explain that you want a lesson; then watch the professional clean your pad, and ask questions (just be sure you get a cleaner who speaks the same language as you do). Most professional cleaners will be happy to do it, says Barbara Fierman. "People who clean for a living rarely have people ask them questions about what they do, so they love it," says Barbara, who says a number of domestically challenged women have hired her company's services for exactly this purpose.

Priceless Advice from the Previous Generations

"There are two things you absolutely have to keep clean: the floors and the windows. Nothing else matters all that much."

—GALINA, 64, QUEENS, NEW YORK

"My grandmother taught me that every single day you should try to do one thing around the house that you won't have to do again the next day. Clean out a drawer for instance. Polish silver salt and pepper shakers. Things like cleaning the sink will just have to be redone the next day, but if you do one thing that lasts for a while, you'll get a sense of satisfaction and also keep things clean and organized." —MARY, 61, HALF MOON BAY, CALIFORNIA

"The best way to tackle domestic chores is to focus first on visual results. If you wash and wax a floor, or do an entire load of laundry, you can quickly see the results of your labor. In times of low motivation starting out this way is a big help." —BETTY, 85, PLEASANT HILL, CALIFORNIA

"To clean Waterford and other fine crystal, use raw rice as a scouring agent— along with a mild soap or whatever solvent you use for the grime and slime. Just swish it around and the rice will get rid of the debris still on the glass."

—CAROLINE, 60, MALIBU, CALIFORNIA

"You can remove mildew from a shower curtain by washing it in the washing machine with a little bleach and laundry soap."

—NORMA, 62, ANN ARBOR, MICHIGAN

"Many clogged drains can be cleared with an application of boiling water. Bathroom drains are often clogged with a mixture of soap and hair, and the hot water dissolves the soap, thus often removing the clog. It is a good practice to pour some boiling water down the shower or tub drain on a routine basis."

—AGNES, 90, FORT DODGE, IOWA

Shopping Guide

Resources for Unique Housekeeping Supplies

Obviously you can buy standard cleaning supplies at any supermarket, so here I'm just listing sites that sell less mainstream items.

BED, BATH AND BEYOND, BEDBATHANDBEYOND.COM: The "beyond" part of this retailer's name encompasses a ton of organizing and cleaning tools.

CASABELLA, CASABELLA.COM: Buying cleaning tools is almost as fun as shoe shopping at this site, because all the tools come in sleek shapes and beautiful colors.

DR. BRONNER'S MAGIC SOAPS, DRBRONNER.COM: Their Pure Castille Soap has been a constant on health-food-store shelves for decades. It can be used to clean everything—rug stains, dishes, hand washables, even your body and hair.

THE GOOD HOME CO., GOODHOME.COM: You can't purchase directly from their site at this point, but it will direct you to places where you can buy Christine Dimmick's line of delicious-smelling natural cleaning products.

HEALTHGOODS, HEALTHGOODS.COM: In addition to green cleaning products, you'll find a lot of serious air- and water-purifying instruments here. If you've got allergies, look here to find ways to get irritants out of your home.

HOME DEPOT, HOMEDEPOT.COM: They sell absolutely every practical hardware-type thing you could need for your *casa*, plus the site has lots of helpful tutorials on tasks ranging from wallpapering to changing a ceiling fan.

MARY ELLEN PRODUCTS, MARYELLENPRODUCTS.COM: This site sells a big selection of super-effective stain removers and other household products.

REAL GOODS, REALGOODS.COM: This site sells "products for an ecologically sustainable future," which means they've got a huge selection of healthy cleaning products for every corner of your home.

Four More Grown-Up Skills to Master

MORE KNOW-HOW YOU NEED TO LIVE HAPPILY IN YOUR HOME AND FEEL LIKE A BONA FIDE ADULT

Now that you've brushed up on all the homemaking basics, there are just a few more things you need to know how to do so you can truly feel like a sophisticated, got-it-together grown-up. Here's a quick primer on key details like flower arrangements, thank-you notes, and fattening your bank account.

1. Fill Your Home with Flowers

Fresh flowers should be a regular feature in your living space—nothing beautifies and brings a place to life like them. A vase of flowers is more than just pretty. It sends a message to anyone who enters (including you) that yours is a well-cared-for home and that the girl who lives there values herself and her friends who enter.

I know flowers seem like an indulgence, but they really don't have to be expensive. One of the cheapest ways to use them is to buy sort of unfashionable flowers and make them over with a few styling tricks.

For example, carnations are often cheap, but you can make them look chic. Just cut the stems short, to about five or six inches, so they're all the

same length; then cut off all the leaves. Arrange them tightly in a small, short vase or glass, so that the blooms are right above the rim of the vase and clustered up against each other.

You can make daisies look stylish by taking just a couple of them, leaving their stems long, and placing them in a tall, thin clear glass vase, so they peek up just a couple inches from the top. And absolutely any flower looks elegant and wonderful chopped really short and placed in a bud vase. The point is, you can buy the cheapest flowers out there, or just buy one or two blossoms from your florist, and get most of the same benefits a big posh bouquet would give your space.

You do need a good variety of vases. Whenever you receive flowers, save the vase, and pick up cheapies in a variety of sizes at places like Ikea (where you can find cool ones for just two dollars). I generally prefer clear glass vases for flowers: they keep the focus on the flower, whereas any vase with a color or pattern on it draws attention to itself, which sort of defeats the point.

Flower-Care Basics

Before you put flowers in a vase, always cut the stems on a diagonal and plunge them into water immediately. "Right after you cut them, stems start to form a scab that will block them from absorbing water," says Rosalie Stern, owner of Flower Dec Floral Design Studio in Los Angeles. "Putting them in water right away will prevent that." The ideal method is to cut the stems under water, in a large bowl, if you can. Cutting them on a diagonal increases the surface area of the cut end, so it can absorb water better.

Place them in water that's slightly warm.

Also, remove all leaves that will be below the waterline. They decay and lead bacteria to grow in the water, which makes the flowers die faster.

Put a single drop of bleach in the water, to kill bacteria. "It's better than flower food," says Rosalie.

Every day, add fresh water to the vase. Every three days recut the stems and change the water entirely.

Pro Advice on Flower Arranging

The easy and always-elegant way to go is to use just one type of flower, but you can make the arrangement more interesting by using two different colors. If you're mixing, say, coral and pink roses, you can either throw them together haphazardly

The Right Flowers for Each Season

With our global economy and easy air shipping, you can get just about any flower at any time of year, but you should nonetheless know when different types of flowers are in season. They'll usually be cheaper then, and look more appropriate in your home. I love using seasonal flowers because they really remind me what time of year it is. That may sound ridiculous, but when life gets super-busy, it's easy to realize a whole month has passed and you have no idea where it went. I think having fresh seasonal flowers in your space helps you live in the moment a little bit better.

Spring flowers: Tulips, hyacinths, peonies, daffodils, anemones, iris, lilacs, pansies, ranunculus, sweet peas, violets, poppies, clematises, paperwhites, lilies of the valley, and buttercups.

Summer flowers: Zinnias, clematises, tuberoses, cosmos, alliums, Queen Anne's lace, and hydrangeas.

Fall flowers: Sunflowers, dahlias, cosmos, zinnias, Chinese lanterns, and hydrangeas. Fall foliage can also be used.

Winter: Since there are no true "winter" flowers, in the chilly season you should use "flowers that aren't strongly associated with a certain season," says Rosalie Stern, like roses, calla lilies, gerbera daisies, and carnations, but buy them in rich wintery colors.

or create a pattern. Use coral ones all around the rim of the vase and pink ones in the middle. Or use mostly coral ones and place just a few pink ones throughout, as if they were polka dots.

For a really sophisticated look, "mix the soft with the tough, and the exotic with the unexpected—think hydrangeas with thistle, roses with brunias," says Luis Collazo of Lotus Flowers in New York City.

It's easiest to arrange flowers from the outside in. First arrange the flowers around the rim; then work your way in. Remember that the flowers in the middle need to have longer stems than those around the sides.

When you're placing two or more arrangements in the same room, there needs to be some harmony between them. The colors should coordinate somewhat and the styles of the flowers shouldn't clash.

One way to make an arrangement really unique and professional-looking is to give it some texture with palm leaves or grasses mixed in with the flowers. Think of them as a stylish alternative to baby's breath.

For a totally pro look, buy long leaves such as banana leaves and wind them around inside the vase to hide the stems.

Here's a tip my mother taught me: To clean a narrow-necked vase, drop a denture-cleaning tablet in and then fill with warm water. Leave it for half an hour or so, then rinse.

2. Manage Your Money

It's no fun to think about money, but most of us have to eventually and the earlier in life you start, the less painful it will be. Rather than looking at budgeting and being financially responsible as a bummer, try to see them as habits that allow you to have more fun, because you're figuring out ways to afford all the things you want to do in life. Here are six basic money rules to abide by.

Have a Budget (Even If You Don't Always Follow It)

To be on top of your finances and save money for big purchases, you need to first know where your money goes. Once you know how much you spend, and on what, you can figure out how to redirect some of that spending to meet your goals better.

The basics on creating a budget: It's tedious, but the first step is to keep a spending diary. At the end of each day, record every single one of that day's expenses and give it a code (*T* for transportation, *F* for food, *E* for entertainment, and so on). At the end of the month add up every expense—the sum is the total of your variable monthly expenses. Next add up all your bills that stay the same or roughly the same every month: your rent, your cell phone bill, your car insurance, and so on. The sum is the total of your fixed expenses. Add your fixed expenses total to your variable expenses total and subtract that sum from your total monthly income. The difference is the amount that, in theory anyway, you're saving each month. If the number is a negative one, that's the amount you're overspending each month—either by going into debt or dipping into your savings.

Once you've discovered how much you're saving (or overspending), seek out ways to spend less and save more (unless you're already saving a ton, in which case I guess you can reward yourself with a visit to bergdorfgoodman.com). Look at the categories of your variable expenses (transportation, food, and so forth) and try to find ways to trim your spending (for some simple suggestions, see the box "Five Little Ways a Girl Can Save Cash" on page 236). Set spending targets for the months ahead that are lower than your current spending, and try your hardest to stick to them.

Even if you never *quite* manage to meet your budgeting goals, you'll be aware of where your dough goes, and be much better off than if you never tried in the first place.

Set Up a System for Paying Bills

Financially responsible grown-ups don't just pay bills whenever it occurs to them. You need a system to ensure it gets done—to avoid late fees, and to not get stuck in a situation where you realize you've got a stack of them piled up and you just spent your paycheck on shoes.

Either arrange for your bill payments to be deducted automatically from your checking account, or, if it helps you feel more in control to pay each one individually, commit to doing so at a set time each week. Every time you get a bill in the mail, open it and set is aside in a standard place—a tray on your desk, for example. Once a week, every week—say, Saturday mornings or Monday nights—tackle that week's pile of bills.

Use Your Debit Card

Now that banks offer debit cards that give you airline miles and can be used anywhere a credit card can, you really don't need to use a credit card. If you're at all prone to spending beyond your means, then forcing yourself to use *only* your debit card is a great discipline and will simplify your shopping decisions considerably. If you don't have enough money in your account to cover the purchase in question, there won't be a decision to be made.

Carry Only Two Credit Cards, Tops

"We advise people to have two credit cards," says Jim Tehan, spokesperson for Myvesta, a nonprofit financial education organization. "One with a very low interest rate, which they use if they ever need to buy something they need to pay off over

a few months, and one with great benefits like airline miles, which they should use for everyday purchases and pay off every month."

Don't be tempted to sign up for a store card at places like Banana Republic just because you'll get 10 percent off that day's purchase. And don't get sucked into applying for more and more cards because of low-initial-interest-rate offers. Having eight credit cards, even if you don't carry balances on all of them, looks bad on your credit report.

Don't Wait to Deal with Debt

Sometimes going into a little credit-card debt can't be avoided—you need emergency dental work for example, or you get invited to spend a long weekend skiing at a friend's parents' place in Aspen and all your friends are going and you really can't afford to miss it, even though you can't afford the plane tickets up front.

However it happens, once you're in credit-card debt, you need to get out of it ASAP—and that means paying significantly more than the minimum payment every month. Ponder this sobering fact: If you have $2,500 in debt and a 14 percent interest rate and you only pay the minimum balance each month, it will take you *16 years* to pay it off and you'll pay $1,980 in interest. If you make a late payment, your interest rate could be bumped up to 28 percent (credit card companies often penalize tardy payers with raised interest rates), and then it would take you *101 years* to pay off that debt, and you'd pay *$30,165 in interest!* So, clearly, discipline is key with credit cards.

Always Save Something

Even if you feel you have absolutely no money to spare, you must put some aside every month. You need two types of savings: One emergency fund with enough cash in it to cover *at least one month's expenses* (standard financial advice tells you to sock away enough for two or three months' expenses but that's often not realistic), and a 401(k), IRA, or other type of retirement fund. If you have student loans or credit-card debt, it may seem silly to save for retirement (since the interest you're earning in the retirement account will probably be less than the interest you're paying on your loans), but Jim Tehan says it's essential to put money aside for the future nonetheless.

What to Do If You're Drowning in Debt

If, despite the fact that you know better, you wind up deeply in debt, it's essential to be honest with yourself about the situation and take action right away, says Jim Tehan. "As a general rule, if you think you might be having financial problems, you are," says Jim. "If you're worried about it, if you're delaying opening your bills, you need to get help." First, call your credit card companies and ask for a lower interest rate. Often they'll accommodate you. "Credit card companies want to retain you as a customer and don't want you to default on your debt, so it's in their interest to help you."

 If that doesn't work or if a lower rate alone isn't enough to rescue you, talk to a credit-counseling or debt-management organization. Just be careful about which one you choose to deal with. As you may have noticed from the amount of e-mail spam on the subject, there are a lot of shady operations out there preying on people in debt. Upstanding debt-management companies are non-profits that work with the credit card companies to help you get out of debt and help the companies get paid. They'll usually stop late-payment fees and negotiate a lower interest rate for you. If you're having trouble making minimum monthly payments, they'll try to negotiate lower ones. They shouldn't charge you much for this. If a debt-management company asks for more than a small start-up fee—fifty dollars or so—and a small monthly contribution, just to cover their costs, walk away. For information on how to choose a debt-management organization, visit myvesta.org.

3. Mind Your Manners

The whole point of etiquette is to make other people comfortable, so if you keep that goal in mind, you'll do fine even if you mess up on some of the details. However, to feel totally confident, you need to know what the rules are, even if you then decide to break them. Here are tips on two areas of etiquette you need to have nailed—table manners and thank-you notes—and some info that it can't hurt to know on the "proper" way to introduce people.

Five Little Ways a Girl Can Save Cash

EAT AT HOME MORE. As we talked about in chapter 2, one of the many advantages of preparing food for yourself is that it costs way less than getting takeout or dining out (unless we're talking dirt-cheap fast food, "$2 for two soft tacos" type stuff, which you shouldn't be putting into your body more than occasionally). The most money-saving and time-efficient way to go is to make big batches of dishes like pasta or soup and then eat the leftovers over the following days.

GO TO THE DRYCLEANER LESS. The second you remove dry-clean-only clothes from your body, carefully hang them up on quality wood hangers. There's no reason you can't get multiple wearings out of these clothes if you take care of them properly and don't leave them crumpled on the floor.

HAVE FRIENDS OVER FOR WINE. Some nights you want to go out to see and be seen, flirt with boys, and soak up the atmosphere of a cool nightspot. Other nights, you want to go out simply to catch up with your girlfriends. On the second type of night—when you're craving a good gab session and don't want to be interrupted by roving men at the bar or it's super-humid and your hair has gone haywire—train yourself to buy a bottle of wine or two and hang out with the girls in your living room. A decent bottle of wine from the liquor store costs ten dollars and will fortify two of you, while a decent glass of wine at most bars and restaurants costs eight dollars. If you convert one-third of your girls'-nights-out to girls'-nights-in, you'll quickly save a lot of dough.

BE MEDIUM-MAINTENANCE. Beauty products and treatments can suck up a ton of your disposable income if you're not careful. A few things are worth paying a premium for, because these pricey ones really do make you look so much more beautiful, but in many cases the cheapo versions are every bit as effective. So be smart and save money everywhere you can. In general, these are the treatments and products you should shell out for: hair color, face moisturizer, foundation, lipstick, and shampoo. And these are some you may as well spend as

little as possible on: manicures and pedicures, body moisturizer, mascara, blush, and conditioner.

BUY GENERIC BASICS. The drugstore-versions of toiletries and everyday necessities like painkillers and razors are generally just as good as the brand-name items they're knocking off. Saving a dollar here and there by using these brands may not seem like it saves a lot of money, but it adds up over time to something substantial. And it's just smart.

A Table Manners Refresher Course

Some of the little details of traditional table etiquette are increasingly out of date, and as long as you adhere to common-sense standards of behavior (not chewing with your mouth open, and that sort of thing), you're not going to offend anyone. Still, as a grown-up, you may as well know what the rules are, because it just feels good to know you're doing everything right. Here are a few table-manners tips, just in case you ignored them back when your parents taught them to you the first time.

- Your utensils should never touch table after you've started eating with them. When you set them down, rest them on your plate, and when you're done eating, place them side by side across the center of the plate, with the knife's blade facing you.

- Never cut your bread with a knife. Tear it into pieces and eat them with your hands. Instead of spreading butter on the entire piece of bread or roll at once, place a slice of butter on your bread-and-butter plate; then use it to butter each piece of bread individually just before you eat it.

- Spoon soup away from you. If you set your spoon down, place it on the plate the soup bowl sits on, not in the center of the bowl.

- Hold your wineglass at the top of the stem or the bottom of the bowl, right where the two meet.

- When you leave the table in the middle of a meal, place your napkin on the chair and push the chair in. When the meal is over, place your napkin to the left of your plate.

The Right Way to Make Introductions

There's a proper way to introduce people to each other, and although the protocol may seem a bit outdated, it can't hurt to keep it in mind. Here are the rules.

- Younger people are presented to older people: "Mrs. Smith, I'd like to introduce my friend Sara."

- In a setting where people have different ranks (these days that mostly applies only to work, but could apply to religious, military, and political settings), people of lower rank are presented to people of higher rank: "Reverend Carter, I'd like to introduce Jeff Clark." "Congressman Smith, I'd like you to meet Sara Jones."

- When a man and a woman are roughly the same age, rank, and so on, the man is presented to the woman: "Sara, I'd like to introduce Jeff Clark."

- Tell the people you're introducing something about each other so they can get started talking without any awkward pauses. "Sara, I'd like you to meet Jeff Clark. He just got back from a trip to Argentina. Jeff, Sara frequently travels to South America for her job in video production."

Pointers on Writing Perfect Thank-You Notes

Stylish grown-up women with manners are disciplined about thank-you notes—not thank-you e-mails or text messages, but proper notes. Of course you need to write them after you receive a gift, but it's also really nice to send one to the host of a party the day after, and to the parents of the bride after the wedding they hosted. Remembering these three rules will help you write touching, expressive ones without having to agonize over them.

- *Cut right to the chase.* The first line of a thank-you note should clearly express your gratitude for the gift, and include the words "thank you."

For example: "Thank you so much for the gorgeous blue vase!" "I had such a fun time at your beach house last weekend; thank you so much for inviting me."

- *Be as specific as possible.* State why you like the gift so much or how you plan to use it. If you're saying thank you for an experience, give an example of why it was so enjoyable. For example: "The color looks perfect in my living room, and right now the vase is filled with pretty peonies." "It was such a treat to get to wake up and smell the ocean in the air, and to spend the days catching up with you."

- *Don't be afraid to gush.* Even if you have to stretch the truth slightly, by heaping praise on the gift or experience, you'll make the note's recipient feel amazing—and encourage him or her to give you more goodies in the future! For example: "How did you know cobalt blue is my favorite color?" "Those Vosges chocolates you served after dinner are the best I've ever tasted. You've given me a new addiction!"

4. Get, and Stay, Organized

Yes, you've heard it before, but it never hurts to be reminded: Keeping your home organized is crucial to living happily in it. Clutter makes it ugly, and not being able to find things in it is hugely frustrating. Plus, being surrounded by things in disarray is stressful on some level, even if you're not an anal person.

If you're one of those inherently organized people who tidies reflexively and can send anything that gets in her way to the Salvation Army without a second thought, you can stop reading. But if, like me, you need to learn the organizational skills some girls are born with, read on. These pointers from pro organizer Cyndi Seidler, president of Handy Girl Organizers in Los Angeles, can help you use your space wisely and kick clutter to the curb.

Everything Must Have a Home

This is major. "Things that don't have a set place, that don't belong anywhere, are the major cause of clutter and disorganization," says Cyndi. You wind up setting them on the counter, or just stashing them on some shelf where you stash every-

thing, and soon chaos ensues. If you have a system for dealing with every type of object, then you can put it where it belongs as soon as it enters your home. Have a pretty bowl near your door and always drop your keys into it when you enter. Have a box for batteries, a box for extension cords, a bowl for spare change.

Also, this way you always know where everything is when you need it. "If it takes you more than thirty seconds to find anything, then you have to work out a better system for where to keep it," says Seidler.

You Need a System for Dealing with the Mail and Other Paper

It's the main thing that enters your home all the time and threatens to build up in a scary way, so keep a tray on your desk, dresser, or entryway table and put mail there the second you walk in the door. Make sure the tray is in plain sight so you can't ignore your correspondence.

To Find More Storage Space, Look Up

Find ways to utilize space above your cabinets or on top of your fridge, or put shelves up on empty walls.

Plastic Storage Containers Are Your Ally

Label them so you'll know what's inside, or buy see-through ones so you'll see what's in them.

If You Store Things Out in the Open, Make Them Look Good

For example, you can keep your dish towels on top of the refrigerator if they're in a good-looking basket and their colors coordinate.

Edit, Edit, Edit!

Holding on to too much stuff is the enemy of a peaceful, organized home. When you're trying to decide whether to keep something or not, ask yourself, "What is its current value to me?" If it *used to be* valuable to you, then it's now just clutter and needs to be disposed of. And if you decide it still has value, then use it, or bring it out where you can show it off, rather than stashing it in an overcrowded closet.

Final Thoughts

It's my sincere hope that you've found some of the information in the preceding pages helpful and inspiring. The thing that's most important to take away from them is how essential it is to create a happy, healthy living space for yourself, and to never let anyone make you feel that you need to spend entire days cooking and cleaning, or piles of money on decorating, to have a domestic life you can be proud of. Because even though a cool girl like you wants to explore all the interesting places the world has to offer and to sample the sort of adventures you can have only when you're far outside your safety zone, all those experiences are sweeter when you know you'll eventually return to a cozy place that feels like home.

Sources

Mark Allen, owner of Le Soir bistro in Newton Highlands, Massachusetts

Jeff Armstrong, executive chef at 17 Restaurant in Houston

Tracey Benton, owner of Trace Elements, a New York City–based interior design firm

Catherine Brophy, owner of Feng Shui Interiors, is a classical feng shui practitioner and interior designer based in New York. She has given workshops and lectures across the country.

Luis Collazo, owner of Lotus Flowers in New York City

Melanie de Coppet, owner of Red Table Catering, which creates delicious meals and cocktail parties in some of Manhattan's swankest pads.

Christine Dimmick, founder/CEO of The Good Home Co. line of house care products

Elizabeth Falkner, owner of San Francisco's famous gourmet baked goods emporium Citizen Cake

Barbara Roche Fierman, owner of New York City's Little Elves cleaning service

Cecile Roesch-Giannangeli, president of www.finewine.com and of the Women's Wine Tasting Club of Washington, D.C.

Kim Haasarud, owner of Los Angeles beverage concepts company Liquid Architecture (www.liquid-architecture.com)

Jacques Haeringer, chef and owner of the classic French-Alsatian restaurant L'Auberge Chez François in Great Falls, Virginia

Adam Jannese, bar manager at London's ultra-hip One Aldwych hotel

Celerie Kemble, a New York and Palm Beach—based interior designer with a line of furniture called Celerie for Laneventure and a line of fabric and wallpaper called Celerie for Zoffany Inc. The signature style of her work for Kemble Interiors has been called "playful modernism."

Edward Lee, chef and owner of 610 Magnolia, which is known for its focus on the freshest ingredients, in Louisville, Kentucky

Sandra Tobin Marx, owner of Southern California's Between the Sheets shops, direct importers of some of the world's finest linens

Patrick McMullan, a New York City photographer who has been a fixture on the fashion, society, and nightlife scene for more than two decades and has published numerous photography books, including *In Tents* and *so80s*

Kristin Moses, marketing and public relations director for Kluge Estate Winery and Vineyard in Charlottesville, Virginia

Laura Newsom, a New York—based interior designer with a classical style, who has worked at top firms, including Easton Moss and Christie's auction house

Maire O'Keefe, owner of Thyme Catering in Los Angeles

Pauline Parry owns Los Angeles catering company Good Gracious! Events, which throws parties both intimate and gargantuan for many of the city's most bold-faced names and high-power organizations

Bryan Rafanelli, owner of Rafanelli Events, plans parties and weddings for high-end clients in Boston, Miami, and Palm Beach.

Karen Reisler, a New York designer who owns her own firm, Karen Reisler Designs. She's known for classic, warm interiors with a touch of the exotic. She's a former magazine stylist who honed her design skills at Parish-Hadley, the high-end firm best known for its involvement in redesigning the White House for the Kennedys.

Cheryl Richards, an award-winning Boston-based photographer

Trudy Rosato, coowner of New York City's Connors-Rosato gallery, who formerly worked at William Doyle Galleries, a New York auction house, as the head of the twentieth-century art department, and at the Museum of Modern Art

Margaret Russell, editor in chief of *Elle Decor* magazine

Sam Sabine is a former restaurateur who now owns Great American Catering, a New York City catering company and events space.

Cyndi Seidler, organization expert and president of HandyGirl Organizers in Los Angeles

Kerry Simon, executive chef and owner of Simon Kitchen, in the happening Hard Rock Hotel in Las Vegas

Rosalie Stern, owner of Flower Dec Floral Design Studio in Los Angeles

Jim Tehan, spokesperson for Myvesta, a nonprofit financial education organization

Denis Toner, president and founder of the Nantucket Wine Festival

Albert Trummer, considered one of the world's best bar chefs, creates drink menus for hot restaurants and watering holes such as New York's Kittichai and Town.

Paul Virant, executive chef at Vie restaurant in Chicago

David Walzog, executive chef of the Glazier Group, which owns the Steak House at Monkey Bar, Michael Jordan's the Steak House N.Y.C., and the Strip House (all in Manhattan) as well as the Strip House NJ and the Strip House Houston (which will open this fall)

Heather Wells, president of Heather G. Wells, Ltd. Architectural Interiors, which has offices in both Boston and Chicago

Heather Whitney Ashforth, a Los Angeles interior designer who's decorated the pads of some of the city's most stylish inhabitants (Reese Witherspoon, for one)

Index

Index